BARBARA KASTEN: STAGES

BARBARA KASTEN: STAGES

BARBARA KASTEN

STAGES

Alex Klein

With contributors
Liz Deschenes
Alex Kitnick
Jenni Sorkin

Institute of Contemporary Art
University of Pennsylvania

JRP | Ringier

Contents

Director's Foreword

Barbara Kasten: Stages is the highly anticipated, first major museum survey of the artist's work. Spanning five decades of Kasten's ongoing engagement with abstraction, light, and structure, the exhibition positions her well-known photographic explorations within an expansive arc of painting, theater, textile, architecture, and installation, and situates her practice within current conversations around sculpture and photography. Kasten's preoccupation with the interplay between three- and two-dimensional forms, her interest in staging and the role of the prop, her cross-disciplinary process, and her innovative approaches to abstraction and materiality speak volumes to our present artistic moment. A new generation of artists inspired by her inquiries can now be seen as her contemporaries.

I am pleased to partner with The Pew Center for Arts & Heritage (PCAH), whose Discovery grant provided crucial early support for curator Alex Klein's research and whose Exhibitions & Public Interpretation grant helped transform our ambitions into a fully realized exhibition, publication, and series of public programs, as well as a commission for the artist to create an ambitious new video installation. PCAH continues to enable ICA and our Philadelphia colleagues to radically reshape contemporary art and culture.

ICA's Board of Overseers daringly supports our curatorial focus on the untested and the new. I thank them, and for their help with *Barbara Kasten: Stages* I also offer my gratitude to: Nancy E. and Leonard M. Amoroso Exhibition Endowment Fund, Pamela Toub Berkman and David J. Berkman, Carol T. and John G. Finley Fund, Marjorie E. and Michael J. Levine Fund, Amanda and Andrew Megibow, Stephanie B. and David E. Simon, Babette L. and Harvey A. Snyder, and Meredith L. and Bryan S. Verona. Barbara and Ted Aronson presciently endowed ICA's publication program, and we thank them for their focus.

ICA is proud to be a research center for contemporary art and ideas at the University of Pennsylvania. We thank Penn's President Amy Gutmann, Provost Vincent Price, and Vice Provost of Faculty Anita Allen for their leadership.

Bortolami, New York; Gallery Luisotti, Santa Monica; and Kadel Willborn Gallery, Düsseldorf represent Barbara Kasten, and we are pleased to have their support through many aspects of the exhibition and this publication's development.

This extensive presentation relied on the participation of private and public collections. I thank the following individuals for generously parting with their works for the duration of the exhibition: Diana Billes, Stefania Bortolami, JK Brown and Eric Diefenbach, Marwan and Hana Dalloul, Kathryn Fleck Persach, Gregory and Aline Gooding, Rodney Lubeznik and Susan Goodman, Scott Ostfeld, and Darlene and Jorge M. Pérez.

The following museums provided loans to the exhibition: Museum of Contemporary Art, Chicago; Los Angeles County Museum of Art; University Art Museum, California State University Long Beach; Philadelphia Museum of Art; Brooklyn Academy of Music Hamm Archives; and Center for Creative Photography, University of Arizona, Tucson.

I am indebted to Alex Klein, ICA's Dorothy and Stephen R. Weber (CHE'60) Program Curator, who conceived of and produced this project. Her sagacity and integrity are visible at every level of the venture. *Barbara Kasten: Stages* is the culmination of years of research and a testament to Klein's unparalleled and unshakable commitment. Supporting Klein, Chief Curator Ingrid Schaffner and Director of Curatorial Affairs Robert Chaney guide ICA's artistic direction, leading our curators to extend the museum in unexpected and welcome directions.

ICA's staff continues to impress me with their dedication and ability. Their talents make it possible for the museum to reinvent itself each season. For his work as Associate Curator and our publications coordinator, we are always pleased to thank Anthony Elms. I am grateful for the essential work of Assistant Curator Kate Kraczon, Whitney Lauder Curatorial Fellow Liz Park, Spiegel-Wilks Curatorial Fellow Egina Manachova, and Curatorial Administrative Assistant Lauren Downing. The Programming team's newest member, Curatorial Assistant Gee Wesley, helped secure rights for this publication and assisted with the coordination of the Kasten Colloquium. Marketing and Communications Director Jill Katz and Communications Associate Becky Huff Hunter bring our projects critical attention and widen our audience. I applaud the dedication of Director of Development Samantha Gibb, Associate Director of Development for Individual Gifts Jeffrey Bussmann, Assistant Director of Development & Alumni Relations Jessica Scipione, and Development Assistant Christina Yu. We thank Administrative Coordinator & Assistant to the Director Eliza Coviello and Business Administrator Shannon Freitas for improving the museum with professionalism and good humor. For maintaining high standards for the "ICA experience," we are indebted to Visitors Services Manager & Program Technician William Hidalgo, Front Desk Attendant Larry Rosen, and longtime ICA guard Linda Harris. I thank Registrar Mandy Bartram Runnels and Chief Preparator/Building Administrator Paul Swenbeck and our installation crew of Philadelphia artists: Greg Biché, Emilia Brintnall, Marley Dawson, Joy Feasley, Jacob Kehs, Thom Lessner, Isaac T. Lin, Preston Link, Patrick Maguire, Rich McIsaac, Nakima Ollin, Raul Romero, Rebecca Suss, and Sophie White. We additionally acknowledge, for their dual roles, Raul Romero for his videography and assistance with the video installation, and Emilia Brintnall for serving as our Interim Registrar. Dana Hanmer, our former Associate Registrar, expertly began the loan process, and ICA's former Writer-at-Large Rachel Pastan skillfully drafted our grant. The multiyear project received indispensable support from interns Hillary Halter, Paz Ortúzar, Emma Pfeiffer, and Kayla Romberger.

ICA is excited to work again with Mark Owens, who, along with Nilas Andersen, developed the unforgettable design of this publication. I am grateful to Constance Mensh for her striking installation photography.

Liz Deschenes's conversation with the artist and the essay contributions of Jenni Sorkin and Alex Kitnick greatly expand our thinking about Kasten's work. The invaluable research assistance by Sarah Burford and Grace Ambrose, and copyediting by Nell McClister, is evident throughout. This publication is a joint venture with JRP | Ringier, and we thank Lionel Bovier, Eléonor de Pesters, and Gilles Gavillet for their collaboration.

PCAH's support enabled us to begin a new program to coincide with the exhibition, a colloquium for area graduate students. Professor Philip Glahn at Tyler School of Art, Temple University, has been essential to its formation, and we thank Penn professors Christine Poggi and Nancy Davenport for their early support of this experiment. I thank colleagues at PennDesign, Pennsylvania Academy of the Fine Arts, Moore College of Art and Design, and University of the Arts for their enthusiasm, and the students who participated.

The question of who gets to be a contemporary artist is at the heart of ICA's mission as an institute and institution dedicated to the unexplored, untested, and underrepresented. With this exhibition, Barbara Kasten is finally getting her due, and it is a great honor for me, and for all at ICA, to present *Barbara Kasten: Stages*. Working with Barbara over the past several years has been both a privilege and a pleasure. I offer her my heartfelt thanks for embracing ICA, our team, and our process.

Amy Sadao
Daniel W. Dietrich, II Director

Appropriately, I first came to know Barbara Kasten's work in the environs of a studio. Kasten is among the foundational artists studied by anyone learning to light a scene or perfect a color print. In my own art education I encountered her *Constructs*—dynamic forms and impossible hues that demonstrated a mastery of composition and camera technique—not in person, but projected on a screen in a classroom. These images stayed with me, but the story of the artist and the full scope of her practice remained somewhat opaque. Fast forward ten years to 2007 in Los Angeles, where many of my artist peers were engaged in a series of heated debates about the state of photography. Chief among these were the stakes being claimed for a new abstraction that emerged at that particular political, critical, and economic moment alongside unprecedented technological advancements and their attendant anxieties. This coincided with the appearance of artworks that seemed to long for analog processes and that paid homage to modernist experiments and utopian energies. In the back of my mind was another image: something seemed familiar, and then I remembered the screen, and I thought of Barbara Kasten.

Barbara and I began a dialogue soon thereafter, and as I learned more about the complexities of her work, the depth and rigor of her investigations, and the milieus that had informed her practice, I wanted to know even more. Abstraction, it turns out, was just the beginning. In her work I found an abiding interest in artistic labor, performance, and the body in space— a body engaged with objects, confronting both her minimal industrial materials and the limits of perception, and an eye unafraid to revel in color, form, and camp aesthetics. Kasten, it seems, had always been eminently in sync with her times, yet in conversation with her predecessors. And so, with *Barbara Kasten: Stages*,

the artist's first major survey in an art museum, we have the benefit of a perspective that allows us to both place Kasten's work in dialogue with previous moments from throughout her extensive career, as well as with a younger generation of artists who have embraced her both as an important precedent and an artistic peer.

To "stage" is to frame, and in the context of this exhibition its meaning is threefold: the staging of an exhibition, the stages within an artistic career, and the way in which Kasten has consistently staged her own work, both in space and for the camera. Although the show is in no way comprehensive, its purpose is to open up new avenues into and out of Kasten's oeuvre. Although Kasten's project has developed through the lens of many different mediums and disciplines, her work has consistently revolved around a core set of conceptual, material, and phenomenological concerns that are best understood when considered in concert. There is much to learn from the formation of her practice, which grew out of the unique and provocative intersection of Bauhaus-influenced pedagogy, the experimental ethos of California in the 1970s, and the deconstructive tactics and design aesthetics of high postmodernism. Yet her most recent bodies of work are perhaps some of her most stunning, physical, and complex to date. This has resulted in a resonance with a new generation of artists whose own work revolves around the tension between the objectness of the "thing" and the flat surface of the image. For these artists, Kasten's work has primarily been encountered on the computer screen and understood through the vocabulary of Photoshop, the jpeg, and the 3D render. While this exhibition acknowledges the way Kasten's analog work anticipates these new, digital modes of seeing, its emphasis is on the critical importance of materiality and the body-in-action to an understanding of her practice.

With this in mind, this publication is decisively organized from the perspective of the present and thus begins with Kasten's own voice, in conversation with artist Liz Deschenes. From there, a set of interpretive essays contextualizes three different strands in Kasten's work: the critical stakes of her *Architectural Sites*, the importance of staging and the role of the prop in her *Constructs* and elsewhere, and the "tactile" beginnings of her feminist fiber sculptures, which laid the groundwork for her lifelong engagement with the optical, the haptic, and the material. A final biographical chronology and an exhibition and publication history are meant to serve as both a granular overview and a resource for future scholarship. Structurally, working backwards underscores the contemporaneity of this project, but it also allows the reader an opportunity to unfold the many layers embedded in Kasten's work, concluding at the beginning, and with a new set of reference points that were not previously possible.

I could not be happier with the other voices that appear throughout this book. Liz Deschenes proved an insightful and sensitive interlocutor, while essayists Alex Kitnick and Jenni Sorkin each offer new road maps and indeed some of the most insightful critical writing on Kasten's work to date. I am indebted to all of them for the strength of their words and observations.

I would like to reiterate ICA's appreciation to The Pew Center for Arts & Heritage for the invaluable resources and advice that they provided at both the research and exhibition stages. In particular, my curatorial process was deeply enriched by numerous hours spent with the artist in her archive and studio in Chicago and by my travels to Los Angeles, the Bay Area, Tucson, and New York to perform research and conduct in-person interviews.

Kasten's galleries have also provided generous support in numerous ways: I would like to thank Theresa Luisotti and Natasha Berokoff at Gallery Luisotti, Santa Monica, where I found inspiration in their Kasten exhibition organized as part of the Getty's *Pacific Standard Time* initiative; Stefania Bortolami and Christine Messineo at Bortolami, New York, for positioning Barbara in conversation with a younger generation from the beginning; Iris Kadel and Moritz Willborn at Kadel Willborn

Gallery, Düsseldorf, whose support of Barbara in the new direction in her work provided the inspiration for the video installation at ICA; and, early on in the process, Jessica Silverman at Jessica Silverman Gallery, San Francisco.

As with any project of this scope, there were many moving parts and many people who played an important role. In particular, Sarah Burford, PhD candidate at Bryn Mawr College, ably assisted me on many components of the exhibition, chief among them the compilation of a detailed exhibition and publication history, which has already proven an invaluable resource. Thank you for your thoroughness, insights, and all-around enthusiasm for the project. Sarah was preceded as Research Assistant by the very capable Grace Ambrose, formerly the Spiegel-Wilks Fellow at ICA. Grace accompanied me on one of my early forays into Barbara's archive, and we spent hours going through troves of material. Her diligence and organizational skills left me in very good hands.

At ICA I must thank the whole staff, under the leadership of Daniel W. Dietrich, II Director Amy Sadao, for their hard work on this complex and multifaceted project. In particular, Chief Curator Ingrid Schaffner and Director of Curatorial Affairs Robert Chaney deserve special thanks for their mentorship and support.

We were lucky to borrow many of the works in the exhibition directly from the artist's personal archive. Barbara was aided in the studio by several assistants over the years, but special thanks are due to Caitlin Arnold for her extensive assistance and color correction skills, and to Kate Bowen, who lent her expertise to the development of the video installation, *Axis* (2015).

Several individuals were of particular help in the many collections from which we borrowed works and where I conducted research: Louie Fleck, Archives Coordinator at the Brooklyn Academy of Music Hamm Archives; Leslie Squyres and David Benjamin at the Center for Creative Photography, University of Arizona, Tucson; Eve Schillo at the Los Angeles County Museum of Art; Ilee Kaplan and Maria Coltharp at the University Art Museum, California State University, Long Beach (who made the miraculous discovery of a trove of original process images, two of which appear

on the cover of this publication); Michael Darling at the Museum of Contemporary Art, Chicago; Peter Barberie at the Philadelphia Museum of Art—thank you, Peter, for being such a good colleague—Kristen Lubben and Matthew Carson, who helped me at the International Center of Photography, New York in the midst of their move; Lucy Gallun at the Museum of Modern Art, New York; and Lucinda Bunnen for her help with images and her permission to screen her wonderful documentary about the making of an *Architectural Site*.

The intellectual community at Penn has provided constant inspiration and stimulation throughout the development of this project, and I must thank my colleagues in PennDesign, the History of Art Department, and across the university. My thanks also to the other colleagues who took the time to listen, read, and discuss along the way—you were invaluable sounding boards: Kevin Moore; Douglas Eklund at The Metropolitan Museum of Art, New York; Yasufumi Nakamori at the Museum of Fine Arts, Houston; Philip Glahn at Tyler School of Art; and Charlotte Cotton. Some of these ideas were also presented publicly at MoMA's Photography Forum and in more intimate conversations through the *Camerawork* group organized by Eva Respini and Sara VanDerBeek—thank you for connecting us with a strong community of women and for your warm reception of this project.

Many individuals generously shared ephemera and reminiscences. Throughout this process we took numerous trips down memory lane, and I now have my own fond memories of the hours we spent together on the phone, on email, and in person: Constance Glenn, Ann Hatch, Barbara Hitchcock, Bill Hunt, Judy Dater, Deborah Irmas, Arata Isozaki, Margaret Jenkins, Ellen Brooks, John Reuter, John Upton, Joyce Nereaux, Martine Syms, Marco Braunschweiler, Timothy Druckery, William Larson, Yancey Richardson, Anthony Pearson, and especially Leland Rice.

New York designers Other Means (Ryan Waller, Vance Wellenstein, Phil Lubliner, and Gary Fogelson) are the able stewards of ICA's graphic identity and worked closely with myself and Barbara on the public presence of the show in both exhibition graphics and marketing—thank you for your exuberance and good humor.

Thank you to Constance Mensh who took the beautiful and crucial installation photographs that appear throughout the catalogue. Debi Bergerson at Shapco, Minneapolis, went above and beyond to ensure that we were able to create the best catalogue possible. The design of this publication has been sensitively and compellingly overseen by Mark Owens, assisted by Nilas Andersen. I could not have imagined this project in anyone else's hands, nor could I have completed it without your patience, feedback, and support: contra mundum.

And finally, I want to extend my profound appreciation to Barbara Kasten herself. I am cognizant that as a curator this is a once in a lifetime opportunity, and it has been a privilege to work so closely together over many years. Thank you for your trust and for welcoming me into both your studio and your home. Your work, your rigor, and your commitment over a long career are an inspiration to me—and to so many other makers. More personally, the value of your friendship is quite simply beyond words.

Alex Klein
Dorothy and Stephen R. Weber (CHE'60)
Program Curator

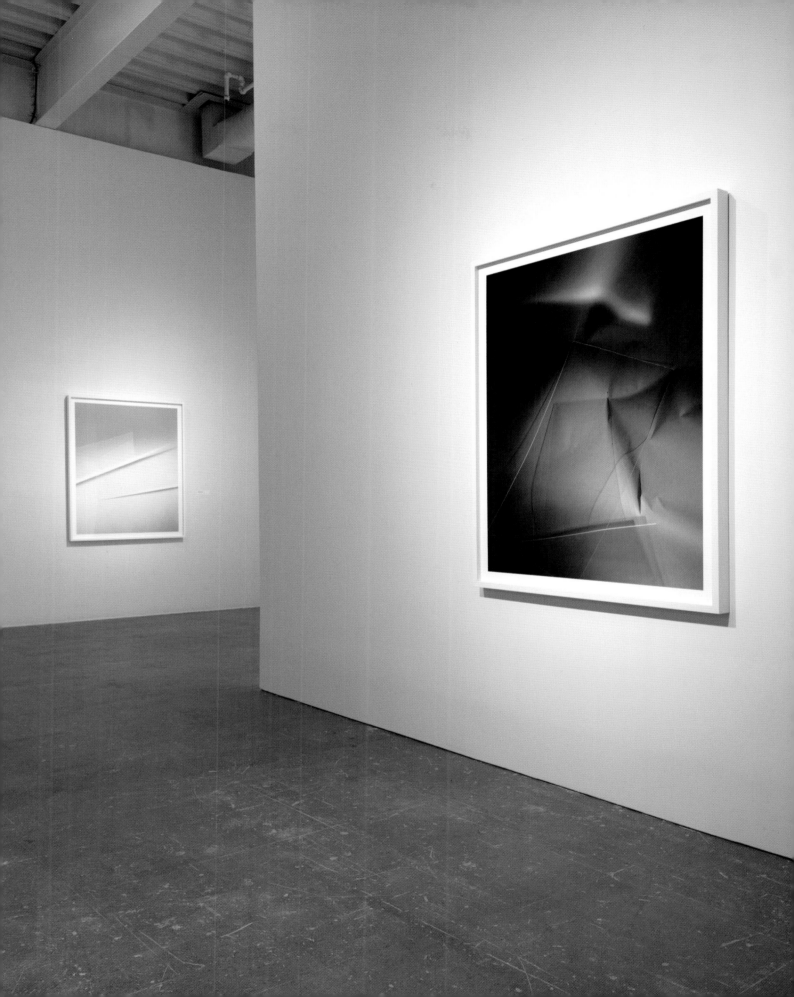

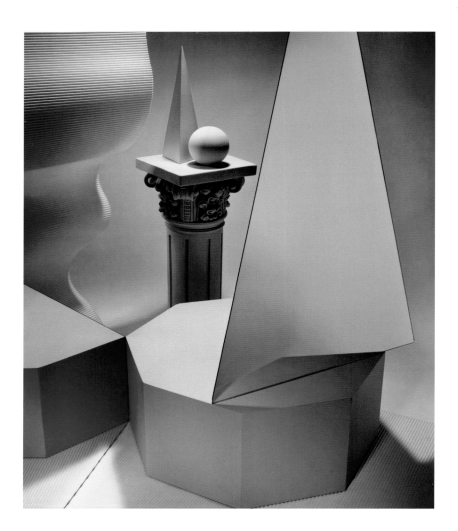

Construct XXII, 1983
Polaroid 20 × 24 Polacolor photograph
24 × 20 in. (61 × 50.8 cm)

Studio Construct 17, 2007
Archival pigment print
53 ¾ × 43 ¾ in. (136.5 × 111.1 cm)

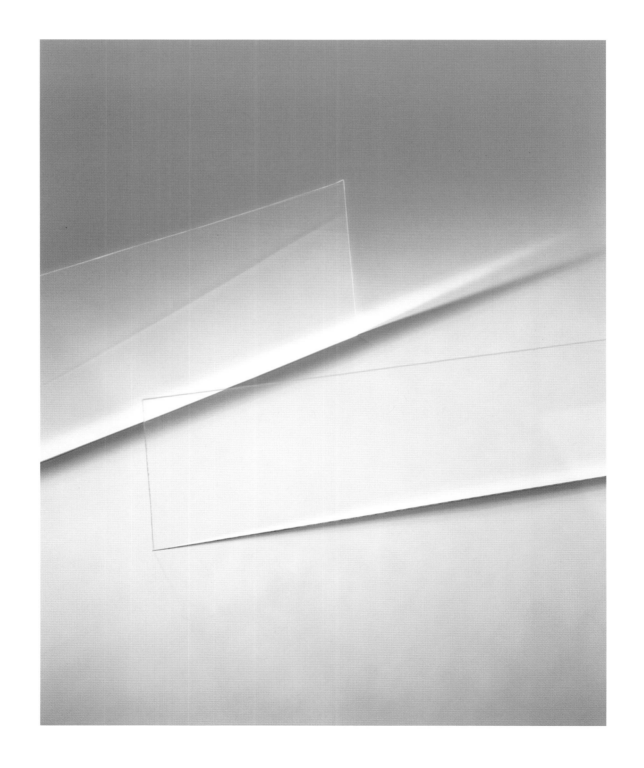

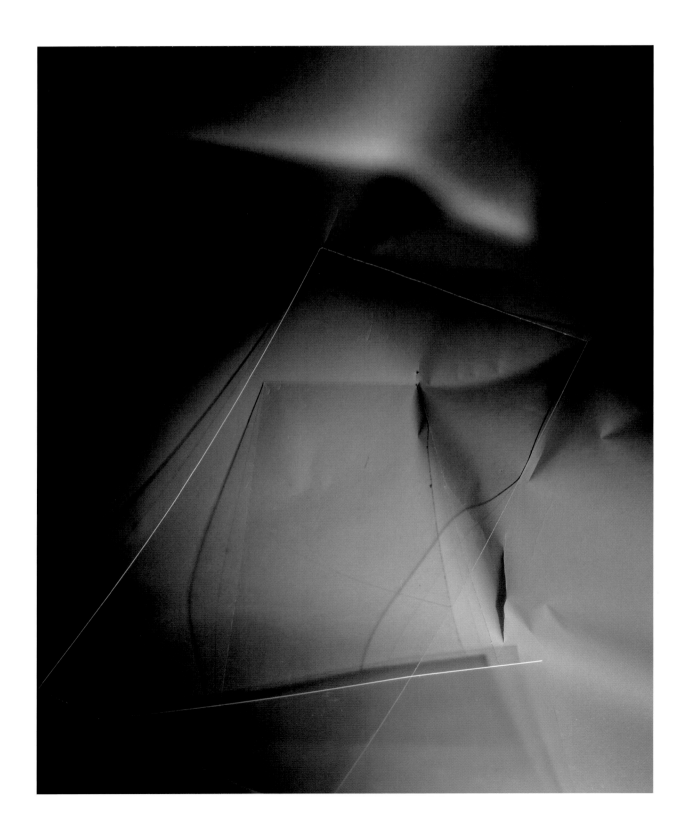

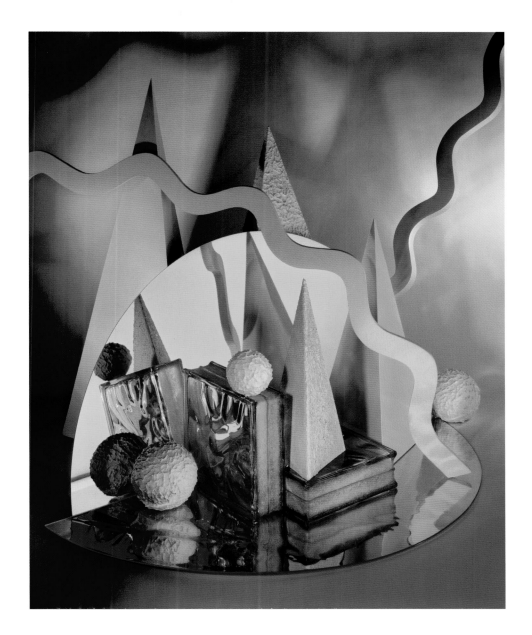

Studio Construct 125, 2011
Archival pigment print
53 ³/₄ × 43 ³/₄ in. (136.5 × 111.1 cm)

Construct 32, 1986
Silver dye bleach print (Cibachrome)
37 × 29 ½ in. (93.9 × 74.9 cm)

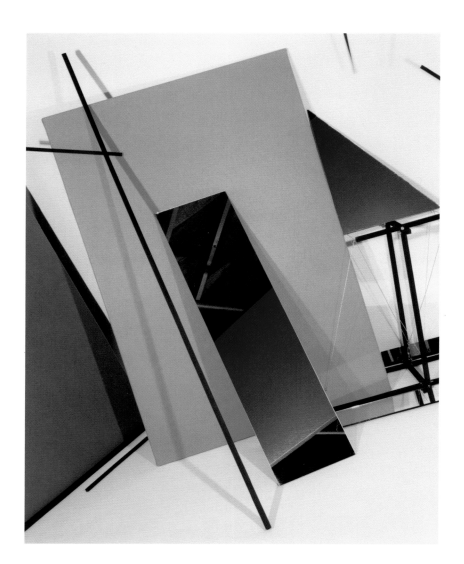

Construct VII-A, 1981
Polaroid Polacolor ER photograph
9 ⅓ × 7 ⅓ in. (23.7 × 18.6 cm)

Amalgam Untitled 79/16, 1979
Gelatin silver print (enlargement
with photogram)
16 × 20 in. (40.6 × 50.8 cm)

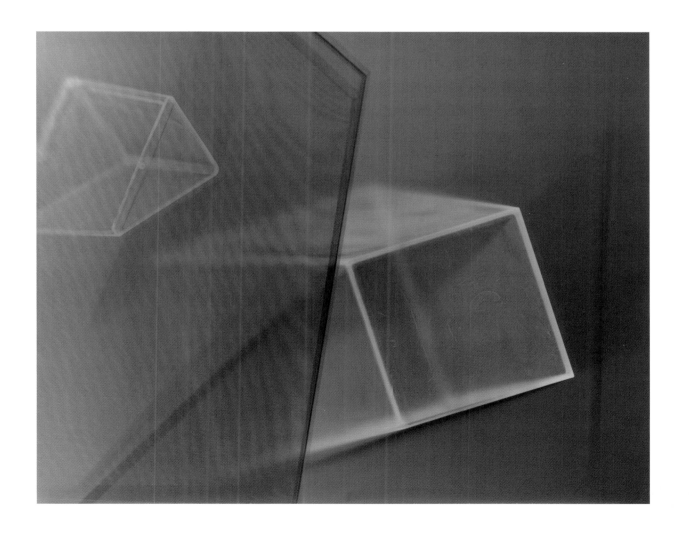

Photogram Painting Untitled 77/3, 1977
Cyanotype (photogram) with
paint stick on BFK Rives paper
30 × 40 in. (76.2 × 101.6 cm)

Construct NYC-4, 1983
Polaroid 20 × 24 Polacolor photograph
24 × 20 in. (61 × 50.8 cm)

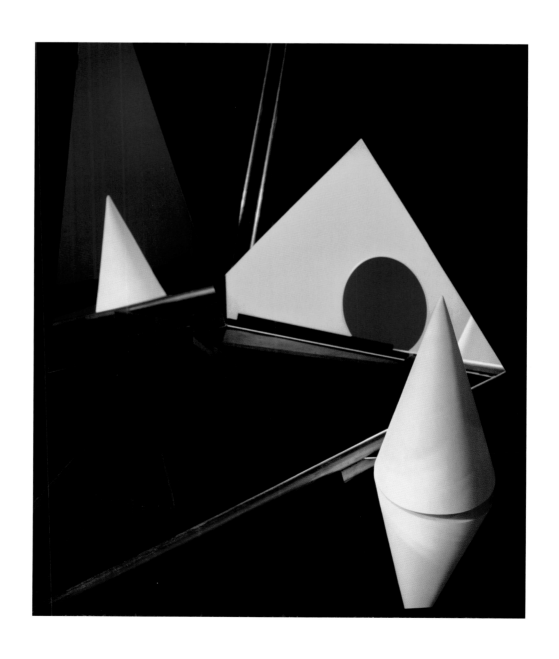

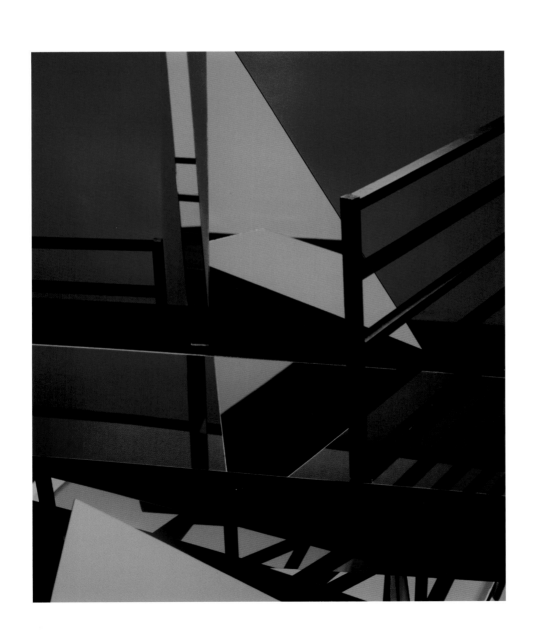

25

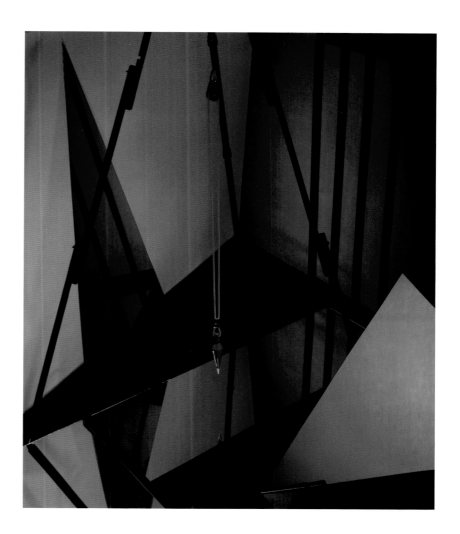

Construct PC/IX, 1982
Polaroid 20 × 24 Polacolor photograph
24 × 20 in. (61 × 50.8 cm)

Construct PC/XI, 1982
Polaroid 20 × 24 Polacolor photograph
24 × 20 in. (61 × 50.8 cm)

Architectural Site 10, December 22, 1986, 1986
Silver dye bleach print (Cibachrome)
60 ½ × 48 in. (153.7 × 121.9 cm)

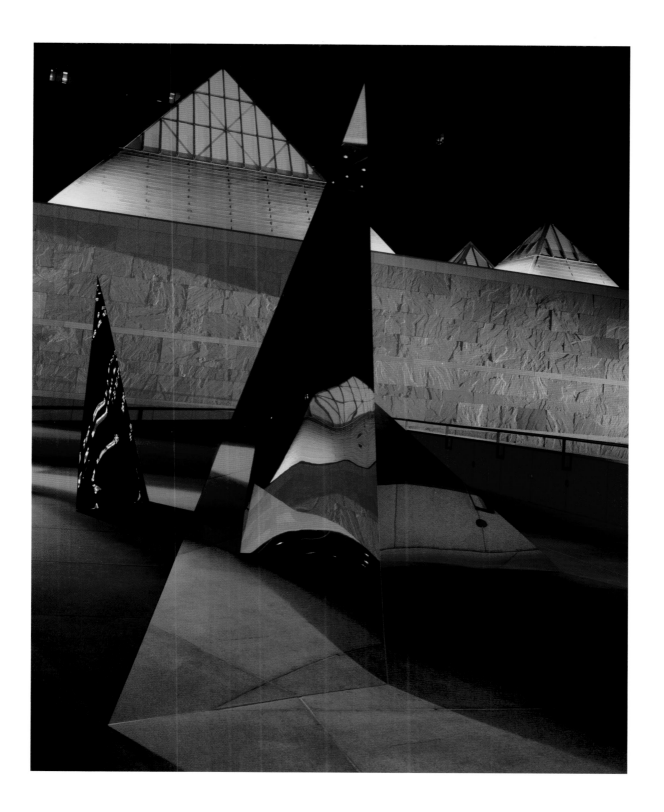

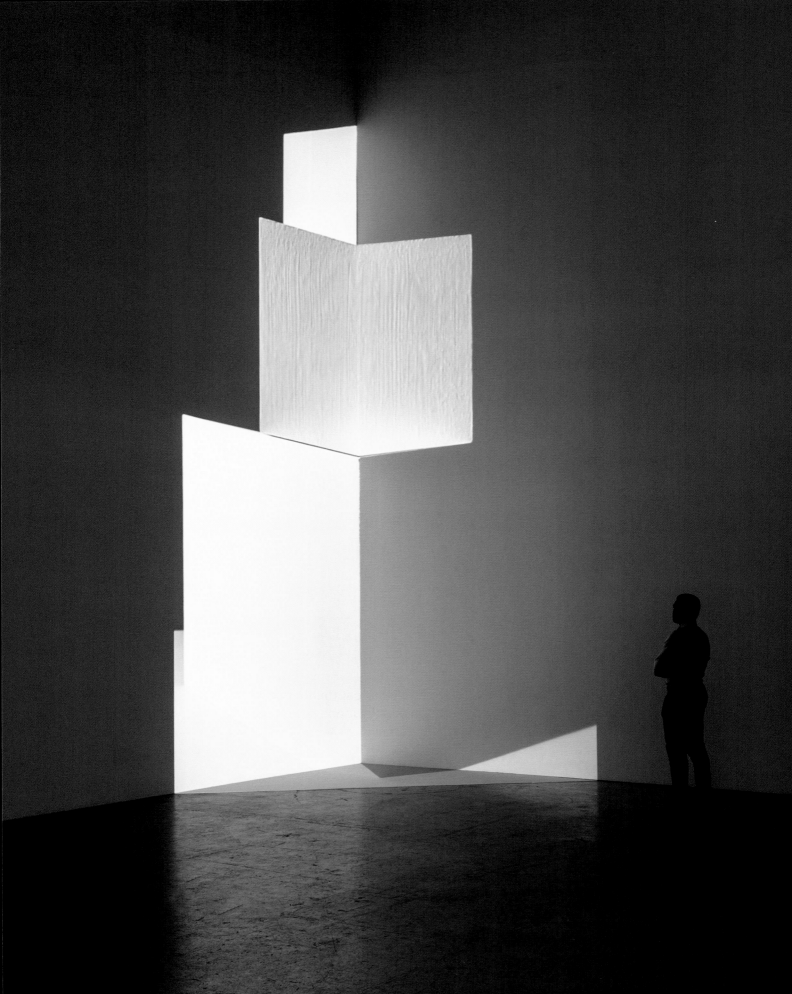

Liz Deschenes In all your bodies of work you are playful with size and scale—small models get enlarged, and massive architecture gets reduced. How do you determine the scale of the work and the proportions of the works to each other?

Barbara Kasten I have never done tabletop setups. I work bodily in the space, moving, touching—I have to be in it. That's the way I make the photographs. In order to make this new installation at ICA, I'm making a mockup in my studio, which is twelve feet high, and I'm going to scale it up almost three times for the gallery, which is over thirty feet high. Making an exact plan to transform a work into another size is new for me. The *Architectural Sites* required intense planning and precision, too, in a somewhat different way. For that I planned an intervention with mirrors to alter the perception of a huge space, but I didn't replicate the space. Normally I work more intuitively, but the video requires planning a sequence and time chart. It looks and functions as a drawing.

LD I think we share the desire to make an experience in all of the spaces where we work. In this case you are working in the studio, but then you are going to present it in the exhibition space, and there will be a completely different set of criteria. Through your process you are going to be discovering things as well, and I think that's what you are talking about, discovery through doing.

BK Right. And you want other people to look at things in a new way, too, and it's elusive, it's ambiguous.

LD It's slippery.

BK Exactly. And it's out of reach. You can't deny it, it's there.

LD You have been working with moirés, the patterns made by two materials layered together, ever since your earliest photograms in the 1970s. How did you first come across the moirés, and what does it mean to be revisiting them in this particular exhibition?

BK I feel like I have a certain set of tools that I always go to, a tool chest that I keep using in different ways. The initial attraction to moiré was as a phenomenon that I saw happening. Recording it with cyanotype was a perfect solution for me as I was making the transition from painting and fiber into photography. It was the most direct way of using photography without a camera. The camera was not of interest to me at that time; I didn't even know how to use one. The idea of using layers of screen to create this very interesting phenomenon and capturing it on a two-dimensional surface is what interested me. That was my eureka moment, which most people have in the darkroom seeing the image come through the developer, but mine took place out in the sunlight.

LD How did you choose the textile pattern that you worked with?

BK It's actually fiberglass window screening—an industrial material. In the 1970s I was making three-dimensional sculpture by weaving a flat tapestry and pulling the warp threads through it.

opposite: *Axis*, 2015
HD video, color, silent,
5:20 min. loop,
masonite, paint
26 × 14 ft. (7.9 × 4.3 m)

So in the process of doing that I wondered if I could translate this into a teaching tool. How do I give students an idea of how to make a three-dimensional form out of a flat surface? It goes back even one more step to when I was young; I made a lot of my own clothes and designed and created patterns to sew. I started thinking of the flat woven surface as a shape that I might have cut out in a pattern—you know, darts to create a form. It was a very useful idea.

Barbara Kasten, fiberglass wall sculpture, 1974 (now lost)

LD What was the context like in Los Angeles at the time?

BK I taught in the fiber departments at various schools. I taught one semester at UCLA substituting for Bernard Kester, who was on sabbatical. After that I got into doing non-silver techniques of photography. It was the late 1960s/early 1970s in LA; Womanhouse had just started, and the women's movement was pretty much coming out of there. I remember hearing Anaïs Nin speak at Womanspace Gallery on Venice Boulevard in LA—she was a popular role model. It was a gathering of women that just wasn't happening much before that, a whole room full of women artists. However, I didn't participate in the movement very much. I never thought of myself as an activist. But I did feel that I was expressing my own form of feminism by believing that my work was valid, and making it was my form of protest.

LD I am curious who you aligned yourself with, not as a peer but as a precedent. I think that I was fortunate to have some really strong female role models in the arts. Sarah Charlesworth, Louise Lawler… I feel like the generation of women before me opened up so many doors that I probably couldn't do what I have done with the recognition that I have received if they hadn't come first. Were there any precedents for you who made it seem that things could be possible?

BK I guess I never thought it was *not* possible. In Southern California at the time, there definitely was a boys' club, and I griped along with everyone else. But I never felt threatened or anxious about my own status. I was ambitious enough to ignore them. However, I did find some of their work interesting, including Robert Irwin, James Turrell, and John McCracken. The women whose work was inspiring were women like Agnes Martin. There was a directness and simplicity to what she did and the spirituality in her work was powerful. Magdalena Abakanowicz was another strong woman and role model. She helped the fiber arts cross the line toward art. I invited her to be a part of an exhibition I did for my graduate thesis because I admired her sculptural approach in fiber. I got to know her personally while I was on a Fulbright in Poland and admired her attitude toward art making. Trude Guermonprez was the most important to me. She was a student of Bauhaus masters and an acclaimed artist and teacher. She was very open to experimentation and a strong woman. Trude and I were about the same difference in age as you and I. She was a very supportive person and I admired her for her tenaciousness and commitment. She didn't stop; she kept working, even through her personal hardships.

LD As I understand it, when Martin made the grids, the only tool she used was a string. You said that you have this set of tools that you use and return to.

I would say that geometry is one of your tools. Not to ask for a laundry list, but what are the tools that you never forget you have? And can you talk about the importance of your hand being involved?

Barbara Kasten, California State University Long Beach, 1982

BK I think in the 1970s I experimented with process and painting techniques differently than people trained in photography did. Not that I think I was a great painter, but my painting experience taught me to love the plasticity of paint and gave me the desire to use it. I worked with mixed media and cyanotype in the beginning, and now I am actually coming back to interdisciplinarity in another way. My curiosity about materials has been constant too. The fabric grid of the screening material has stayed with me. In fact, I still have the same roll of screen that I started out with forty years ago.

LD What year was your film *High Heels and Ground Glass*?

BK It was a labor of love over ten years. I received an NEA grant in 1980 to do a documentary on women in photography, and in the course of my research I came across Florence Henri. I didn't know much about her at the time. I found out she was in her eighties and living outside of Paris. She was one of the women I really wanted to meet and interview for the film.

LD But you weren't an activist?

BK I wasn't promoting my own narrative, which I think was how I understood activism and feminism at the time: women who were mothers and had families and who shared their lives; others allowed their femininity to become part of their work. I showed my feminine nature differently. I never had the inclination to be a mother. What I really wanted was to be just as good an artist as anybody, men included. I believed that one of the ways to do this was to make work that would compete and even be better than the men's.

LD And to apply to the NEA for a grant to discuss colleagues.

BK Well, I was aware that there were many films about male photographers. I thought: Where is the film about women? There weren't any. I certainly didn't have a reputation as a videographer or documentarian—my work was totally different. I had the support of many friends who were photography teachers and curators. When I got the grant, I arranged to go to France to meet Henri and videotape her. Unfortunately, she was in a nursing home and in her last stages, and I just didn't have the heart to put her on film.

Barbara Kasten directing *High Heels and Ground Glass*

I did get to spend some time with her, and she died a month or so later. I began to think about which other women would be important to document. I realized that there were several people in their

eighties who were known but who were still not receiving the attention that they should have: Gisele Freund, Louise Dahl-Wolfe, Lisette Model, Maureen Loomis, and Eiko Yamazawa. I invited a photography historian, Deborah Irmas, to join me. We wanted to represent women photographers across the field: the commercial portrait photographer, the historian, the reporter. The women we interviewed were all feisty women with such personalities. Lisette Model was incredible—she was flamboyant. I mean, no wonder Diane Arbus loved her—she was outspoken, telling us where the lighting would be best for her. Whereas Louise Dahl-Wolfe, who was a huge commercial success, was so sweet, such a motherly type. But she was also strong. All these women were really forward-thinking individuals. I could relate to them very easily.

High Heels and Ground Glass, produced by Deborah Irmas and Barbara Kasten, 1990, 29 min. From top: Louise Dahl-Wolfe, Maurine Loomis

LD Activism has the word "act" in it—which is what you were doing by pursuing this documentary over ten years and completing it.

BK I loved doing it, because I really loved meeting these women. They are all gone now. We also interviewed

Barbara Morgan and Ruth Orkin. We were supposed to interview Berenice Abbott, but we didn't have the money to travel to everyone. So, you know, my choices were purely selfish—I really wanted to meet these women and I wanted to get the documentary out in the world, both for their sake and for mine. And don't forget, I was just discovering photography. I wasn't trained as a photographer, so I didn't get any formal history except through research on my own. I learned about photography from observation. I was married to the photographer Leland Rice who was very active as a curator, teacher, and historian. Photographers were social and formed close friendships… we mingled with the greats in the history of photography. Ansel Adams visited us, Jacques Henri Lartigue stayed with us, Frederick Sommer and Imogen Cunningham were friends. It was a much smaller group then, and now that is lost because there are so many people interested in photography. That's not a bad thing, but it changes the personal dynamic.

LD The much-deserved recognition of your work has come from the next generation of artists and curators. Is it important for you to have this expanded group of peers working with similar concerns and materials?

BK I never felt that I had a peer group before, and now I do. There are younger artists who respect what I do, and I respect what they do. So what if there is a thirty-year age difference between us? We are talking on another level. I think that's because I'm still creating. There is a genuine link. Maybe they've found a role model in the same way that I've found a peer. I've found a group of artists who can understand what I am doing and not pigeonhole it, and it's not a matter of looking to me and borrowing forms or ideas that I might have. We are exchanging ideas, and it's exciting.

LD Alex had asked me when I first became aware of your work, and I can't

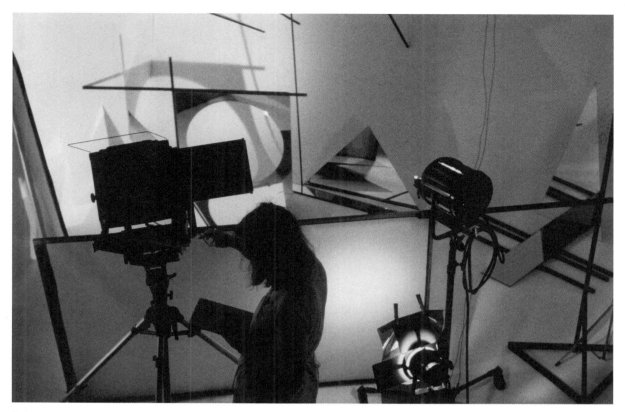

Barbara Kasten photographing her installation at California State University Long Beach, 1982

remember a time as an artist that I haven't been aware of your work.

BK The nice part is when we first met I felt like I knew you as a friend.

LD This brings me a to a completely different set of questions. You and I have had some affinities naming things and using similar materials. I'm interested in the realm of self-reflexivity and how you came across the title *Construct*. Was that a way of pointing out what people were looking at, or was it more tongue in cheek? If a title can be interpreted in many different ways, I think humor gets brought into it.

BK It was a term connected to Bauhaus ideology. The work was a construction that was made on site to be photographed. It also relates to the fact that an object is being photographed and yet part of the idea is to deconstruct that reality and make it an abstraction rather than representing the real thing. What always fascinated me about doing photography in this way is presenting something in three dimensions and yet

denying it as well, with a flat surface. I could paint those shapes—and I certainly looked at enough painting, such as Kandinsky, who used similar constructed forms—but I was bringing the contemporary into it by using photography. I was using photography in a way that it was not supposed to be used. That was the challenge for me: taking that medium and painting, too, and pulling them in different directions. I continue to work with that concept even now. In my most recent work, which I began in 2006, I use clear Plexiglas to simultaneously deny that there is something there because you can see through it, and acknowledge the physicality of the piece because there is a shadow there. I am not photographing the piece of acrylic; I am photographing the shadow of it.

LD As your work has evolved, it has been pared down over time. I am not going to use the term that you might expect me to use, "minimalism." I am curious what decisions you have made such that the work has this sort of essentialism to it.

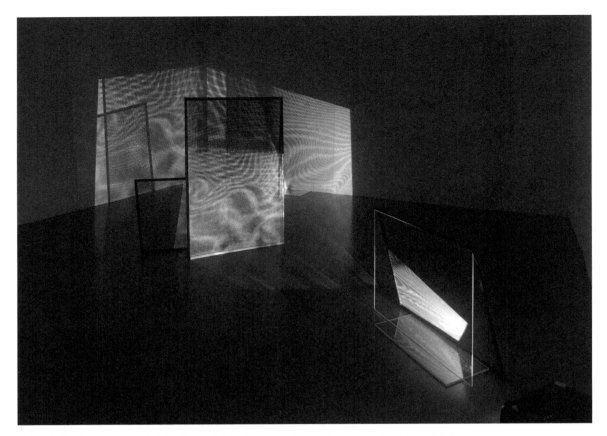

Barbara Kasten, *Scenes*, 2013, installation view, Galerie Kadel Willborn, Düsseldorf, Germany. Photo: Achim Kukulies

BK I did want to go back to the essentials, which to me were the geometric shapes, the negative image, and the material. I have many books on Bauhaus theater, and I loved the props that the artists made. They used the same imagery in paintings and photographs. It was part of an overall practice that didn't seem to have boundaries, and I liked that. I feel like at some point I learned too many techniques, and that was another reason to go back to the simplicity and the basics — it was getting too sophisticated and it didn't feel true to myself after a while. Now, because of digital printing and the internet, the surface of a photograph is becoming monotonous, and the photographic object has lost its importance. That's why I liked the Polaroid surface so much. It was so different from the general photographic printing surface. It has physicality to it, a presence.

LD With all of the ways that we could complain about the immaterial these days, I would argue that there has been a real return to the material. I am curious

how you feel about the embrace of the way that you are working now. How do you respond to the question of abstraction, and to the way in which your own work has been positioned around that very large and often misused term.

BK It is often misused. I mean, there are different kinds of abstractions, and I think that people don't always draw the distinction. I like to think about what I do more as an idea-based progression of abstraction than as a deconstruction of a real object. You and I do share a similar tendency toward what is essential. It's the translation of light into something readable or experiential. For me it's not light but the shadow.

LD If you could, how would you choose to position your work in the conversation around abstraction?

BK I wouldn't position it as abstract photography. There seems to be a need to identify subject matter and it's place in the world. But that's one of the reasons I make the work that I do, so that

there is no recognizable subject and no representational value. I am not photographing reflections from this bottle, for example. I really want the shadow, and I don't want it to look anything like the bottle. I want it to have its own identity, its own being. It's like going down to the core of who we are, in an almost spiritual way. It's ephemeral. We can't put our finger on it. There is a mystery to it. It's out of our control. We are presenting the qualities of light, not light itself. I think we are both after the intangible experience of witnessing a phenomenon.

LD It's really nice to hear you talk about the intangible, because I think it goes back to not wanting a name. It's ambiguous. It's slippery. I have been reluctant to think about the work in terms of abstraction and much more inclined to think about the phenomena that you are describing, which is not the expectation of photography.

BK In photography there is so much room for everything. Unfortunately, because the phenomena that we work with happen to be closely connected to a photographic process, we end up getting assimilated into that, but we shouldn't be. There are other people doing similar things in other mediums.

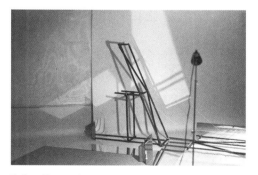

Barbara Kasten, photo-documentation of an installation, 1979

LD You have decided to have a survey exhibition in the particular context of ICA, an institute of contemporary art, which determines the viewing around the work. What I am struck by in this conversation is that you have taken a really firm stance, and that is revealed in the work. For example, going out and doing your own research, because you weren't

given a certain history of photography. That is a really active proposition. And not only did you do that, but now your research is available for this generation and for future generations to learn from, and that is a remarkable contribution on top of being a maker. I think that you have actively pursued a lot of things in the work that are bold and inspiring.

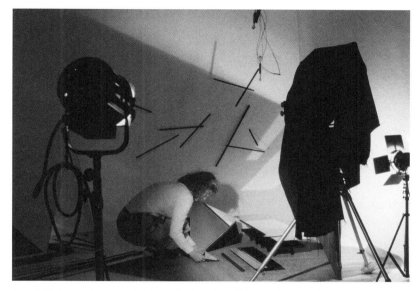

Barbara Kasten creating her installation at California State University Long Beach, 1982

And I love that you taught fiber. (Actually, I wanted to bring up earlier that I am sure that you are aware that the word "moiré" is French for "mohair.") I would also say that one of your big tools is that you taught. I'm sure you learned a lot by teaching. Your practice is much more assertive than maybe some of the conversations have been around it. You have essentialized the decisions and use an economy of means.

BK I think you are what you do. I'm sure you see this in your work, too. There is a progression along the way, not necessarily linear, and certain ways of working are innate.

LD Can you talk about that progression? Maybe this is oversimplifying things, but I believe that these tools we've been discussing become a part of your body. I think that being an artist is, among other things, the capacity to make decisions. When you make a decision is when you are making the work.

BK I think that there are these eureka moments when you know that "this is it." Sometimes it's difficult, because it is not there yet and I know I have to keep pushing for the harder thing, for the elusive and unknown, which ultimately is "it."

LD What is the harder thing, Barbara?

BK I dream about work. I'm really so obsessed with it, I can't wait to get back in the studio because I think I know what I have to do next. But sometimes I try what I've envisioned as the answer, and it's not it. Sometimes I push and I push and it's like trying to put a round peg in a square hole. But just when you are giving up, there is an answer. It's almost like you need to push yourself to the point of such intensity, and it's when you take that breath afterward that it comes, doesn't it?

September 12, 2014
New York, NY

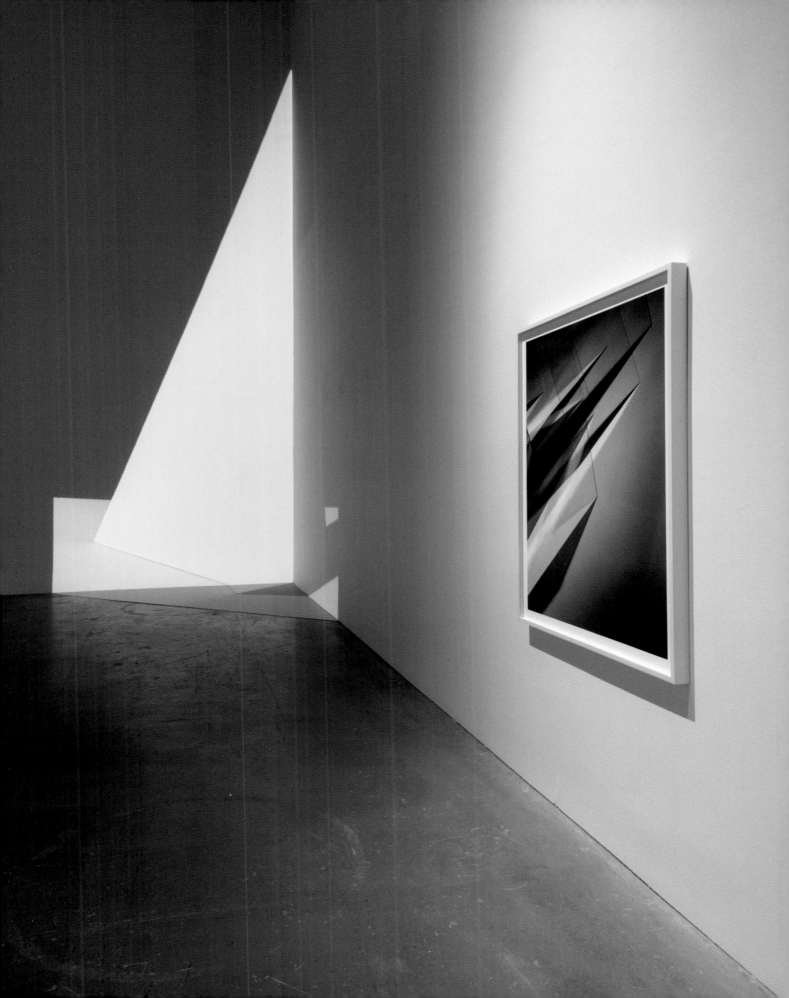

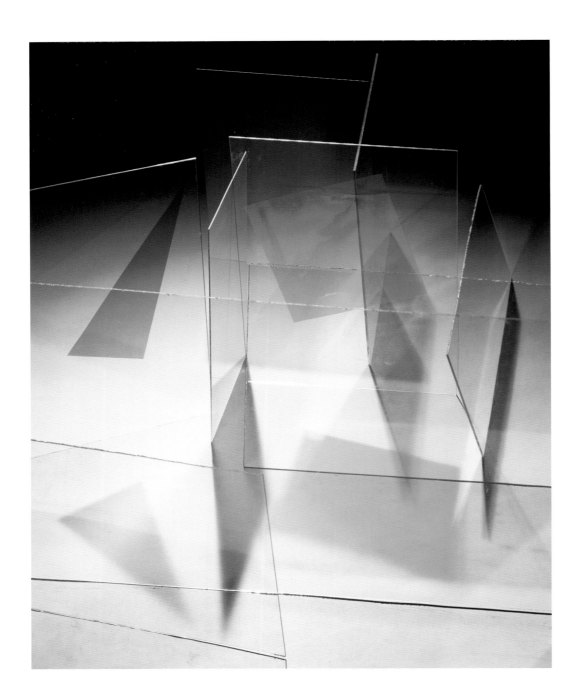

Transposition 8, 2014
Fujiflex digital print
60 × 48 in. (152.4 × 121.9 cm)

Transposition 7, 2015
Fujiflex digital print
60 × 48 in. (152.4 × 121.9 cm)

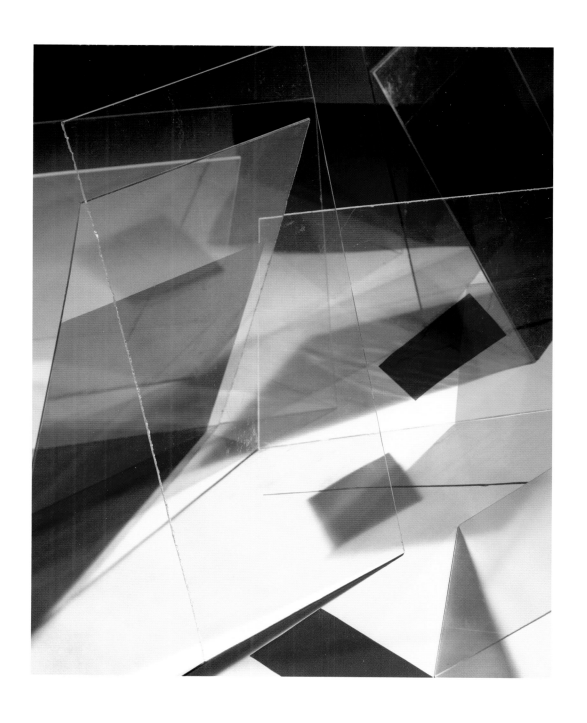

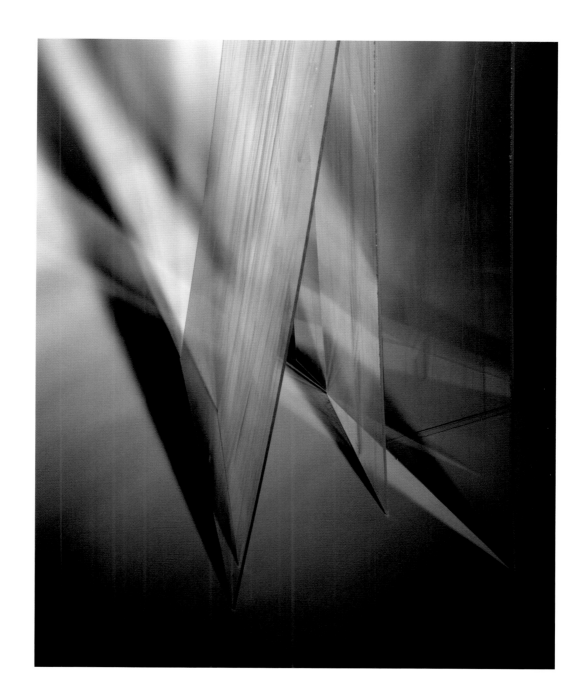

Studio Construct 69, 2008
Archival pigment print
53 ¾ × 43 ¾ in. (136.5 × 111.1 cm)

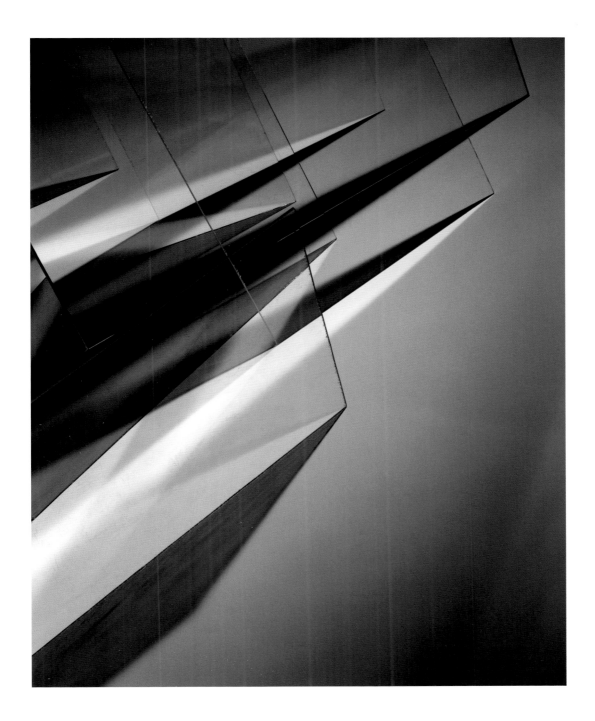

Studio Construct 8, 2007
Archival pigment print
53 ¾ × 43 ¾ in. (136.5 × 111.1 cm)

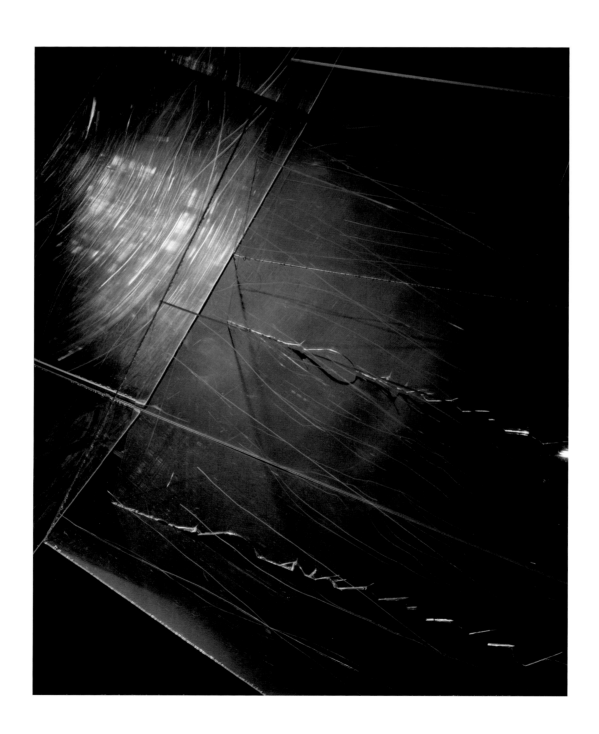

Incidence 3, 2010
Archival pigment print
53 3/4 × 43 3/4 in. (136.5 × 111.1 cm)

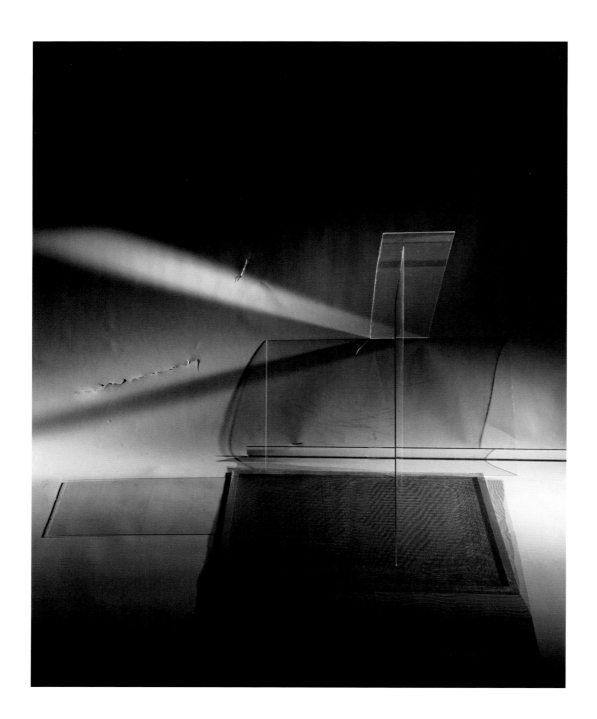

Scene VII, 2012
Archival pigment print
54 ½ × 43 ½ in. (138.4 × 110.5 cm)

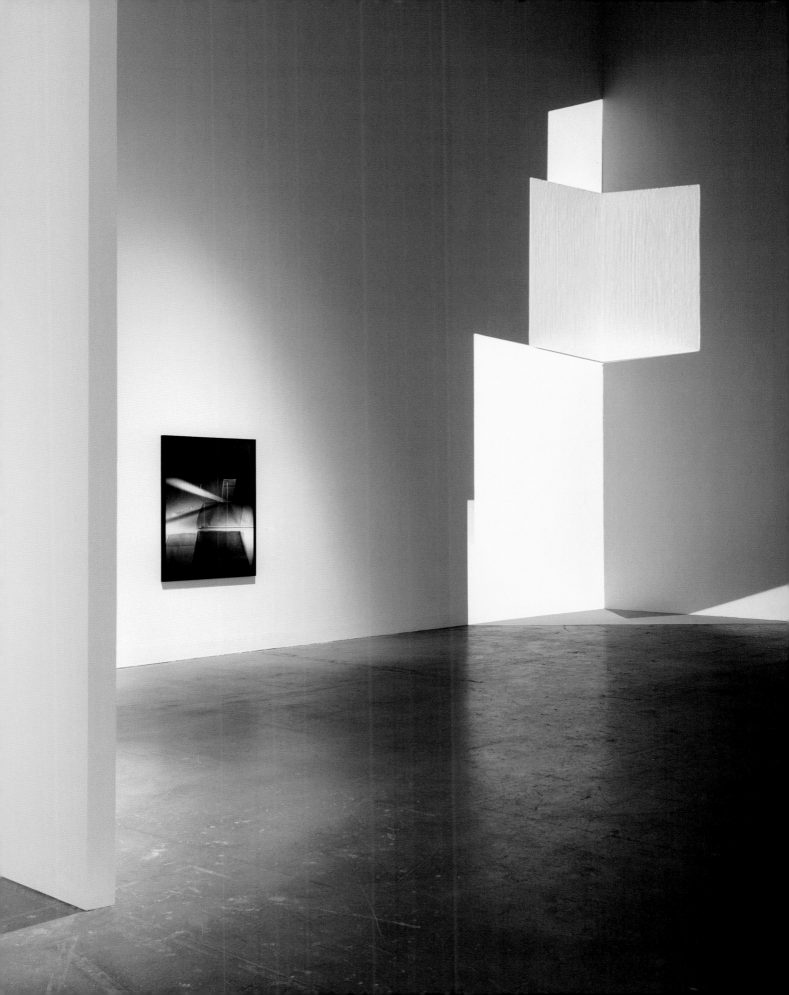

The Cliffs, 1990
Silver dye bleach print (Cibachrome)
36 ¼ × 28 ¾ in. (101.6 × 76.2 cm)

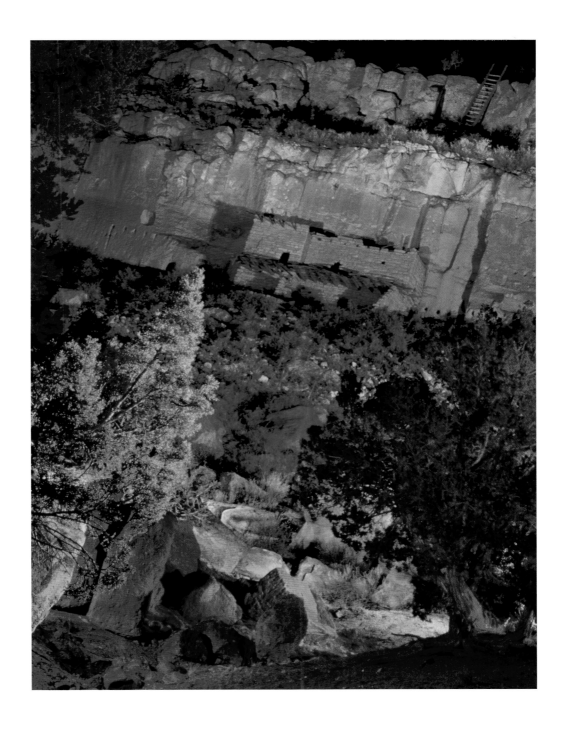

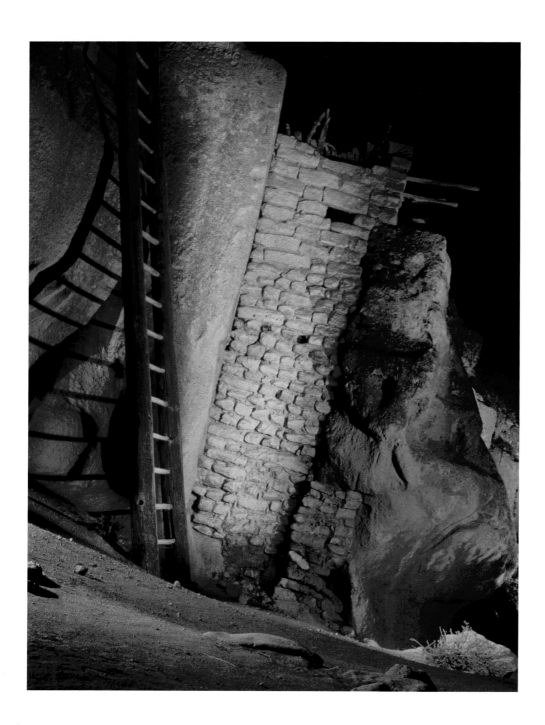

Axis Mundi, 1990
Silver dye bleach print (Cibachrome)
36 ¼ × 28 ¾. (101.6 × 76.2 cm)

Tanagra Goddess IV, 1995
Silver dye bleach print (Cibachrome)
5 × 4 in. (12.7 × 10.2 cm)

Tanagra Goddess VI, 1995
Silver dye bleach print (Cibachrome)
5 × 4 in. (12.7 × 10.2 cm)

46.Amphora-Rhodes, 2nd Century BC, 1996
Cyanotype
60 × 22 in. (152.4 × 55.9 cm)

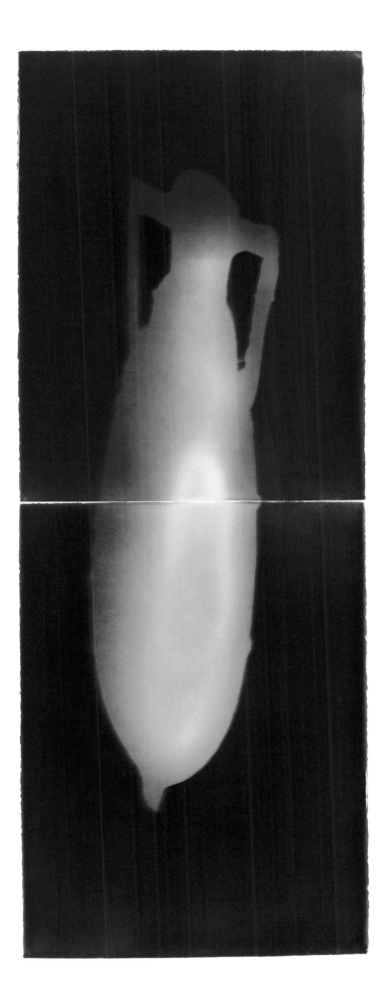

Tanagra Goddess X, 1995
Silver dye bleach print (Cibachrome)
5 × 3 ¾ in. (12.7 × 9.5 cm)

Tanagra Goddess IX, 1995
Silver dye bleach print (Cibachrome)
5 × 3 ¾ in. (12.7 × 9.5 cm)

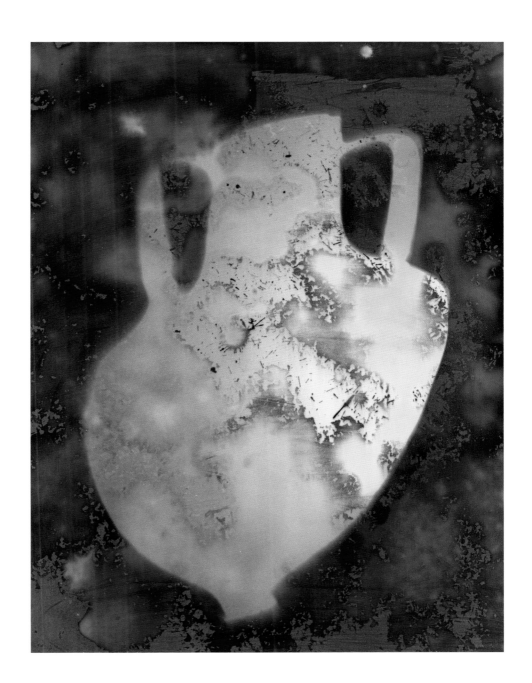

6.Amphora-Aegean, 5th Century BC, 1996
Cyanotype
30 × 22 in. (76.2 × 55.9 cm)

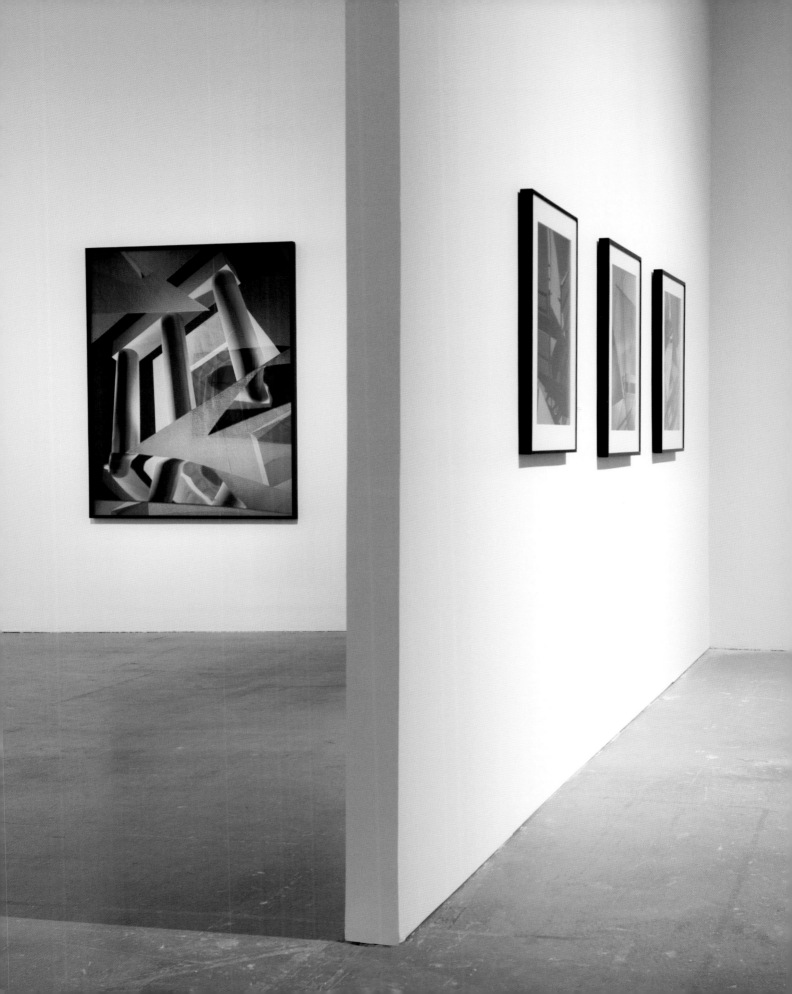

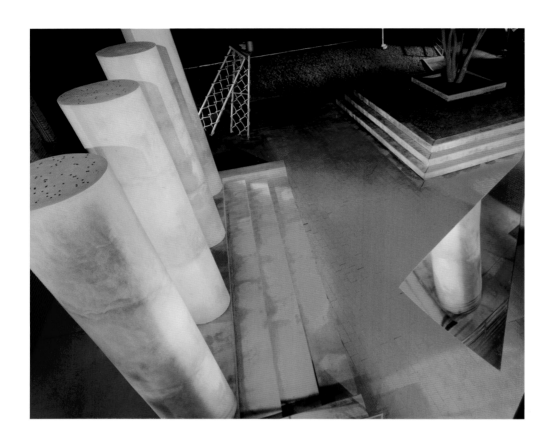

Architectural Site 9, December 21, 1986, 1986
Silver dye bleach print (Cibachrome)
29 ½ × 37 in. (76.2 × 101.6 cm)

Architectural Site 8, December 21, 1986, 1986
Silver dye bleach print (Cibachrome)
60 ½ × 48 in. (153.7 × 121.9 cm)

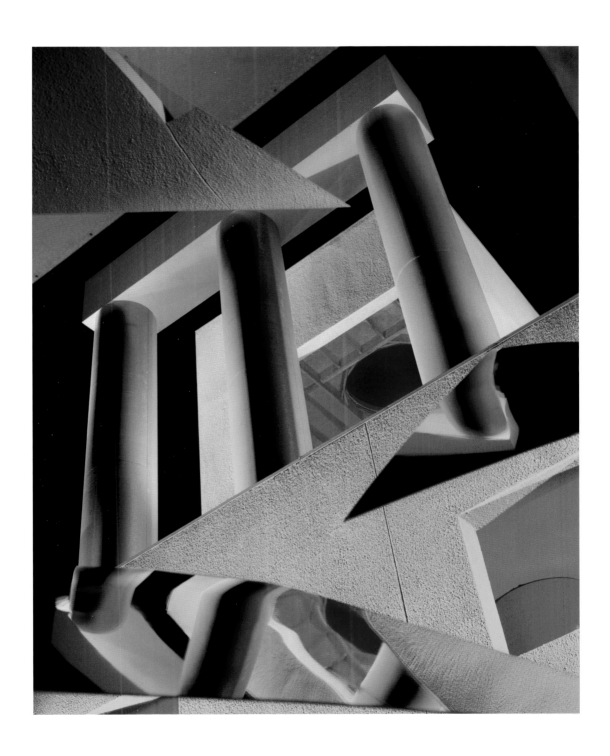

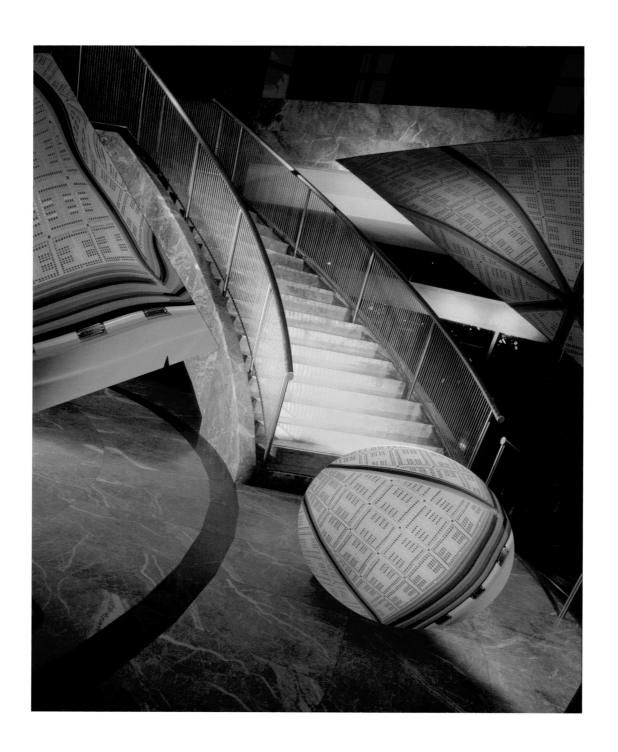

Architectural Site 7, July 14, 1986, 1986
Silver dye bleach print (Cibachrome)
60 ½ × 48 in. (153.7 × 121.9 cm)

Architectural Site 17, August 29, 1988, 1988
Silver dye bleach print (Cibachrome)
48 × 61 in. (121.9 × 154.9 cm)

Architectural Site 3, June 14, 1986, 1986
Silver dye bleach print (Cibachrome)
60 ½ × 48 in. (153.7 × 121.9 cm)

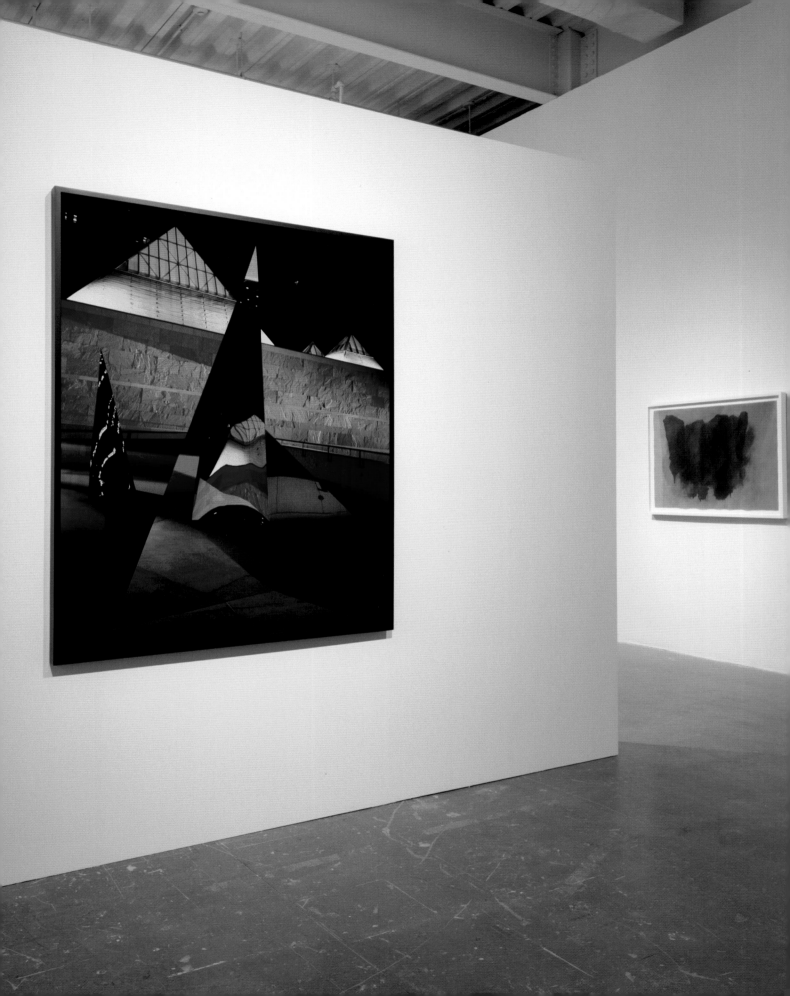

In his 1991 book *Postmodernism, or, the Cultural Logic of Late Capitalism*, Fredric Jameson takes the reader on a short architectural tour around Los Angeles, visiting John Portman's Bonaventure Hotel and, as he puts it, "the great free-standing wall of Wells Fargo Court (Skidmore, Owings and Merrill)—a surface which seems to be unsupported by any volume, or whose putative volume (rectangular? trapezoidal?) is ocularly quite undecidable."[1] As anyone who has ever driven past these buildings knows, it is rather difficult to get one's head around them. Perhaps the trickiest part of Portman's hotel is figuring out how to get into it. Skywalks project out from its mirrored, multi-cylindered form into neighboring buildings, but there seems to be no way to walk in from the street. (The best way in, it turns out, is via the underground garage.) Once inside, the visitor finds a confounding space layered with elevators, balconies, greenery, and fountains—altogether more ecological than architectural in effect. In contrast to this dense indoor environment, Wells Fargo Court seems to have no interior at all—the building offers up a massive, shifting surface reflecting the clouds outside. Representing two sides of the same coin (all inside, all out), these buildings, Jameson argues, both convey a sense of groundlessness and disorientation. Neither accommodates a properly human presence. As Jameson puts it, "This latest mutation in space—postmodern hyperspace—has finally succeeded in transcending the capacities of the individual human body to locate itself, to organize its immediate surroundings perceptually, and cognitively to map its position in a mappable external world."[2]

In addition to the Bonaventure and Wells Fargo Court other examples of postmodern architecture abound in downtown Los Angeles, and one wonders what Jameson might have made of them in his analysis. Take, for example, Arata Isozaki's Museum of Contemporary Art, completed in 1986, which sits right across the street from Wells Fargo Court along Grand Avenue, on Bunker Hill. In distinction to the Bonaventure's delirious breakdown and Wells Fargo Court's gleaming surface, MOCA offers a hybrid structure that cobbles together a variety of historical forms, including the pyramid, the plaza, and the barrel vault, into a distinctly contemporary mise-en-scène. In accordance with its historical pretensions, the complex is clad not in glass but in the artisanal material of Indian sandstone. Far from the roadside architecture and Mediterranean stylings that characterize so much of Southern California's vernacular building, this is an architecture for a Los Angeles that never existed—a properly civic space meant to signal to the world the city's maturity. If the building's design brief was to represent an image of civilization, however, one wonders if the architect did not deliver the project with a bit of irony: the finished building looks less like it belongs to a living civilization than

something made from its spare parts. A series of prints Isozaki made a few years before depicting his *Tsukuba Center in Ruins*, 1983, a print made to bring out the untimeliness of the myriad historical references in the project, would seem to confirm this idea.[3] As opposed to Albert Speer's concept of ruin value, a romanticization of how buildings would look to viewers in a thousand years' time, Isozaki's ruins—mute, flat, and darkly ironic—are seemingly oblivious to beholders. Rather than evoke past glories they appear as so much leftover rubble. To borrow Robert Smithson's great phrase, one might think of them as "ruins in reverse," ruins that do not emerge from great buildings but that, rather, preempt them.[4] Such a reversal, in fact, might be emblematic of postmodernism more generally: It constructs ruins. Or, as Smithson would say, it makes you forget the future rather than remember the past.[5]

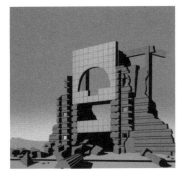

Arata Isozaki, *Tsukuba Center in Ruins*, 1983

Despite the aesthetic differences between MOCA and its neighbors, one might argue that they share something in common, given the difficulties they present to bodies trying to locate themselves in space and time. In fact, when the artist Barbara Kasten photographed Isozaki's building as part of her *Architectural Sites* series, 1986–90, she seems to have seen it through Jameson's eyes: as "postmodern hyperspace," as glassy, mutated, and "undecidable." The year MOCA opened, Kasten went down to the building with a crew and set up a film set's worth of lights, gels, and mirrored props to shoot it. She worked at night so as to be able to

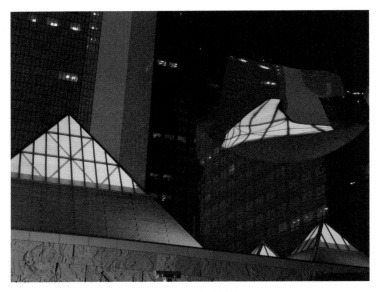

Barbara Kasten, *Architectual Site 11, December 22, 1986*, 1986

wash the subject with unnatural light. In *Architectural Site 10,* 1986 (p. 27), a variety of isosceles triangles that she constructed stand upright in the MOCA courtyard, playing off the architecture's pyramidal struc-tures. The ground pitches forward below; fuchsia, pink, and purple lights—the whole pastel palette—suffuse the scene. In *Architectural Site 11,* 1986, a large sphere hovers like a spaceship in the upper right corner—the camera lens is tilted up here—warping a pyramid across the way. Strikingly, there is no foreground or background in either of these images. There is no figure or ground. The sliver of sky between the two buildings in the upper left corner of the second photograph is simply a piece of a puzzle fitting into place. Though one critic has insisted that Kasten's photographs are "quiet occasions of sabotage that challenge

the final word of the architect and inflexible authority of the monumental building," one might also argue that they make buildings even harder and icier, locking them into their surrounding space.[6] Buildings in Kasten's hands transform into obdurate crystals without entryways or interiors. Three-dimensional spaces are compressed and compacted into veritable cities of quartz. The result is a kind of space so inhuman that today it looks as if it must have been generated with digital effects. It is a derealized space that challenges one's sense of scale. One might say, in fact, that the buildings look more like models than full scale constructions. It is a sign of Kasten's ingenuity that she accomplished this manipulation the old-fashioned way—using the camera itself.

—

The behind-the-scenes photographs that Kasten often made of her shoots capture all the trappings of a feature film production—floodlights, director's chairs, snack tables—yet the final images do little to suggest narrative; they mostly foreground their status as sets and stages, as *constructions*. (One picture features Kasten surrounded by hardware: the artist as director, auteur, impresario—and indeed, her images feel directed and produced.) Employing large mirrored shapes, similar to the kind that she had used in her *Construct* series, 1979–86, which convey something of the look of product photography without the product, Kasten eventually made three huge Cibachrome photographs of MOCA, roughly four by five feet, which present the structure in parts and at odd angles. If, in some sense, Kasten dragged the conventions of studio photography into the street, she radically altered its ends. Whereas product photography typically isolates objects, Kasten's photographs fragment them: they combine architectural structures through reflective surfaces that catch other structures and incorporate them into the building, freezing them into formal compositions, but they also have the effect of cutting through the architecture. Gordon Matta-Clark's *Splitting*, 1974, in which the artist literally sliced a suburban house in half with a chainsaw, is a provocative counter-example. In distinction to Matta-Clark's literalism, all of Kasten's "cuts" are a result of stagework and seamless sleight of hand. Moreover, they share none of the rough materiality of Matta-Clark's work, which the artist once described as "anything but illusionistic," and which was, importantly, meant to be experienced in space—to be walked through.[7] Perhaps somewhat perversely, Kasten turns to architecture with an opposite project: to flatten and turn it into image. Her sets were never open to actors or audiences. They were never meant to be experienced by bodies. (Perhaps it goes without saying that no human figures ever appear in Kasten's architectural images.) They were always meant to be seen as pictures. All of that said, Kasten is nevertheless interested in a different kind of materiality: the construction of the image. Her photographs are built things, to be sure.

—

Even before the *Architectural Sites*, Kasten's work had been engaged in architectural issues.[8] A photograph from her *Construct* series was included in the July 1985 issue of the Los Angeles–based magazine *Arts + Architecture* dedicated to the topic "Postmodernism: The Uses of

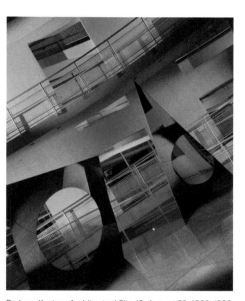

Barbara Kasten, *Architectual Site 18, August 29, 1988*, 1988

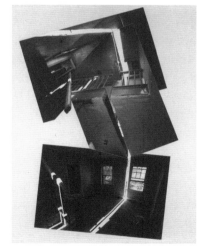

Gordon Matta-Clark, *Splitting*, 1974; chromogenic prints mounted on board; 40 × 30 in. (101.6 × 76.2 cm); Purchase, The Horace W. Goldsmith Foundation Gift, 1992 (1992.5067), The Metropolitan Museum of Art

History," alongside work by architects such as Isozaki (his Tsukuba Center prints), Michael Graves, and Charles Moore, as well as artists Peter Shire and Alexis Smith, who, the magazine insisted, were all working "with the integration of different artistic disciplines."[9] Here, Kasten showed a particularly suggestive example from her *Construct* series. After two rather modest line drawings by Graves (a villa amid a grove of trees) and Frank Gehry (a crumple of lines), Kasten's *Construct A+A*, 1984, provides a prismatic tableau of arches, isosceles triangles, and stuccoed domes that gives a taste of history enmeshed in warped space. Boiled down to dislocated decorative elements, the past is dropped into a mise en abyme. Whereas many of these elements had been included, in 1977, in what the architectural historian Charles Jencks called "the language of postmodern architecture," here they are presented free of syntax, a heap of language. If architectural postmodernism itself was already hybrid and impure, as Jencks claimed—at one point he referred to it as "conscious schizophrenia"—in Kasten's hands it stutters and breaks down all the more.[10] Any stable reference to a past epoch is reflected into a mere simulation. Material and image appear only as refractions of one another.

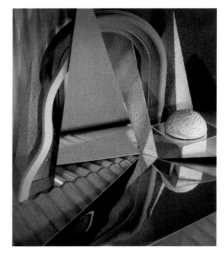

Barbara Kasten, *Construct A+A*, 1984

—

Kasten may never have translated the architectural implications of her work into architectural space had *Vanity Fair* not approached her about making a suite of photographs depicting the lobbies of new corporate headquarters to accompany an article by the fashion journalist Kurt Kilgus.[11] These "entranceways," as Kasten says, seemed to signify something new about space and corporate power.[12] Two years earlier, Chauncey Hare had published a book of photographs called *This Was Corporate America* (1984), its very title acknowledging the shift towards a new way of doing business. Inside one found black-and-white depictions of quartered cubicles, men in shirt and tie behind books and desks. By contrast, Kasten's spaces were evacuated of people and variegated. In his 1981 book *The Skyscraper*, Paul Goldberger noted, "At the end of 1980, most of the large skyscrapers under construction in New York City contained at least some sort of public atrium, retail mall, or 'galleria,' as it has been common to call such places, and that alone distinguished the new group of buildings from its predecessors."[13] Kasten's first target in what was to become the *Architectural Sites* fell into this category: the Lipstick Building in New York, a postmodernist edifice completed in 1986 by Philip Johnson and John Burgee. Though her work here is similar in spirit to what she would later do in Los Angeles, Kasten took a slightly different approach in the Lipstick Building; in addition to shooting indoors, she placed two orbs on the black-and-white floor of its lobby, which recedes into the background like an infinite chessboard, to make an unlikely scene. (The orbs reflect a phalanx of walls and columns.) One might say that Kasten abstracts space in her photographs, or that she submits an already-abstract space to further processes of abstraction. Indeed, today one often thinks about abstraction in relation to finance— and it seems important to note that the Lipstick Building was, and still is, largely devoted to financial services.[14] Beyond capital's ability to put everything in equivalence and thereby pull the specificity out of things, finance has entered a world beyond things in which fluctuations of value are determined by whispers and clicks rather than the movement

of commodities. All our relations, we know from Marx and others, are abstract ones—mediated by money—but today they are increasingly difficult to follow. How could one possibly tease out our current web of relations?

In Kasten's photographs of the Lipstick Building and the World Financial Center, in which a huge pink void obstructs a staircase, the artist addresses this sense of unreality by picturing centers of financial activity as hallucinatory spaces in which it would be difficult to stand on two feet. (The very idea of site encapsulated in her titles takes on an ironic ring here given that these spaces are fundamentally networked and global, and that a certain type of corporate architecture seemingly finds its home anywhere on earth.) What is interesting, though, is that these spaces are hallucinatory to begin with. "Wherever capitalism goes its illusory apparatus, its fetishisms, and its system of mirrors comes not far behind," the Marxist geographer and social theorist David Harvey once wrote.[15] Finance, in other words, brings an illusory apparatus with it; the vertigo was already there, before Kasten got to her sites. What she did was exacerbate it. One might even argue, in fact, that Kasten does not so much abstract space in these photographs as much as she mirrors abstraction. She then counters that abstraction by making these scenes concrete: she makes them visibly constructed. As the architectural historian Reinhold Martin has argued, corporate architecture tries to perpetuate a story about its illusory nature when, in fact, glass and mirrors are simply materials like any other. "The tricks with mirrors and other real materials

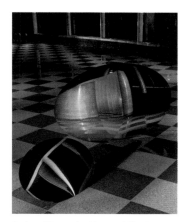

Barbara Kasten, *Architectural Site 1, June 10, 1986*, 1986

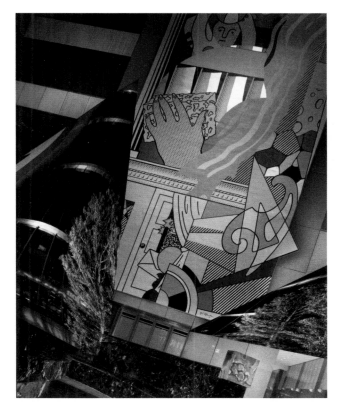

Left Barbara Kasten, *Architectural Site 3, June 14, 1986*, 1986

Above Bernard Madoff pictured in his offices in the Lipstick Building in "The 17th Floor, Where Wealth Went to Vanish," *The New York Times*, December 15, 2008. Ruby Washington/The New York Times/Redux

performed by corporate globalization produce the illusion that there is an illusion," Martin writes, "the illusion that their materiality is illusory, unreal, derealized."[16] Corporate architecture wants to keep the illusion alive that it is somehow unreal. (For if it were real one might be able to do something about it.) Kasten's photographs peel back this illusion by showing

how illusions are produced. She shows illusions to be jury-rigged and distinctly handmade. The artifice of her propwork is always subtly apparent, which is not to say that we can figure out these scenes and make them right.

—

The *Architectural Sites* are a study of two typologies: after the financial centers, Kasten shot a series of museums. But why was the museum the next logical target? After all, Kasten took on this part of the project after the *Vanity Fair* commission had fallen through. When she went on to shoot a vertiginous tour of Richard Meier's High Museum of Art, a hallucinatory romp through Bruce Goff's Pavilion of Japanese Art, and a Googie-d vision of Marcel Breuer's Whitney Museum in which the building's famous bridge is turned into a zig-zagging diagonal, she was not on assignment. (Her photograph of the International Center of Photography, which catches the Empire State Building in its sights, would seem to bridge the gap.) In an essay from 1990 expanding on Jameson's conclusions, Rosalind Krauss suggested that the postmodernist logic of late capitalism was working its way through the space of the museum as well.

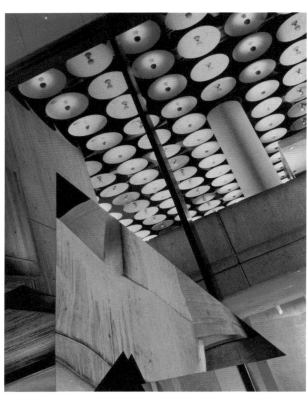

Barbara Kasten, *Architectural Site 15, October 19, 1987*, 1987

Traditionally assigned the task of preserving history, the museum had become a site in which to experience space. Much of this shift had come about as a result of the museum's embrace of minimalism, albeit a kind of revised version of it that privileged its sensational properties. Though valued for opening up onto real space, Krauss noted that minimalism always had an industrial logic about it as well—it was dependent on plans and large-scale production—and as a result it seemed to prepare something new for capitalism even as it offered a moment of respite from it in its phenomenological address. Ultimately, these two strands

of its practice—its industrial-phenomenological dialectic—transmuted into something new. "The revision of Minimalism such that it addresses or even works to produce that new fragmented and technologized subject, such that it constructs not an experience of itself but some other euphorically dizzy sense of the museum as hyperspace, this revisionary construction of Minimalism exploits, as we have seen, what was always potential within Minimalism," Krauss wrote. "But it is a revision that is, as well, happening at a specific moment in history. It is happening in 1990 in tandem with powerful changes in how the museum itself is being reprogrammed and reconceptualized." [17]

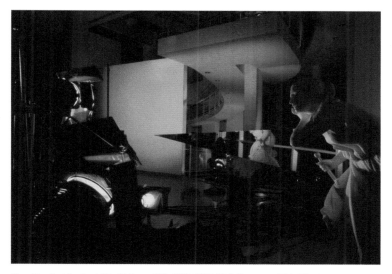

Shoot for *Architectural Site 17, August 29, 1988*, 1988, High Museum of Art, Atlanta

When Kasten began photographing her museums in 1986, she was clearly working off the fumes of such a transformation; one might even say that she was reconceptualizing the museum via the viewfinder of a new fragmented and technologized subject. Indeed, her photographs communicate nothing if not a "euphorically dizzy sense of the museum as hyperspace." Though one might ask whether such a view is symptomatic or critical, or if it allows transformations to be seen, I want to suggest that there might still be yet another frame of reference. While the claim of defamiliarization has become an all-too-common trope in art criticism, a claim that the radical power of works of art is their ability to show us something in an opposite way to the manner in which we are habituated, I would argue that there might also be something radical about a process of *familiarization*. For in a way, this is what Kasten's work does; it familiarizes us with the effects of a world that sets out to convince us more and more each day of its determination to remake the world. This is what the world is about to look like, Kasten's work says.

In her essay Krauss argues that much of the rethinking of minimalism had to do with the inclusion of Light and Space artists, such as James Turrell, into its canon. This switched the terms of the debate over from structure to atmosphere, privileging perception and experience over the facts of objecthood. While living in Los Angeles in the 1970s Kasten had contact with many of the artists associated with Light and Space and while she took things from them, she also marked a clear difference. Where artists such as Turrell and Robert Irwin blurred the boundaries of architecture in their installations, often reconfiguring it—rounding the corners, dividing

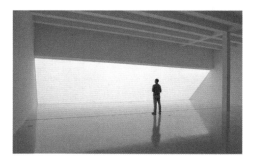

Robert Irwin, *Untitled*, 1971; synthetic fabric, wood, fluorescent lights, flood lights; 96 × 564 in. (243.8 × 1432.6 cm); Collection Walker Art Center, Minneapolis; Gift of the artist, 1971

it with scrim—to test perception, Kasten's insistence on photographing her constructions—not to mention her interest in the precedent of Constructivism—places her at a certain distance from them. Though Kasten exhibited the structures that she used as photographic subjects and props at various points in her career, she always insisted that they be seen as images. In her 1985 exhibition at Wright State University in Ohio, *Toward an Interconnectedness of All Things* (pp. 90–91), Kasten created a tableau of various columns, pyramids, curved walls, and lights that could best be seen from above. Humans couldn't enter it. It was like a picture, or a reflection in a pool. For Kasten experiences are always limited, bounded, and distinct from atmospheres. They end at the edge of the print. They never rise to the level of the environment. As a technology of isolation and capture inherently bound up with the concept of the frame, photography in Kasten's hands becomes a critical act.

As I mentioned earlier, Kasten's *Architectural Sites* grew out of her series of *Constructs*. To make these works she built structures in her studio of wire, wood, and cable, which are characterized by an enormous amount of tension. In one of my favorites, *Construct XVIII–Y, 1982* (p. 129), we see a composition pulled tight with screws. One imagines the great pleasure of unfastening them and watching the entire structure crash to the floor. It makes one wonder what it would be like—and what it would mean—for the *Architectural Sites*, and their subjects more generally, to come undone.

1 Fredric Jameson, *Postmodernism, or, the Cultural Logic of Late Capitalism* (Durham: Duke University Press, 1991), 12–13.

2 Ibid., 44.

3 *Tsukuba Center in Ruins*, 1983. For more on Isozaki's engagement with ruins and history, see David B. Stewart, "Gods and Men," in *Arata Isozaki: Architecture 1960–1990* (New York: Rizzoli, 1991), 9–17.

4 See Robert Smithson, "A Tour of the Monuments of Passaic, New Jersey" (1967), in *Robert Smithson: The Collected Writings*, ed. Jack Flam (Berkeley: University of California Press, 1996), 72.

5 Smithson, "Entropy and the New Monuments," 11.

6 Patricia C. Phillips, "Barbara Kasten," *Artforum* (December 1989): 138.

7 Gordon Matta-Clark, quoted in Pamela M. Lee, *Object to Be Destroyed: The Work of Gordon Matta-Clark* (Cambridge: MIT Press, 2000), 21.

8 A reviewer in 1984 noted that "sometimes her geometry alludes to architecture, as in *Triptych II*, whose tilted arches echo the doorways and distorted perspective of de Chirico's paintings." Robert L. Pincus, "Barbara Kasten," *Los Angeles Times* (March 23, 1984), Part VI: 14.

9 Barbara Goldstein, "Portfolio," *Arts + Architecture* (July 1985): 28.

10 Charles Jencks, *The Language of Post-Modern Architecture* (London: Academy Editions, 1977). 6. When Kasten photographed Gehry's Loyola Law School in Los Angeles some two years later, she submitted its grey non-load-bearing columns to screeching highlights of pink, yellow, and blue; shot from above.

11 Though Kasten completed her work, the photographs were never published. It is worth noting that other artists at the time were interested in similar types of spaces. See, for example, Dan Graham and Robin Hurst, "Corporate Arcadias," *Artforum* (December 1987): 68–74.

12 "A couple of years ago I was asked to do an illustration for an article a friend of mine was writing for *Vanity Fair* magazine," Kasten said in an interview. "He was writing an article about the new architecture and how lobbies and entranceways to some corporate headquarters were incredibly opulent, giving you the sense of walking into a fantasy or another world." Thomas Harrop, "Lights, Camera, Architecture!," *Darkroom Photography* (July 1989): 32.

13 Paul Goldberger, *The Skyscraper* (New York: Knopf, 1981), 139.

14 I think it is worth noting that the offices of Ponzi schemer Bernie Madoff were on the seventeenth floor of the Lipstick Building until his arrest in 2007. Accompanying a *New York Times* article the following year is a remarkable photograph of Madoff in front of a 1973 series of prints by Roy Lichtenstein, which are themselves appropriations of Theo van Doesburg's series of drawings showing the process of abstraction; his case study transforms a cow into a variegated collection of geometric shapes. Diana B. Henriques and Alex Berenson, "The 17th Floor, Where Wealth Went to Vanish" (*The New York Times*, December 14, 2008).

15 David Harvey, quoted in Reinhold Martin, *Utopia's Ghost: Architecture and Postmodernism, Again* (Minneapolis: University of Minnesota Press, 2010), 103.

16 Ibid., 122.

17 Rosalind Krauss, "The Cultural Logic of the Late Capitalist Museum," *October* 54 (Autumn 1990): 14.

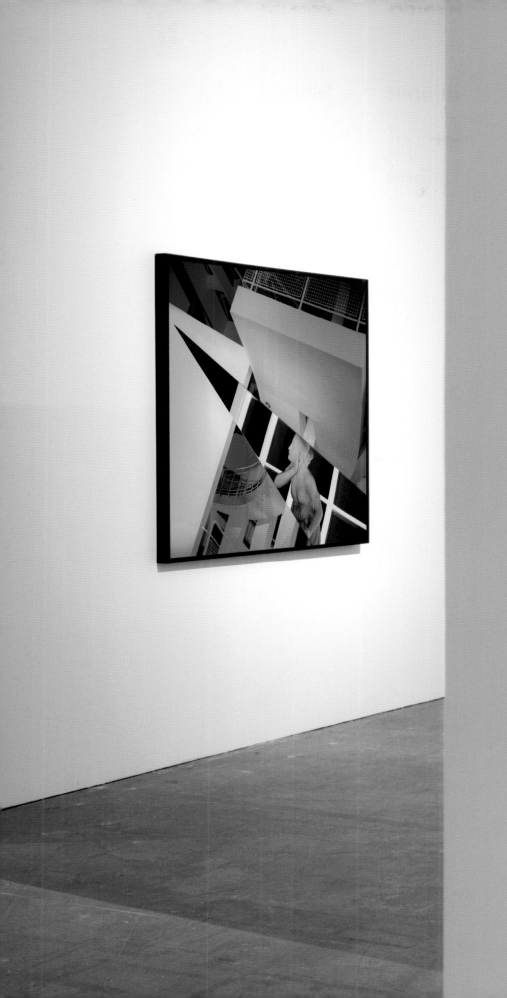

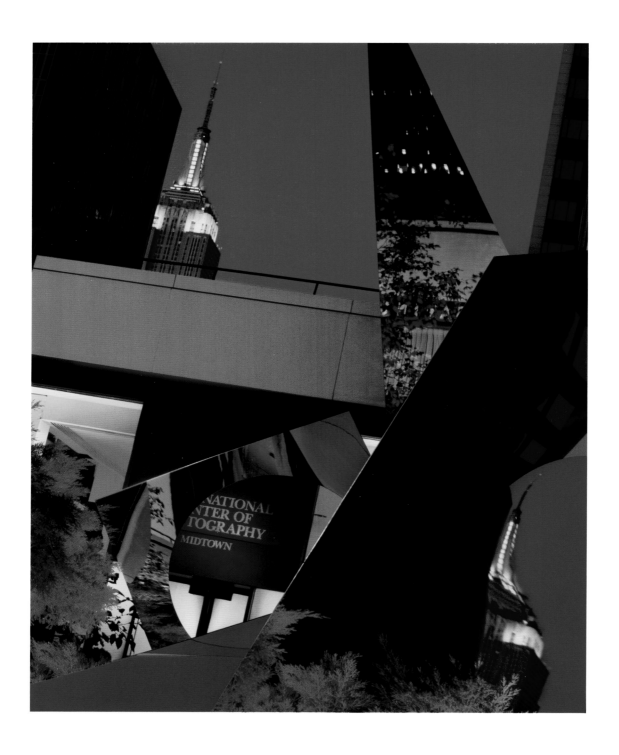

Architectural Site 20, August 26, 1989, 1989
Silver dye bleach print (Cibachrome)
60 ½ × 48 in. (153.7 × 121.9 cm)

Architectural Site 19, July 19, 1989, 1989
Silver dye bleach print (Cibachrome)
60 ½ × 48 in. (153.7 × 121.9 cm)

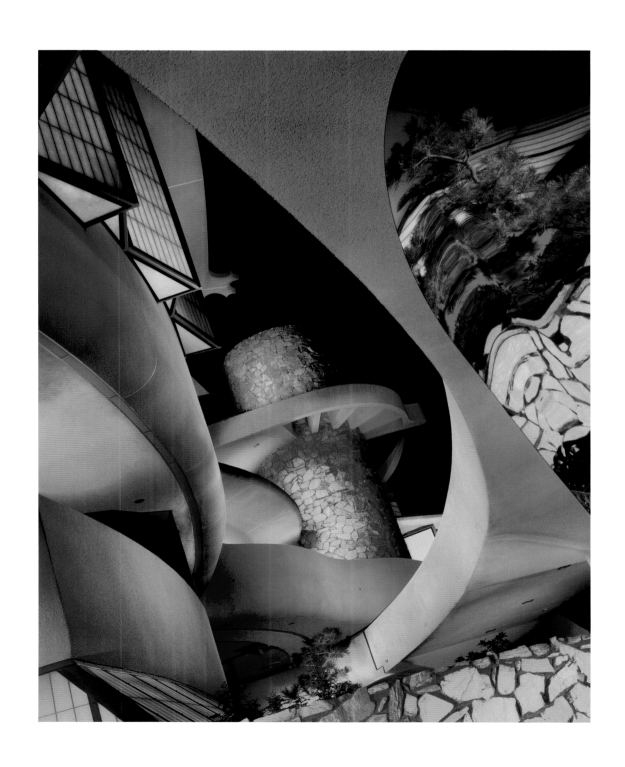

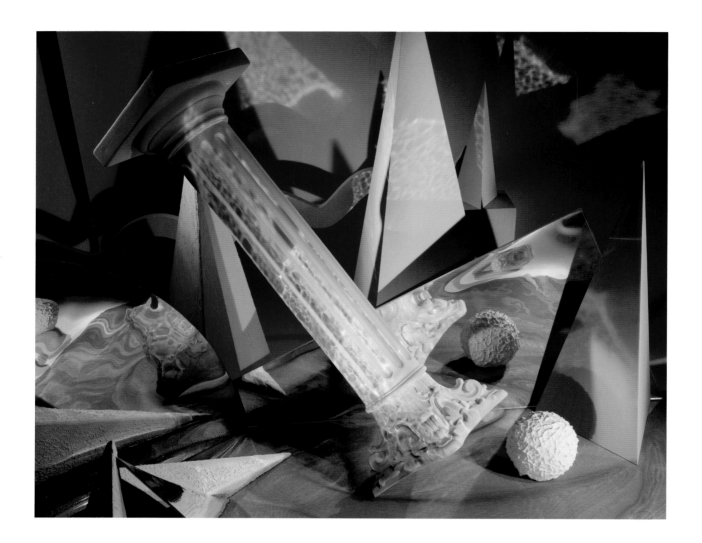

Construct 33, 1986
Silver dye bleach print (Cibachrome)
29 ½ × 37 in. (74.9 × 94 cm)

Metaphase 3, 1986
Silver dye bleach print (Cibachrome)
37 × 29 ½ in. (94 × 74.9 cm)

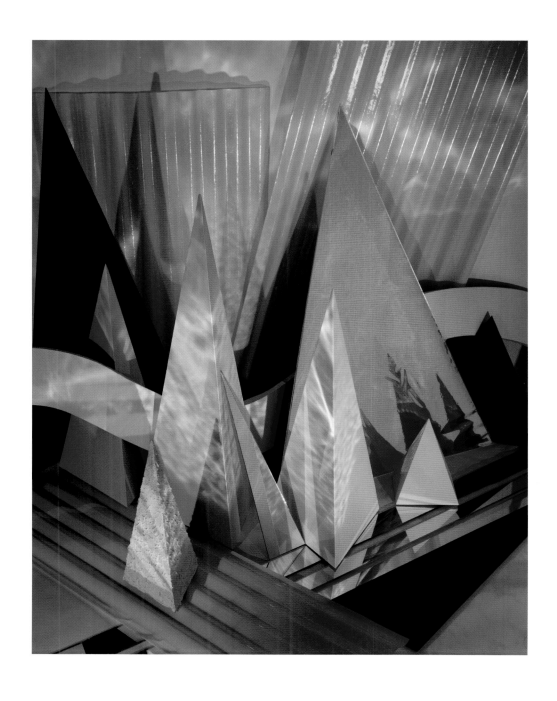

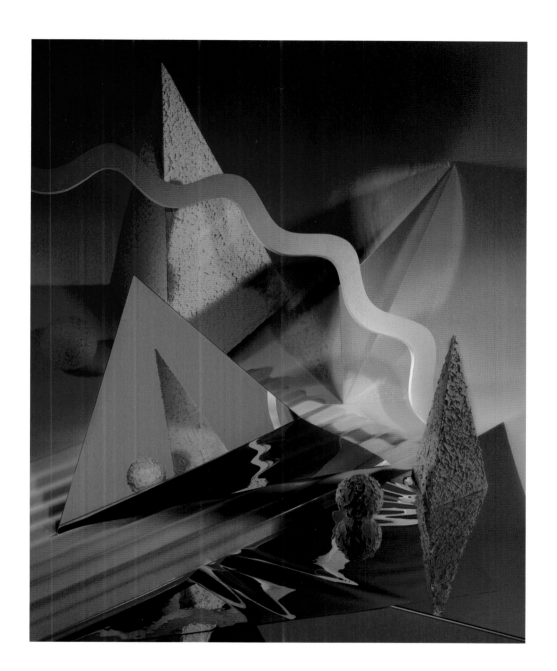

Metaphase 5, 1986
Silver dye bleach print (Cibachrome)
37 × 29 ½ in. (93.4 × 74.9 cm)

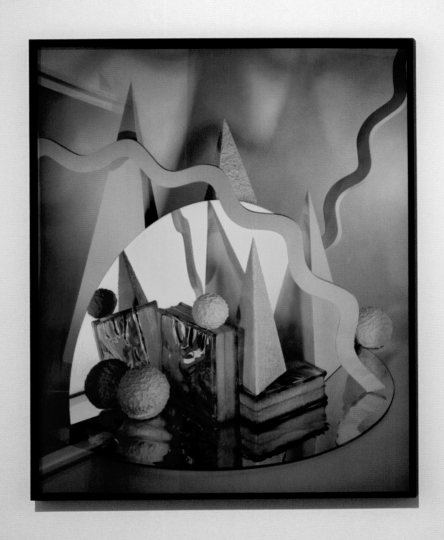

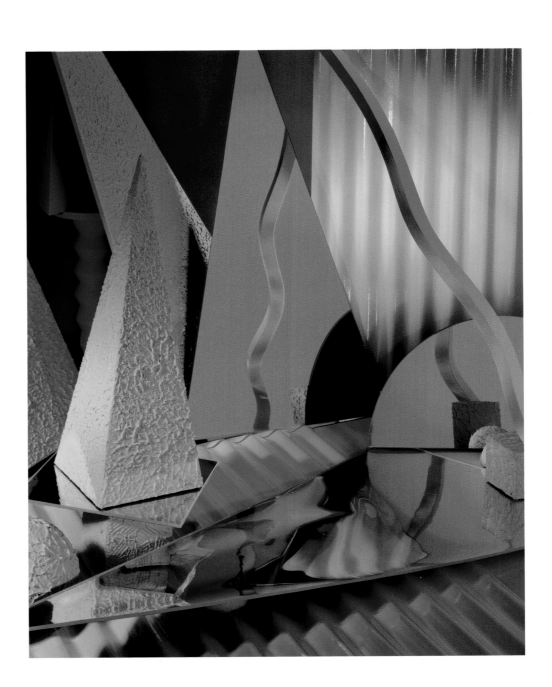

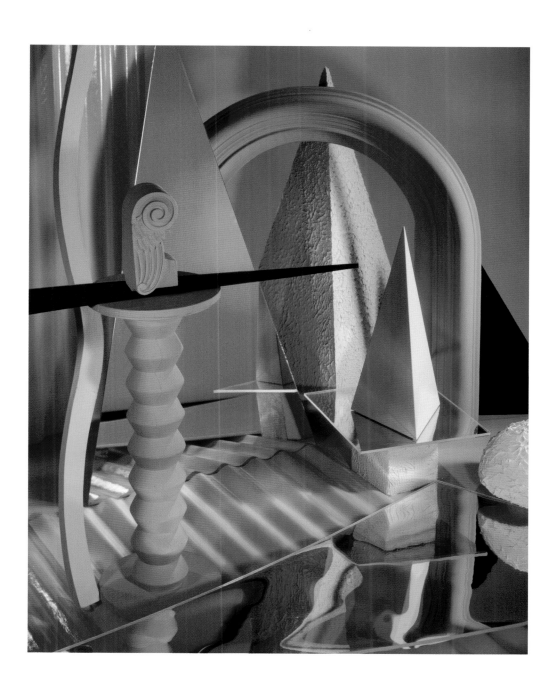

Diptych II Construct XXX-XXIX, 1985
Silver dye bleach print (Cibachrome)
Two parts, 37 × 29 ½ in. (94 × 74.9 cm) each
37 × 59 in. (94 × 149.9 cm) overall

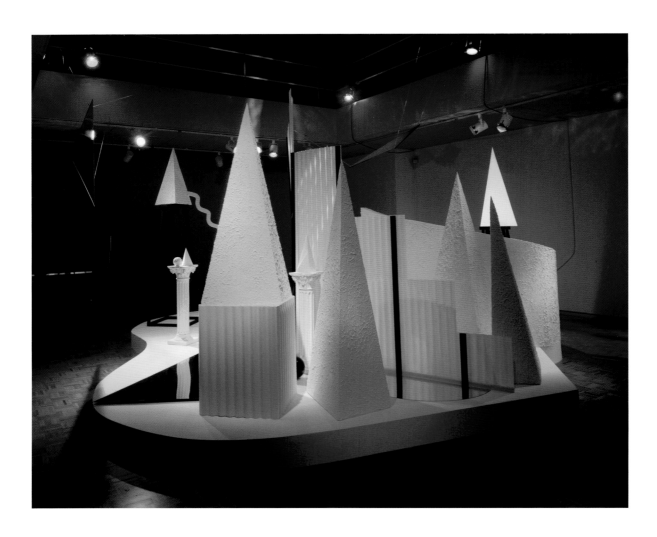

Toward an Interconnectedness of All Things,
installation view, Wright State University, 1985

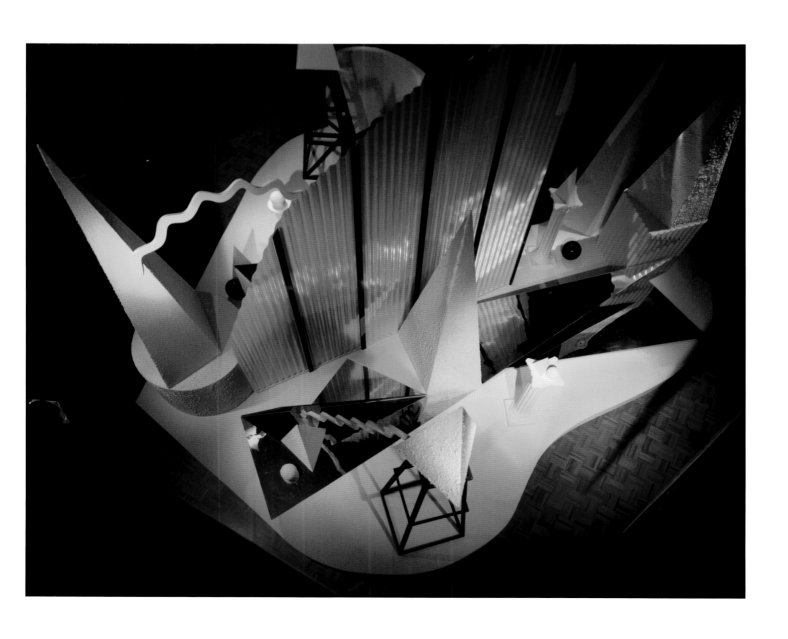

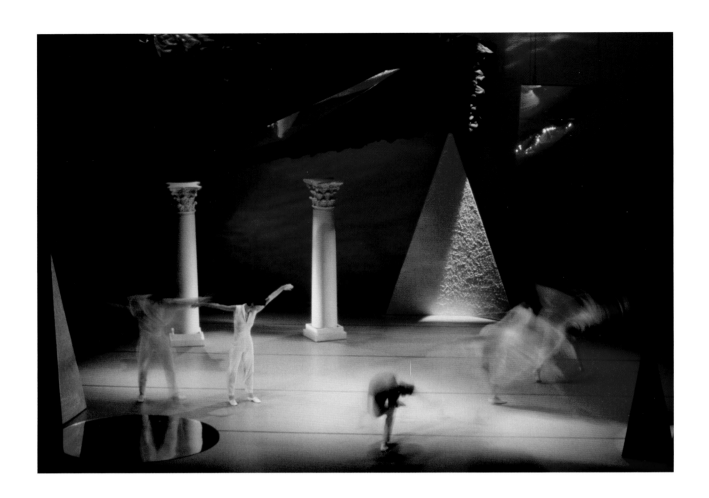

Inside Outside/Stages of Light, 1985
Video documentation of performance
at the Brooklyn Academy of Music
Choreography: Margaret Jenkins
Dancers/collaborators: Melissa Rolnick,
Mercy Sidbury, Livia Blankman, Ellie Klopp,
Bryan Chalfant, and Greg Gibble
Costumes and set design: Barbara Kasten
Lighting: Sara Linnie Slocum with Barbara Kasten
Sound score and design: Bill Fontana
Videography: Mark Robison

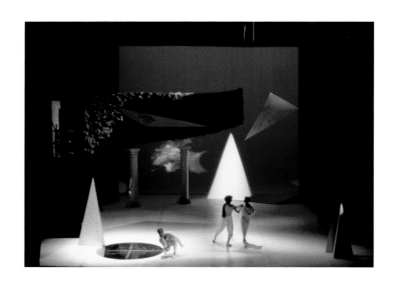

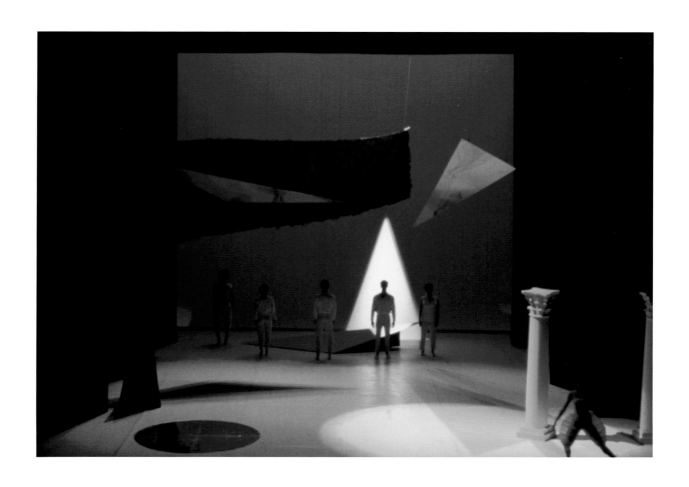

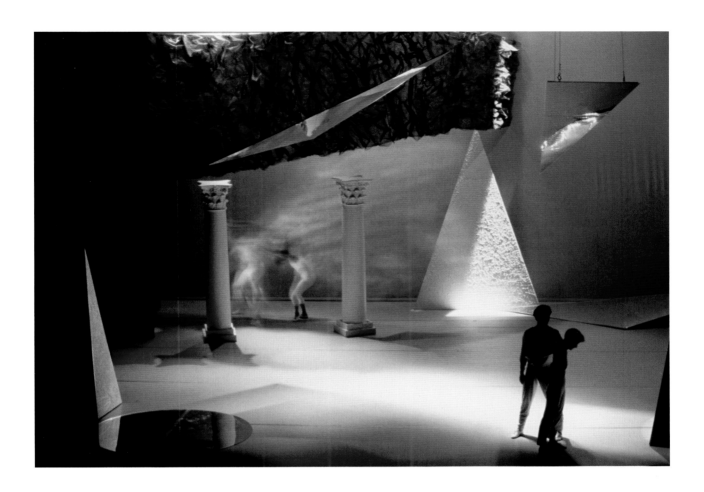

Margaret Jenkins and Barbara Kasten,
photo-documentation, *Inside Outside/
Stages of Light,* 1985

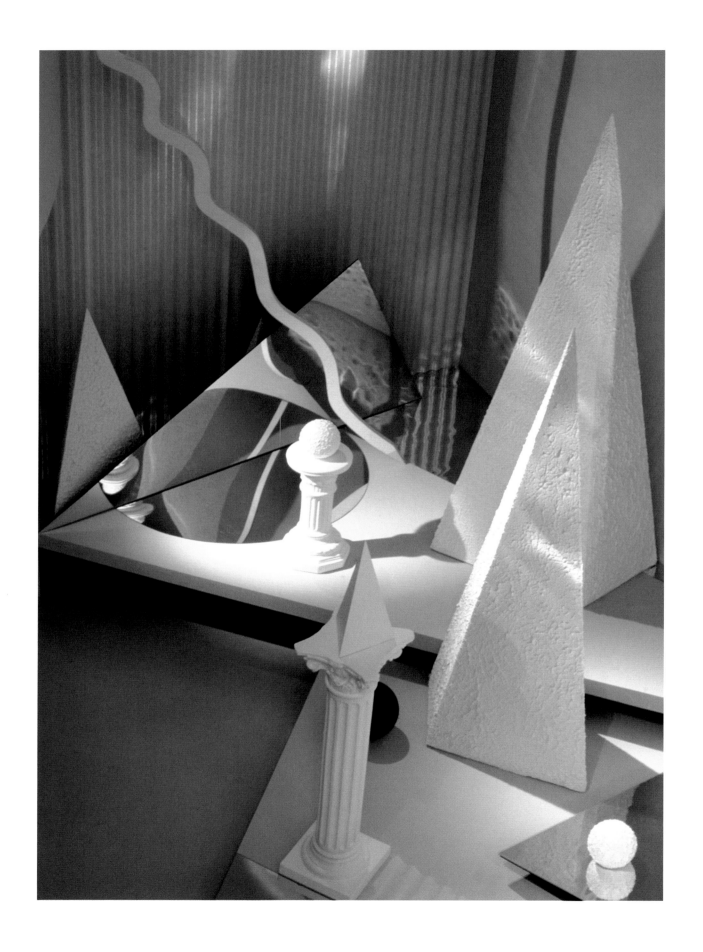

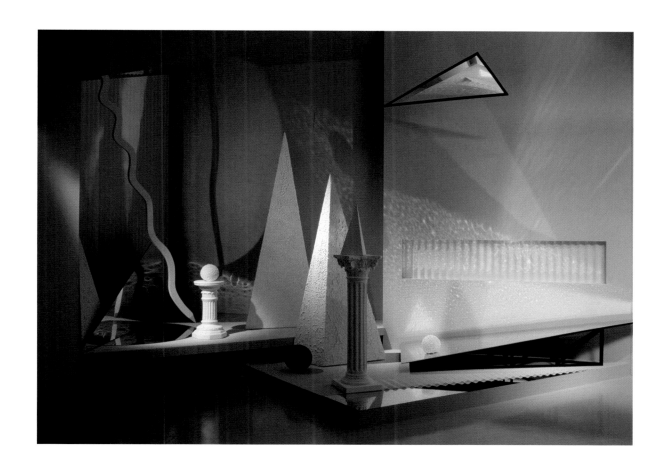

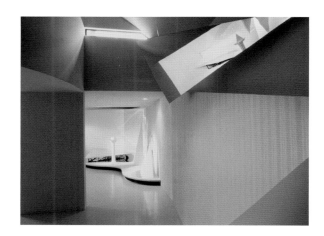

Exact Seeing, installation view,
Capp Street Project, 1985

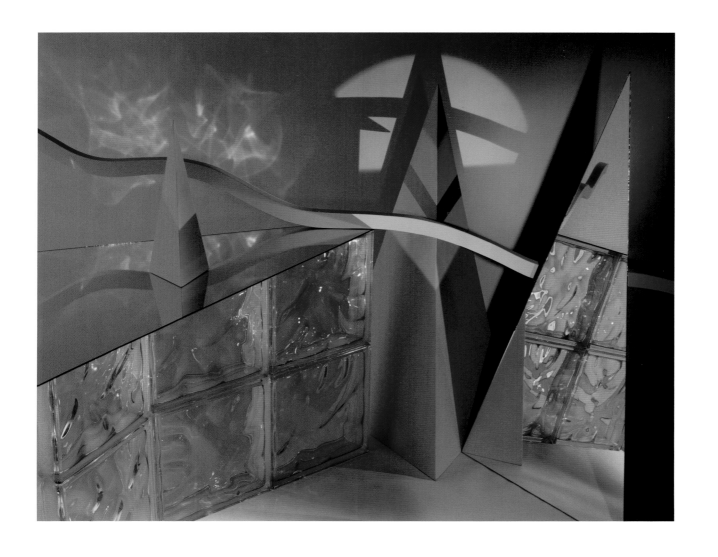

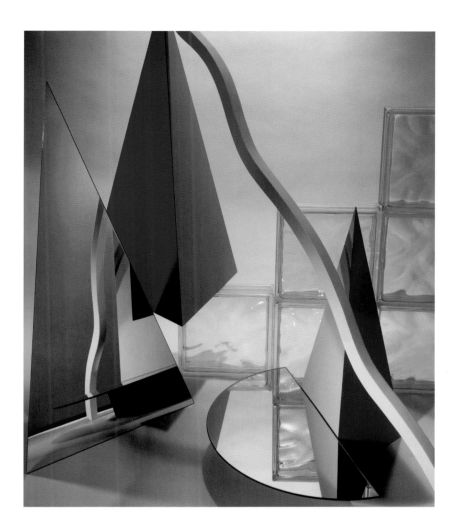

Construct NYC-16, 1984
Silver dye bleach print (Cibachrome)
29 ½ × 37 in. (74.9 × 94 cm)

Construct XXVII, 1984
Polaroid 20 × 24 Polacolor photograph
24 × 20 in. (61 × 50.8 cm)

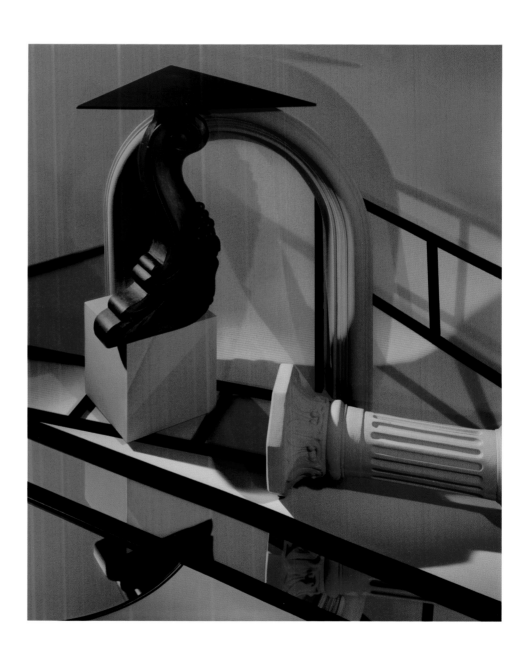

Construct NYC-12, 1984
Silver dye bleach print (Cibachrome)
37 × 29 ½ in. (94 × 74.9 cm)

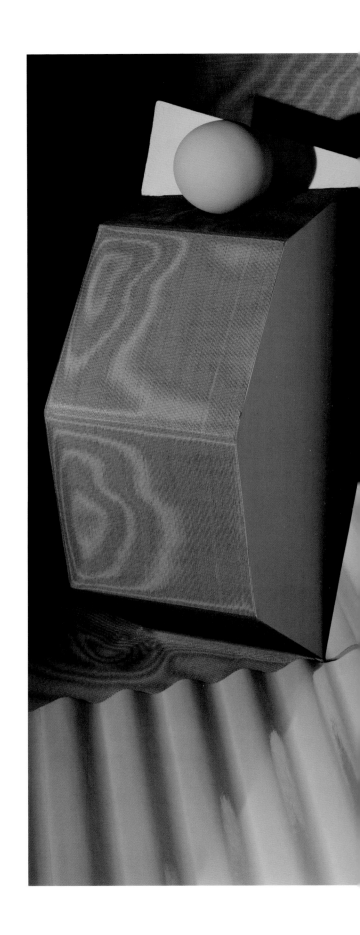

Construct NYC-17, 1984
Silver dye bleach print (Cibachrome)
29 ½ × 37 in. (74.9 × 94 cm)

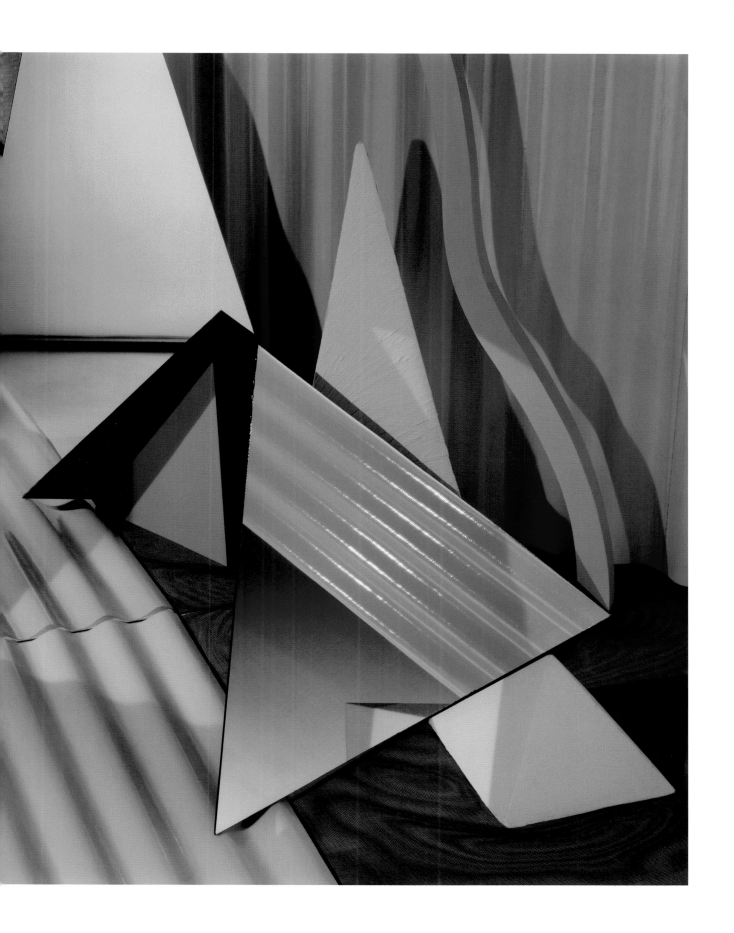

A shaft of light, a pencil-thin line, a sheet of Plexiglas, a moiré-patterned square, a shadow, a tear in the backdrop — these are the elements that comprise Barbara Kasten's large-scale photograph *Scene VII*, 2012 (p. 48). The word "scene" can refer to either a static view or a sequence of actions, and from her earliest fiber sculptures to her abstracted photographic constructions in the studio, Kasten's work has occupied a provisional space in which meaning and materials are rarely fixed, except, perhaps, for an instant on film.[1] If theater is often implied in her work, it is due in no small part to her engagement with sculptural objects or, "props." Although the term suggests the artifice of Hollywood and the stage, Kasten's props are also essential actors. A prop is both a substitute or surrogate and a thing that holds something up; its dual nature is one of both representation and physical support.

Appropriately, the majority of the materials in Kasten's photographs are literally propped against one another. Although physically precarious, this setup allows the artist a certain responsiveness and fluidity when working with the camera in mind. As she moves through her installations, which are most often scaled to the body, her set pieces must be pliable and permeable so as to permit adjustments and enable the effects created by light, shadow, color, and reflection. These objects are thus always on the cusp of being moved, stacked, rearranged, and projected upon. Their use-value extends beyond the tension between the flat surface of the image and the physical experience of sculpture in-the-round. They signal a relationship to the body: its presence and its ghosting.

The body in motion is also glimpsed in the photo-documentation of Kasten assembling her constructions, or as she calls them, "stage-sets." Slightly blurred, her figure is caught in a moment of working: unfurling a large roll of fiberglass screening, adjusting tiny wires on a structure, crouching over an object, shifting a Plexiglas shape, casting a shadow, or simply walking by. These images are not of performances per se, but there is no doubt about their performativity and measure of labor. Artist Anthony Pearson, who cites Kasten as an influence, has commented on the importance of this dimension of her process: "The pauses in her work are the photos that she took, so the photograph isn't a stand-in for an idea. It's a copy of an activity, or an action, or an experience... I really think of her as an artist in action and not as an artist whose photographs are a final thing."[2] In considering Kasten as an "artist in action," then, if the photograph is understood as a "copy of an activity," we might go further and think of the prop as a stand-in for the artist at work, that is as a kind of "body double."

In 1979 Kasten stepped away from a brief period of experimentation in the darkroom with a work titled *Amalgam Untitled 79/34*. Almost as if she had lifted up the "curtains" in one of her *Photogenic Paintings*, she revealed a modest installation set up for the camera, composed primarily of a light stand, a black window screen, a pane of glass, and a translucent cube. Although the frame ends before we are allowed to see the light fixture perched atop the stand, the artist has left the electrical cord plugged into the wall in plain view, the punctum of the scene. The cord is also a reminder that not only is the photograph a product of light, but it has been *produced* for us to see. At any moment the objects could topple and the image could go dark.

Barbara Kasten, *Amalgam 79/34*, 1979

The animating quality of light, which permeates much of Kasten's work, has been a preoccupation since the beginning. It is evident early on in her process as she experimented with exposing cyanotype prints under the California sun and photochemical paintings with an enlarger before she finally found her métier in the artificially lit environs of the studio. While Kasten would seem to anticipate so much of the work from the past twenty years that is set up or staged for the camera, much of her own thinking is indebted to the inspiration she found in Constructivist and Bauhaus theater experiments, which she first encountered in the mid-1960s as a young woman living in Europe and, later, through books and the photography collection she amassed with her then-husband, photographer and curator Leland Rice.

In 1980, Kasten described the "culminating effect" of finally seeing many of these early avant-garde works in person. In particular, the 1979 exhibition *Paris-Moscou, 1900–1930* at the Centre Georges Pompidou in Paris—which has been cited as the first comprehensive exhibition of the Russian avant-garde—where Kasten studied everything from costume designs by Varvara Stepanova to the spindly constructions of the Stenberg brothers. Indeed, this experience coincided with Kasten's move away from the flat surface of the picture plane and into the space of what would become her best-known series, *Construct*. In the work of these and other artists from the early twentieth century—particularly László Moholy-Nagy—Kasten discovered a sense of freedom and an ability to move among media and to sidestep disciplinary prejudices.

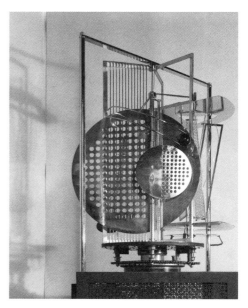

László Moholy-Nagy, *Light Prop for an Electric Stage (Light-Space Modulator)*, 1930; Harvard Art Museums/ Busch-Reisinger Museum, Gift of Sibyl Moholy-Nagy, BR56.5

Yet while Moholy-Nagy's photograms informed Kasten's understanding of photographic materiality, it was his theatrical engagement with light that proved most influential.[3] Around the time of this transition from her diagrammatic *Amalgams* to her spatialized *Constructs* Kasten wrote, "The references I have discovered to constructions, light modulators, reflections, space, time, [and] movement [are] very important to the work I am in the process of developing."[4] Here, the term "light modulator" refers to Moholoy-Nagy's *Light Space Modulator* or *Light Display Machine*, 1930, a multifaceted, machinic sculpture that when set in motion projects an array of luminous optical effects. Tellingly, its original title was *Light Prop for an Electric Stage*.

These multiple titles for Moholy-Nagy's sculpture point to what art historian Alex Potts has described as a "fundamental and productive uncertainty about its identity… It can be viewed in different ways: as a

kinetic sculpture but equally as a model for a fairly elaborate mechanism, or even as a proposal for a mobile architecture." Yet there is no doubt that Moholy-Nagy's intent was that the "prop" be employed as "a self-contained piece of 'abstract' theater."[5] Although the *Light Prop for an Electric Stage* was meant to be seen in person, Moholy-Nagy also made numerous photographs of his sculpture, as well as a short film, *Lightplay: Black/White/Gray*,1930, which was so well-received that he reportedly expressed disappointment that people seemed to prefer the mediated representation to the actual object.

—

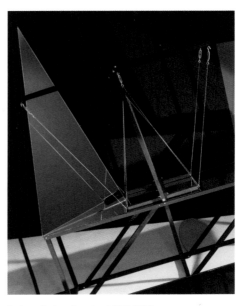

A Polaroid advertisement from the early 1980s reads: "Just bring your props and your creativity."[6] The tagline could almost have served as an unofficial motto for Kasten, who quickly embraced the possibilities opened up by the instantaneous results and vivid colors of the medium of large-format Polaroid film. Her earliest *Construct* works are populated by materials that Kasten sourced from hardware stores, boating-supply shops, and plastics emporiums. Hooks, rods, fasteners, mirrors, and fiberglass screening were all of a piece with the "finish fetish" work that was synonymous with the male-dominated sculpture scene in Los Angeles in the late 1960s and 1970s. Yet along with these industrial materials, we also see evidence of the handmade. Many of Kasten's works possess a delicate tension, while others seem almost casual, such as *Construct IX-A*, 1981 (p.133), in which the forms are simply leaned against a moiréd backdrop. With her relocation to New York in 1982, her materials became more formalized, geometric plaster objects that she alternately built herself and purchased from architectural supply catalogues.

Barbara Kasten, *Construct LB/6*, 1982

From the beginning, Kasten referred to these sculptural arrangements produced to be photographed in her studio as "sets." As curator Robert Sobieszek wrote in his statement for Kasten's 1981 solo exhibition at the George Eastman House:

> Kasten builds nearly room-sized assemblages, made of plastics and metals, glass and fabrics, lines and planes, volumes and coils, colors and textures. These are the components of the measurable universe she documents with her camera. But the large scaled articulations, these constructivist environments, are a definite locus of her vision. These rooms of shapes and appearances are completed works of art in themselves, although they also await another transformation by the camera. They are the theatrical sets within which the artist plays out her perceptions.[7]

Barbara Kasten working in the 20 × 24 Polaroid studio, 1982

A set implies both actors and actions, and we must imagine Kasten laboring in the theater-like space of her studio. As she moved materials and sculptural elements around in space, Kasten would occasionally step out of her ensemble, duck under the dark cloth draped over her large-format camera, and look through the upside-down gridded viewfinder to consider her scene. With multiple trips back and forth between the camera and her set—her intuitive process sometimes lasted several days—she would adjust the forms until she was satisfied.

At this juncture she would begin the incremental process of adding color to her otherwise neutral forms and backdrops. A sheer colored scrim might be backlit and reflected in a mirror while lights with different colored gels illuminated different portions of the frame. A single long exposure would record each step in which colored lights would be turned on and off for different lengths of time so that they could be metered properly and mixed until the desired outcome had been achieved.[8] The end result, which on the surface of the Polaroid would appear to be a simple recording of a still life, arrests a process that could have never been entirely visible to the unmediated eye.

Barbara Kasten in her New York studio, 1983. Photo: Kurt Kilgus

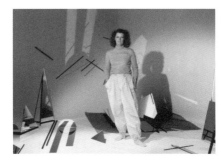

Barbara Kasten standing in her installation at California State University Long Beach, 1982

In a 1983 lecture at the Center for Creative Photography, Kasten reflected on this process and the importance of her material interactions: "I love getting in and really moving these pieces around and having physical contact with the shapes, with the forms, with the material itself. And yet when I deal with it and I am working with the sculpture, my thoughts are not really about what I am going to photograph."[9] The physical imme-diacy that Kasten describes here is abstracted through the mediation of photography. While Kasten's installations for the camera are meant to be navigated by the artist in the privacy of her studio, when produced for the space of the exhibition these same elements appear static and frozen in a sculptural tableau. Absent their artist-protagonist, Kasten's gallery constructions transform phenomenological space into a proscenium with a fixed perspective.

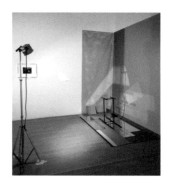

View of Barbara Kasten, *Construct I-A*, 1979 and sculptural installation in *Situational Imagery*, UC Irvine, 1980

Here, it is useful to return to Kasten's own terminology: she refers to these works alternately as "stage-set," "theatrical-like set," or simply "the set."[10] From the moment that Kasten first exhibited her *Constructs*, she not only suggested theater, she insisted upon it. Kasten debuted her 8×10" Polaroids in the 1980 exhibition *Situational Imagery* at the galleries at UC Irvine, placing them adjacent to an installation of her studio props lit by a theater light sitting prominently in the middle of the gallery floor.[11] But it was in 1982, with her exhibition organized by Constance Glenn at the University Art Gallery at California State University Long Beach, that this theatricality was most fully realized. In addition to Kasten's ambitious new 20 × 24" Polaroids, she also showed a new body of work: a 27-foot long installation and six 8×10" Polaroids that had been produced from it.

The installation featured massive backdrops, translucent colored scrims, large geometric mirrors, black-rod assemblages, thin metal wires, and screening material. Powerful floodlights animated the ensemble with reflections and shadows. A guardrail not only prevented visitors from entering but also conferred on the installation a fixed frontality similar to that of the photographs. And yet, for Kasten, there was a crucial difference between the two modes: "In these photographs I am presenting to you my own selective vision of the sculpture. It's my perception, it's my photographic vision that you are seeing, and in the sculpture itself you can experience your own relationship to it."[12] Reviewers remarked on how one's relationship to the installation changed as one moved through the gallery. Reflected colored fields would come in and out of view, angles would shift, and the shadows would seem to move. Others described the set as "captivating" and suggestive of a tactility that was not perceptible in the photographs. Moreover, the display of both sculpture and photography activated a series of dichotomies between the physical and the optical, the machinic and the handmade, the phenomenological and the imaginative.[13]

—

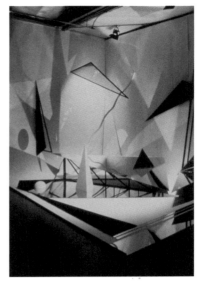

Barbara Kasten, sculptural installation at Karl Bornstein Gallery, Santa Monica, 1984

At this moment Kasten's approach to photography in the round was in keeping with other developments in the contemporary art world that probed the relationship between sculpture and theater. For example, Joan Jonas showed towering cone shapes, drawings, and other objects in her first museum exhibition, at ICA Philadelphia in 1976, and titled it *Stage Sets* (and indeed she premiered her play *The Juniper Tree* in the gallery). But Kasten was operating within a somewhat different context, working between photography and sculpture on the West Coast. In a 1980 article in *Modern Photography*, critics Andy Grundberg and Julia Scully wrote about the exciting new landscape of color photography then emerging from California. Citing Kasten alongside figures such as John Divola and JoAnn Callis, they described these artists' theatrical compositions and aesthetic as having "a color sense that borders on Technicolor, print-making on a large scale, a concern with construction or fabrication, and an involvement—often ironically distanced—with decorativeness, sensuality and the gaudy milieu of Hollywood."[14] These were artworks that were produced out of the particular context of the image industry itself.

This particularly Southern Californian engagement with the materials and tools of cinema, theater, and the media more generally led to the creation of artworks that trafficked in the sheen and finish of commercial images even as they destabilized them and revealed their fragility. Commenting on the ambiguous nature of Kasten's photographs, Grundberg and Scully observed, "We are directed to consider the image as a picture and an abstract one at that… The pictures are theatrical inasmuch as they are about staging and artistic 'play.'"[15] Yet these are certainly not the same "pictures" that were being produced contemporaneously by the group of artists in New York often referred to as the "Pictures Generation," for whom the media image was the locus of a critique of representation in its many facets. Ever the "constructivist," Kasten instead transformed the "picture" into both a site of artistic production and a production in the theatrical sense.

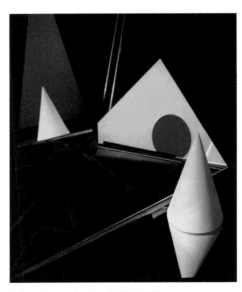

Barbara Kasten, *Construct NYC-4*, 1983

Props, of course, also conjure the realm of prop photography and the window display, and it is perhaps no coincidence that one of Kasten's earliest jobs was as a stylist in a department store. It is this other sense of the term "prop" that connects Kasten's "pictures" to the world of desire and the commodity. In thinking about precedents for this kind of approach, one is immediately reminded of the colorful commercial still lifes of photographer Paul Outerbridge, who began his career as a theater designer and spent his final years in Southern California. Kasten acknowledged that she was attracted to Outerbridge's use of "ambiguous objects," and one also suspects to his camp sensibilities.[16] In her own work this manifested itself in a non-utilitarian employment of off-the-shelf materials or, alternately, in making useless objects appear as if they could be used for something.

Paul Outerbridge, *Kandinsky*, 1937
Collection of Marek Lieberberg

In the West Coast artworld this kind of object confusion, however, was not exclusive to the province of photography. Kasten's approach also resonates with that of another artist working in Los Angeles in the 1970s, Guy de Cointet. Like Kasten, de Cointet kept a live-work space in an industrial building where he "arranged his studio like a stage set."[17] His absurdist plays drew on the formats of daytime television and experimental literature, but were formally driven by his highly stylized sets and brightly colored geometric props, which shifted function and meaning over the course of each performance, sometimes even going on to serve as furnishings in the artist's home. In de Cointet's plays, language and image fashion a series of actions to be decoded, but they also attribute utility, however seemingly nonsensical, to his cones and cubes, which perform as open vehicles or sites of projected desire rather than as fixed representations.

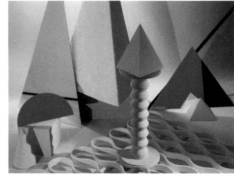

Barbara Kasten, *Construct NYC-20*, 1984

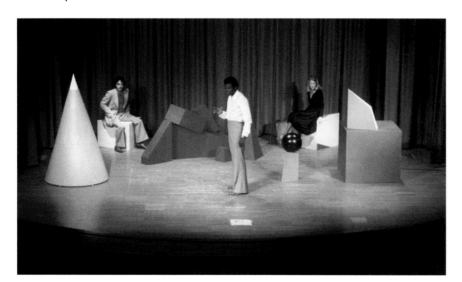

Guy de Cointet and Robert Wilhite, *Ethiopia*, Barnsdall Park Theatre, Los Angeles, 1976. Photo: Manuel Fuentes

This ambiguity also recalls the work of William Leavitt, another Los Angeles-based artist whose objects trouble the boundary between the fabrications of the entertainment industry and the creations of the artist's hand, serving as what curator Bennett Simpson has called "Hollywood readymades."[18] Critic Siegfried Kracauer, writing about photography during the Weimar era, described the props he encountered on a film set as "a bad dream about objects that has been forced into the corporeal realm," but nevertheless reminds us that there is nothing artificial about

their fabrication. Props are made from the same raw materials as their real-life counterparts, but they only need to be just believable enough to function in front of the lens of the camera or to be seen from a distance on stage.[19] To be sure, Kasten's props were used to different effect and drew upon different references than de Cointet or Leavitt, but what she does share with these artists is an interest in the tensions between imaging and objectness and staging and composition.

By the time of her 1985 exhibition at Capp Street Project, it was as if Kasten wanted to see what would happen if her props were left to their own devices (pp. 96–97). In response to the architecture at Capp Street, she installed her now-familiar repertoire of objects and mirrors, illuminating them with pastel lighting. She also incorporated pyramid-shaped props from the San Francisco Opera Company and activated her tableau on select dates with the help of dancers from the troupe of noted choreographer Margaret Jenkins.

Barbara Kasten and Margaret Jenkins, *Inside Outside/Stages of Light*, 1985
Photo: Bonnie Kamin

The Capp Street Project installation acted as a kind of life-size maquette for Kasten, and the next logical step was to realize a new production on the stage through another collaboration with Jenkins, *Inside Outside/ Stages of Light*, 1985. Kasten created architectural-scale versions of her studio props, designed costumes for the dancers, and conceptualized the lighting with the help of designer Sara Linnie Slocum. Kasten's movable sets composed of neoclassical columns and geometric mirrors echoed Jenkins's postmodern choreography and Bill Fontana's abstract soundscapes. When it debuted in New York as part of the Brooklyn Academy of Music's Next Wave Festival, the performance met with rave reviews that lauded the synergy between the choreography, visuals, and sound.[20] If Kasten had previously expressed an interest in movement, in collaboration with Jenkins it was realized with the help of the dancers' bodies, which propelled the props around the stage, alternately hidden by and reflected in them.

Although Kasten would never again so explicitly engage the space of the theater itself, her explorations of sculptural tableaux in the gallery would find their ultimate expression a few months later in a large-scale, site-specific installation at Wright State University in Dayton, Ohio. A prismatic miniature city of plaster pyramids, neoclassical columns, and mirrored planes on a raised platform, *Toward an Interconnectedness of All Things*, 1985 (pp. 90–91), was designed to be seen both in the round and from above. The installation reused props from Capp Street alongside new architectural elements created specifically for the show, and this time, once again, the body in motion was the viewer's. This engagement with the sculptural potential of the prop would go on to inform a series of smaller, dramatically lit stand-alone arrangements Kasten exhibited in a major solo show in Japan organized by the Asahi Shimbun. If up to this point Kasten's work had constituted a kind of theater without a narrative, in her ambitious *Architectural Sites* her propwork would quite literally set the stage for her engagement with the "expanded cinema" of photography in the directorial mode.

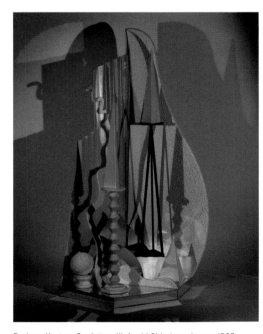

Barbara Kasten, *Sculpture III*, Asahi Shimbun, Japan, 1985

To insist upon the "prop" in "appropriation" is to suggest another reading of much of the artwork produced in the particular context of Southern

California from which Kasten emerged. These rehearsals of language and form are stand-ins for "the real thing," and their theatricality should be read outside of the predominantly East Coast debates about minimalism and allegory. Other figures in this narrative could include artists such as Allen Ruppersberg (whose *Al's Grand Hotel*, 1971, Kasten remembers visiting) or realign figures like Jack Goldstein alongside de Cointet and Leavitt. Today, we find echoes of this approach in the varied practices of artists ranging from Christopher Williams and Mathias Poledna to Elad Lassry, Alex Israel, and Kathryn Andrews, who create work with objects rented from Hollywood prop houses and expertise hired from Burbank studios. While keenly aware of appropriation's deconstructive tactics, their domain is one of natural artifice, accrual, and the uncanny.

Kasten's pictures and props—fantastic scenes created with borrowed materials—occupy a crucial place in this alternate history of West Coast artistic production. Significantly, the prop has returned in her most recent work with a new autonomy. In her video installation *Axis*, 2015, footage of plaster and wooden props, both new and repurposed—a stack of cubes, a pyramid, an axial form—are projected in a corner at architectural scale. Filmed in black-and-white, the objects rotate in space, extending the walls of the gallery to create a new illusionistic architecture. The experience dislocates the embodied viewer once again, traversing the historical conjuration of Moholy-Nagy's "electric stage," the phenomeno-logical perception of California Light and Space, and the computational forms of the three-dimensional render. In this new work the prop, once static and now in motion, serves a double function as both object and actor. Indeed, for Kasten, the prop, like the photograph, operates as both a proposal and a proposition, its usefulness equally tied to its mobiliza-tion as to its materiality.

1 Kasten's titles often imply multiple meanings. For example, her most well-known body of work, *Construct*, underscores that the materials in her scenarios have been actively constructed by the artist while also gesturing to her interest in the historical avant-garde, Constructivism, and ultimately acknowledging that the photograph is itself a "construct."

2 Anthony Pearson, conversation with the author, Los Angeles, CA, October 2013. I have written previously on the nature of process and labor in Kasten's work, in *Terminus Ante Quem*, exh. cat. (Chicago: Shane Campbell Gallery, 2010).

3 Kasten came into direct contact with Moholy-Nagy's photo-gram experiments through the exhibition that Leland Rice co-organized in 1975, *Photographs of Moholy-Nagy from the Collection of William Larson* at the Galleries of the Claremont Colleges.

4 Barbara Kasten, grant application to the John Simon Guggenheim Memorial Foundation, c. late 1979 or early 1980. Although this partic-ular application was not successful, Kasten would go on to receive a Guggenheim grant in 1982 that facilitated her even-tual move to New York.

5 Alex Potts, "László Moholy-Nagy: Light Prop for an Electric Stage, 1930," in *Bauhaus 1919–1933: Workshops for Modernity*, exh. cat. (New York: Museum of Modern Art, 2009), 274.

6 Polaroid, cited in Sally Norman, "'Big Picture' focus is snap judgement: Polaroid's Akron show offers art that refreshes," *Cleveland Plain Dealer* (September 21, 1985).

7 Robert Sobieszek, "A Theater of Construction/ Deconstruction," statement for Barbara Kasten's solo exhibition at George Eastman House, November 1981.

8 In her studio Kasten employed continuous tungsten lighting, while at the Polaroid studio in Cambridge, she worked with strobes that were set off at multiple intervals during a single exposure.

9 Barbara Kasten, lecture at the Center for Creative Photography, University of Arizona, Tucson, 1983.

10 Kasten used these terms in artist statements throughout the early 1980s, notably in her 1981 statement accompanying the group exhibition *Media Relief* at John Weber Gallery, New York.

11 *Situational Imagery* considered the relationship between sculpture and photog-raphy, including works that were set up for the camera and staged in space. It was co-curated by Rice and curator Melinda Wortz.

12 Barbara Kasten, lecture at the Center for Creative Photography, University of Arizona, Tucson, 1983.

13 See Mark Johnstone, "Windex index: Barbara Kasten/Centric 2," *AFTERIMAGE 10*, Nos. 1 & 2 (Summer 1982) and "Installation and Image," *Artweek* (February 27, 1982); Danica Kirka, "Kasten exhibit draws from setting she created," *Daily Forty-Niner* (February 11, 1982): 3–4; Dinah Berland Portner, "Taking the Leap into the Third Dimension," *Los Angeles Times* (February 21, 1982); and Merie Schipper, "Barbara Kasten at Cal State Long Beach," *Images & Issues* (September/October 1982): 72.

14 Andy Grundberg and Julia Scully, "Currents: American Photography Today," *Modern Photography* (October 1980): 94.

15 Ibid., 166.

16 Barbara Kasten, lecture at the Center for Creative Photography, University of Arizona, Tucson, 1983.

17 Marie de Brugerolle, *Guy de Cointet* (Zurich: JRP|Ringier, 2011), 15. It is also interesting to note that de Cointet worked for sculptor Larry Bell, whose work is often associated with California Light and Space.

18 Bennett Simpson in a public conversa-tion with artist Kathryn Andrews and the author on the role of the prop in artistic practice, ICA, February 1, 2012.

19 See Siegfried Kracauer, "Calico-World: The UFA City in Neubabelsberg" (1926), in *The Object Reader*, ed. Fiona Candline and Raiford Guins (London: Routledge, 2009), 326–30. Kracauer goes on to write about props, "They are not organisms that can develop on their own. Woodworking shops, glassmaking shops, and sculpture studios provide what is necessary. There is nothing false about the materials: wood, metal, glass, clay. One could also make real things out of them, but as objects in front of the lens [Objectiv] the deceptive ones work just as well. After all, the lens is objective [objectiv]."

20 Jennifer Dunning, "Dance: Margaret Jenkins Company," *The New York Times* (Friday, October 25, 1985).

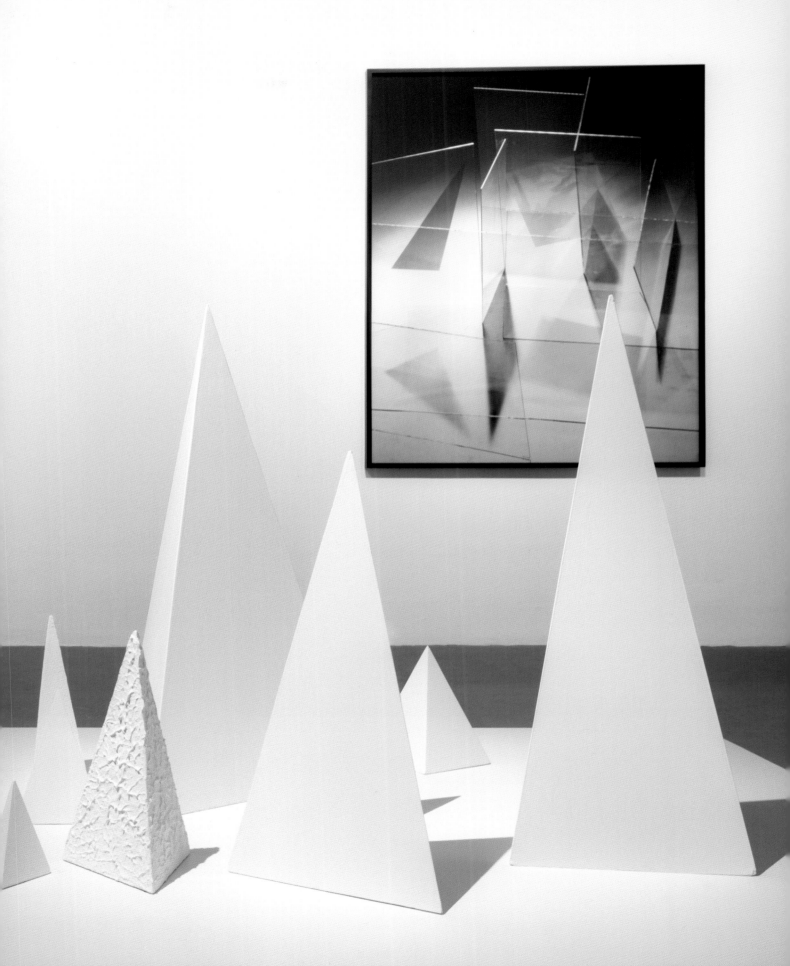

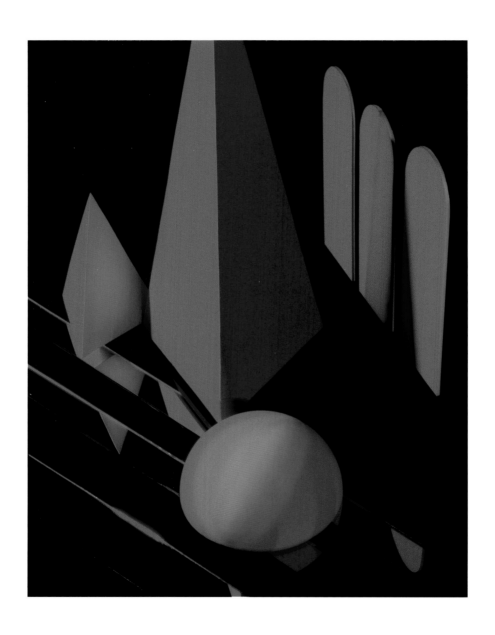
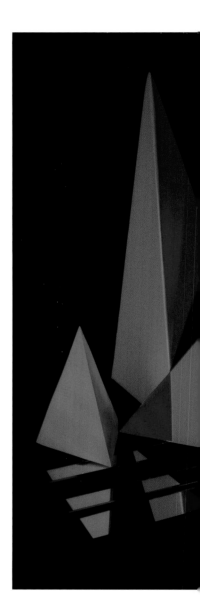

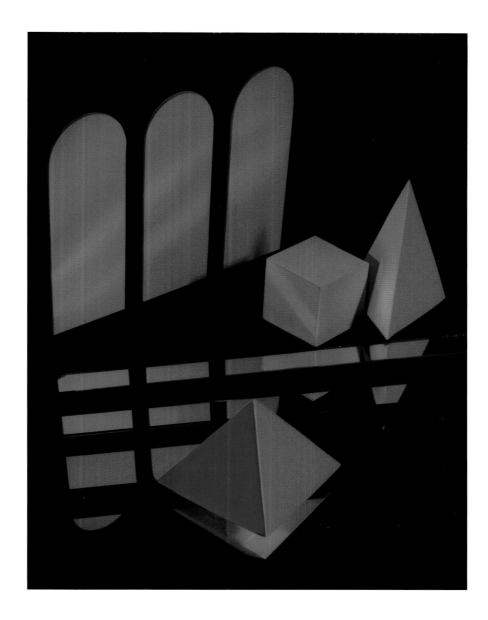

Triptych II, 1983
Silver dye bleach print (Cibachrome)
Three parts, 37 × 29 ½ in. (94 × 74.9 cm) each
37 × 89 ½ in. (94 × 227.3 cm) overall

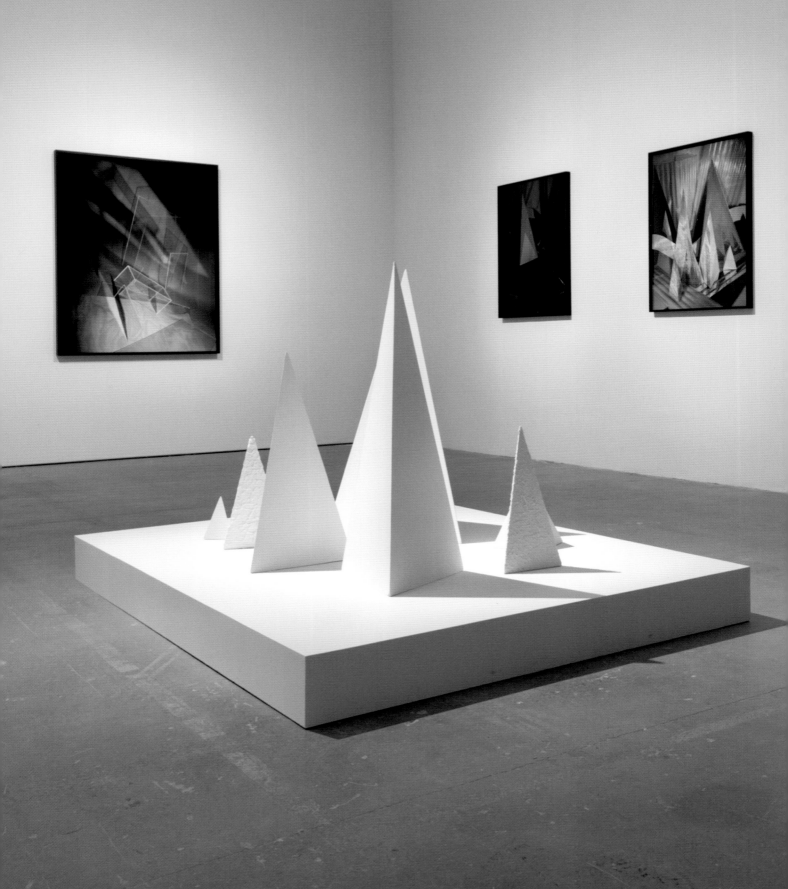

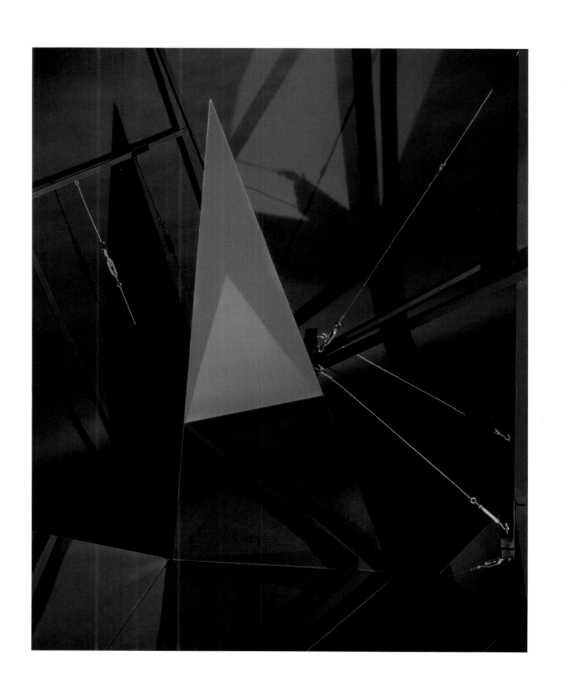

Construct XVI, 1982
Silver dye bleach print (Cibachrome)
37 × 29 ½ in. (101.6 × 76.2 cm)

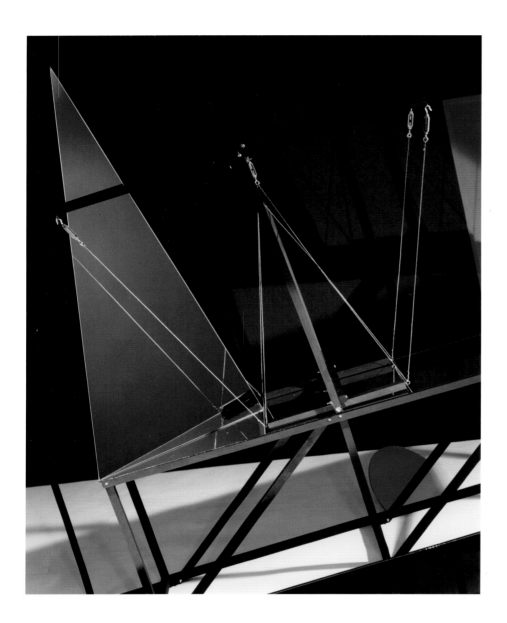

Construct LB/6, 1982
Polaroid Polacolor ER photograph
9 ⅓ × 7 ⅓ in. (23.7 × 18.6 cm)

Construct LB/1, 1982
Polaroid Polacolor ER photograph
7 ⅓ × 9 ⅓ in. (18.6 × 23.7 cm)

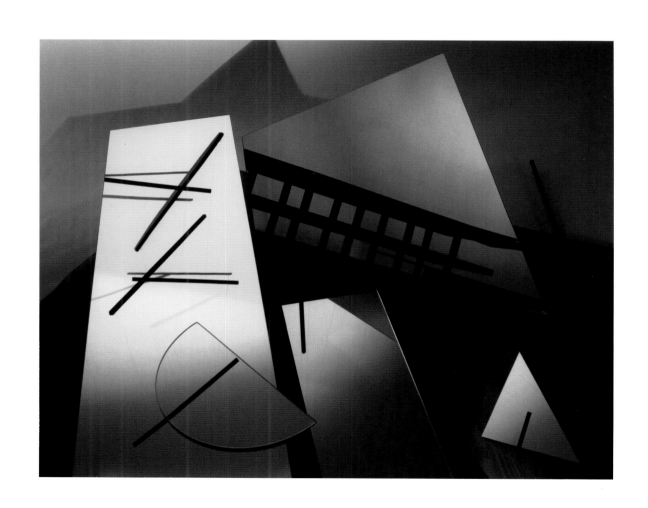

Construct LB/5, 1982
Polaroid Polacolor ER photograph
9 1/3 × 7 1/3 in. (23.7 × 18.6 cm)

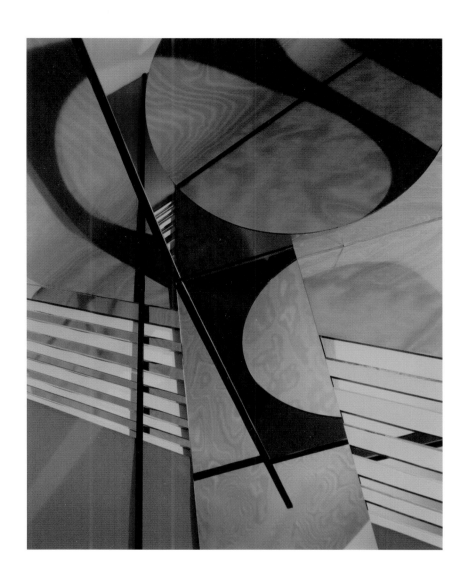

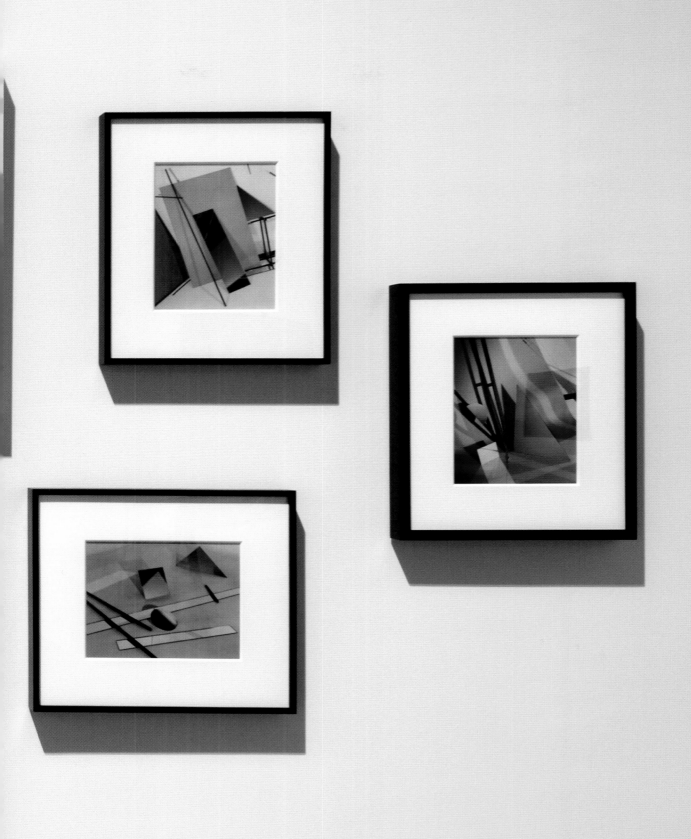

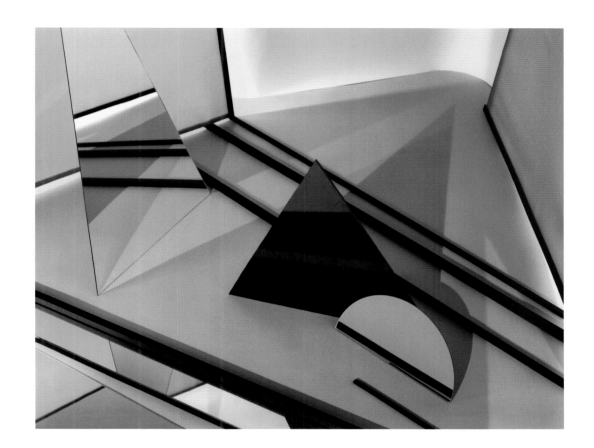

Construct XIX, 1982
Polaroid Polacolor ER photograph
7 ⅓ × 9 ⅓ in. (18.6 × 23.7 cm)

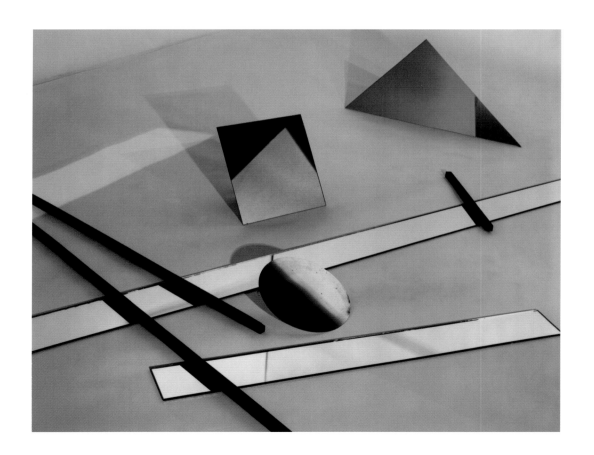

Construct V-A, 1980
Polaroid Polacolor ER photograph
7 ⅓ × 9 ⅓ in. (18.6 × 23.7 cm)

Construct XIII, 1982
Polaroid Polacolor ER photograph
9 ⅓ × 7 ⅓ in. (23.7 × 18.6 cm)

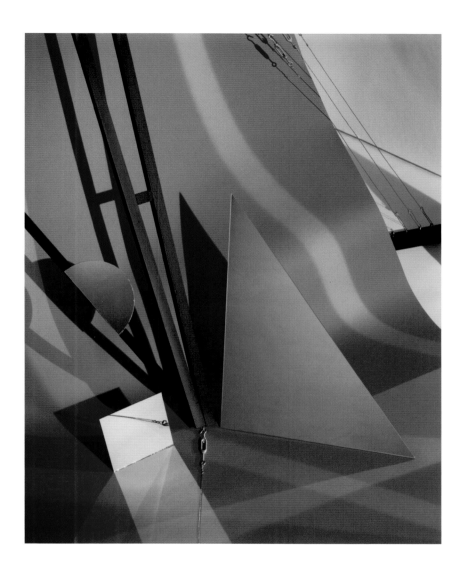

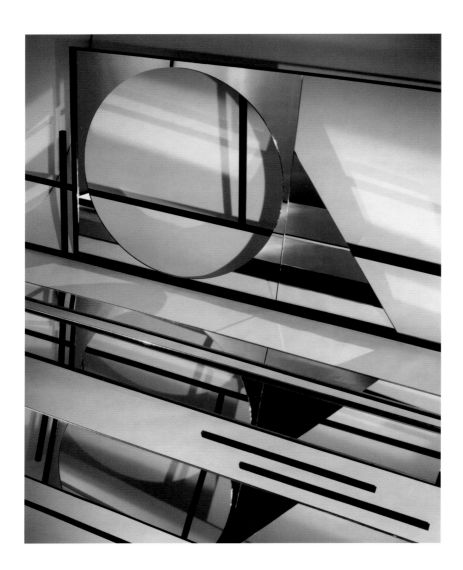

Construct XI-A, 1981
Polaroid Polacolor ER photograph
9 ⅓ × 7 ⅓ in. (23.7 × 18.6 cm)

Construct XVIII-Y, 1982
Polaroid Polacolor ER photograph
7 ⅓ × 9 ⅓ in. (18.6 × 23.7 cm)

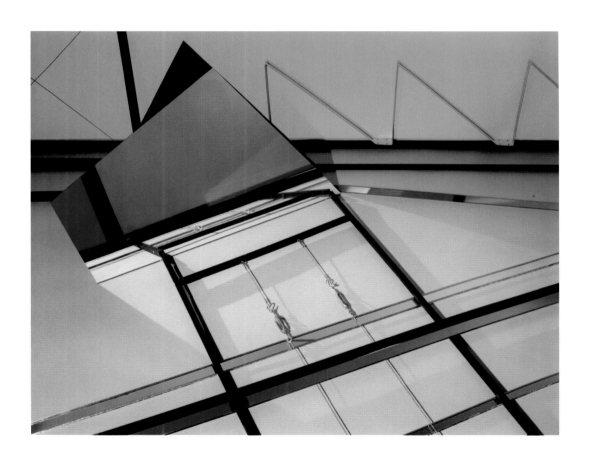

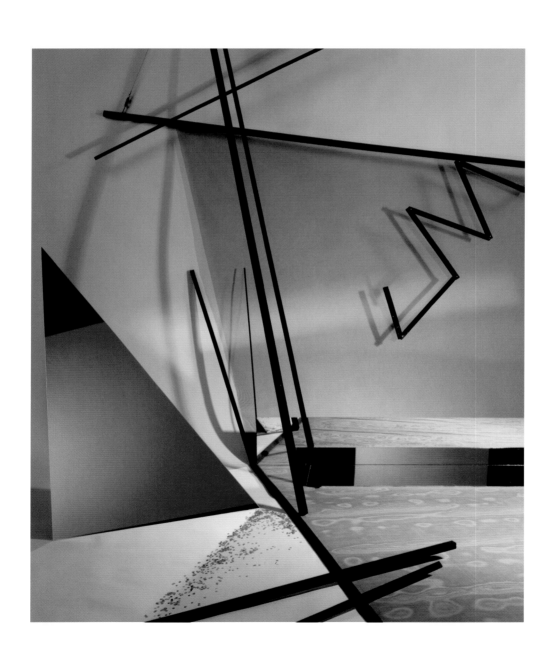

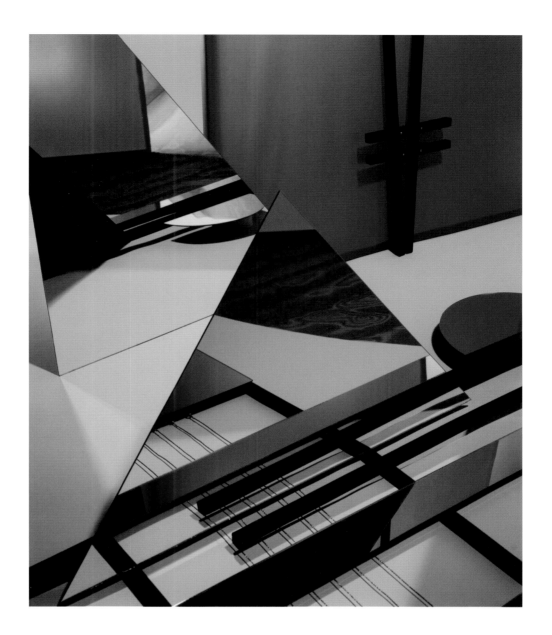

Construct PC/1A, 1981
Polaroid 20 × 24 Polacolor photograph
24 × 20 in. (61 × 50.8 cm)

Construct PC/4B, 1981
Polaroid 20 × 24 Polacolor photograph
24 × 20 in. (61 × 50.8 cm)

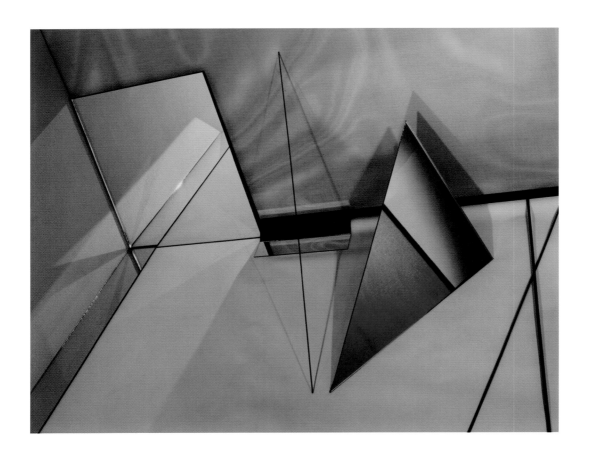

Construct VI-B, 1981
Polaroid Polacolor ER photograph
7 1/3 × 9 1/3 in. (18.6 × 23.7 cm)

Construct IX-A, 1981
Polaroid Polacolor ER photograph
9 1/3 × 7 1/3 in. (23.7 × 18.6 cm)

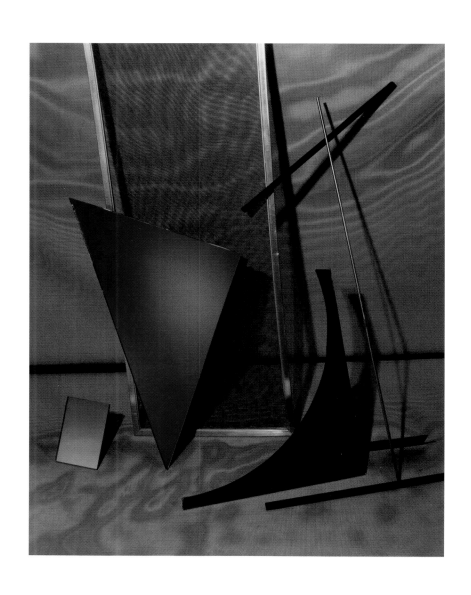

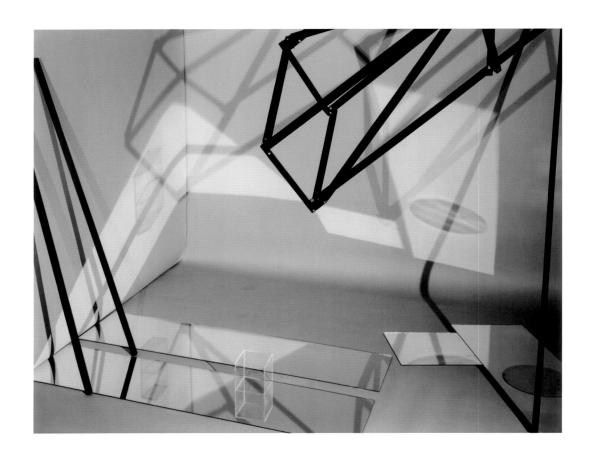

Construct IV-C (variation), 1980
Polaroid Polacolor ER photograph
7 ⅓ × 9 ⅓ in. (18.6 × 23.7 cm)

Scene I, 2012
Archival pigment print
54 ½ × 43 ½ in. (138.4 × 110.5 cm)

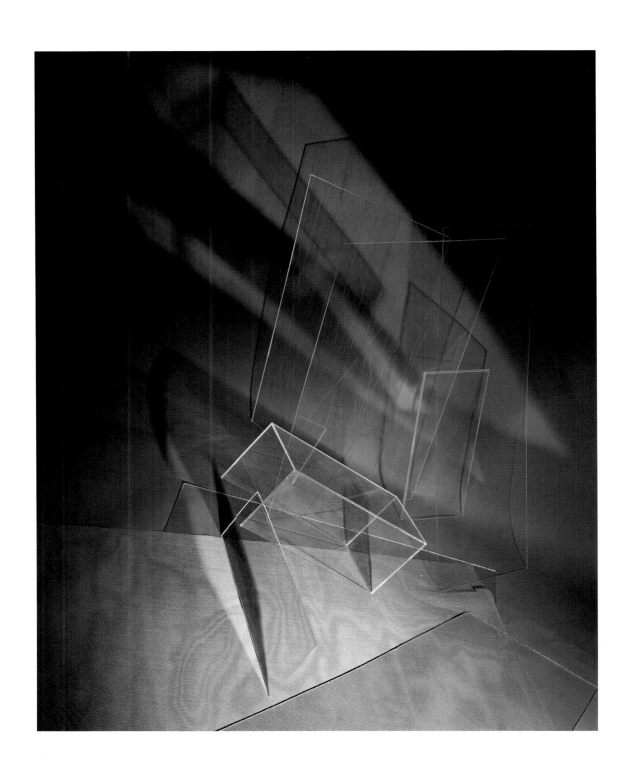

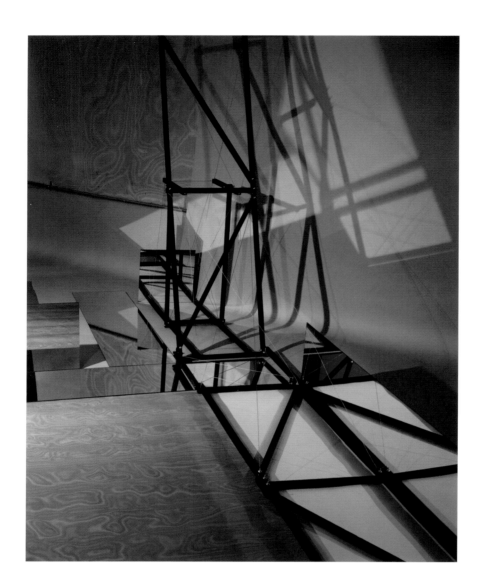

Construct III-A, 1980
Polaroid Polacolor ER photograph
9 ⅓ × 7 ⅓ in. (23.7 × 18.6 cm)

Construct I-A, 1979
Polaroid Polacolor ER photograph
7 ⅓ × 9 ⅓ in. (18.6 × 23.7 cm)

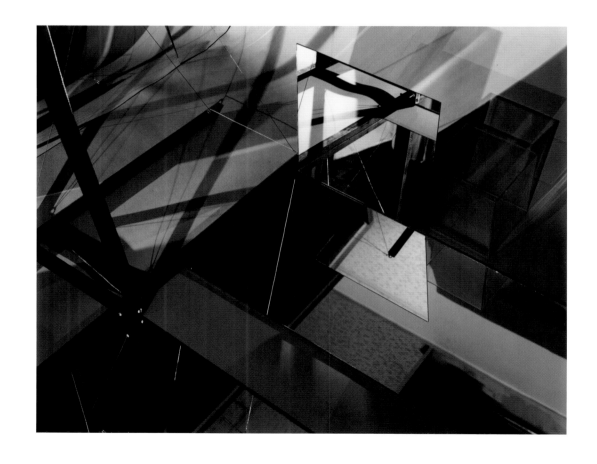

Amalgam Untitled 79/34, 1979
Gelatin silver print
20 × 16 in. (50.8 × 40.6 cm)

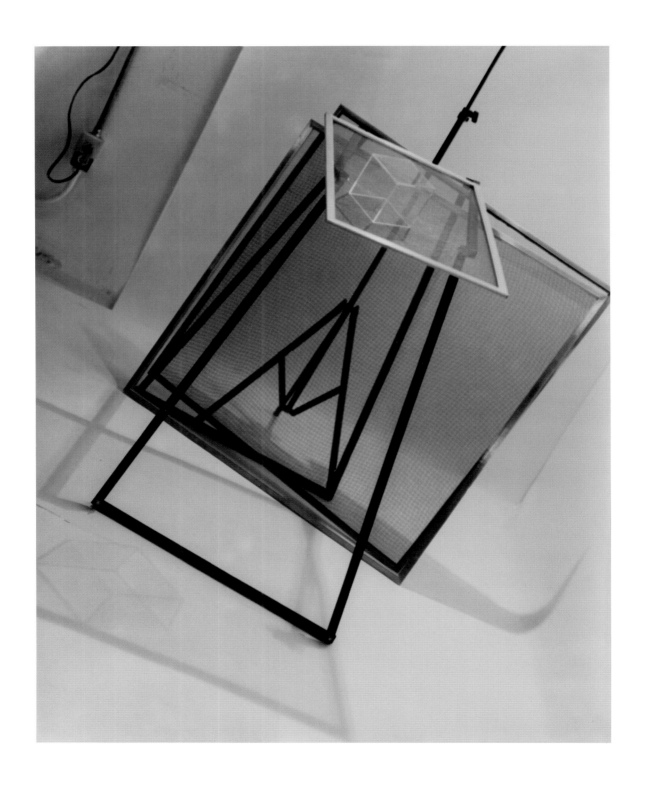

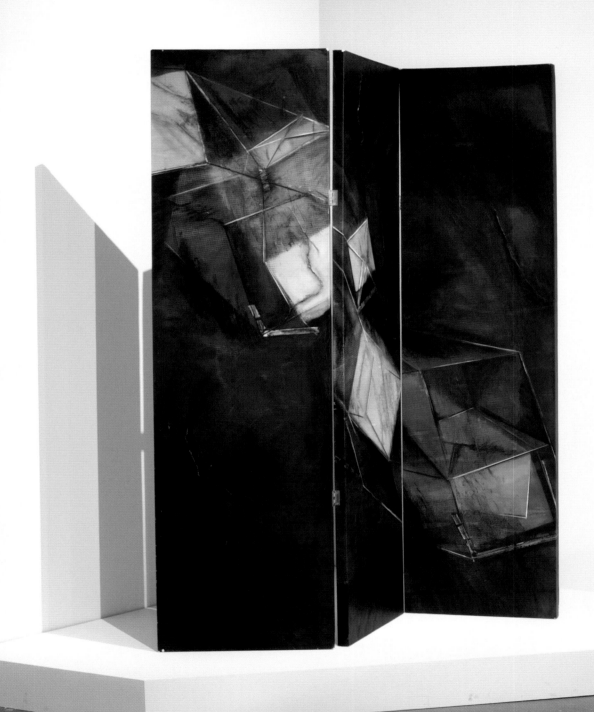

Photogram Painting Untitled 77/22, 1977
Gelatin silver mural paper with oil paint,
Three parts, 78 × 22 × 2 ½ in. (198.1 × 55.9 × 6.4 cm) each
78 × 66 × 2 ½ in. (198.1 × 167.6 × 6.4 cm) overall

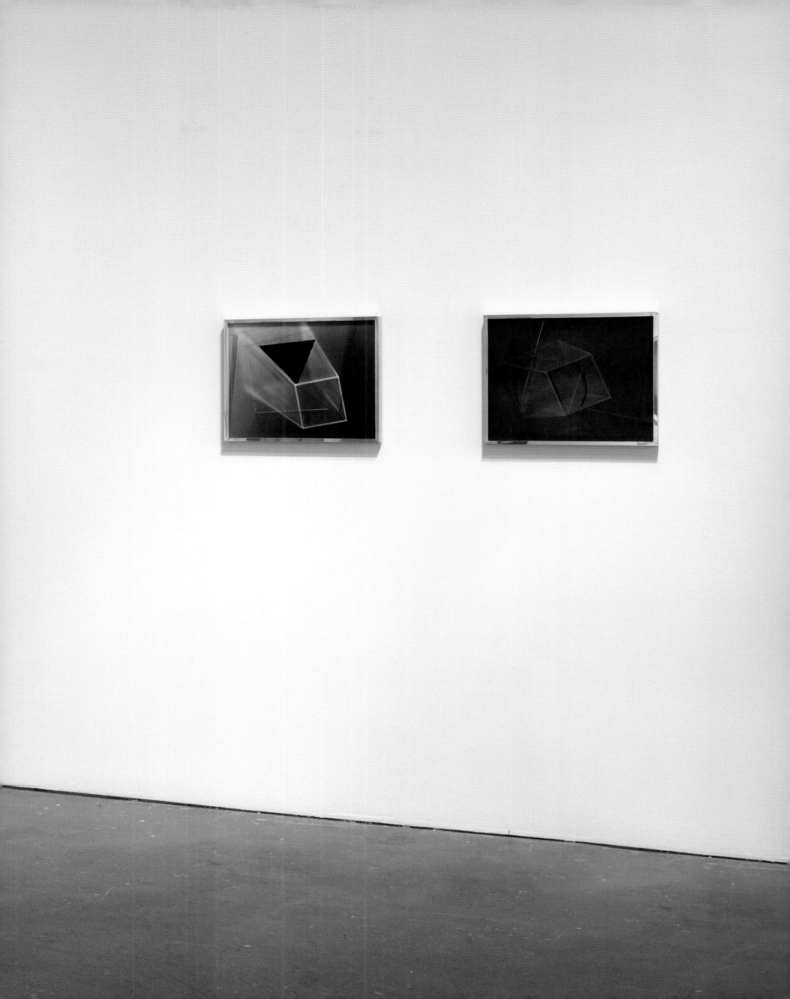

Amalgam Untitled 79/9, 1979
Gelatin silver print (enlargement with photogram)
with acrylic paint and crayon
16 × 20 in. (40.6 × 50.8 cm)

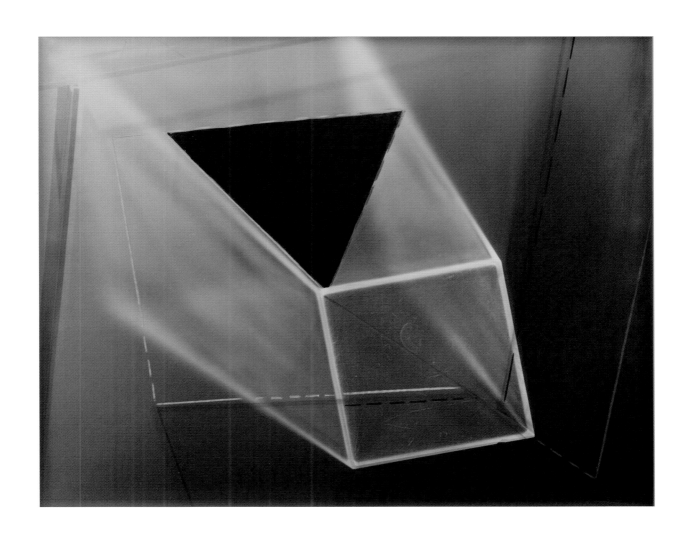

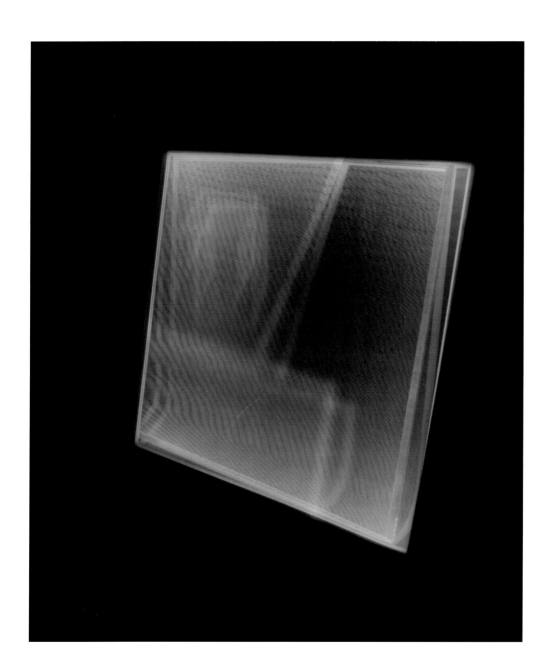

Amalgam Untitled 79/22, 1979
Gelatin silver print
(enlargement with photogram)
20 × 16 in. (50.8 × 40.6 cm)

Amalgam Untitled 79/18, 1979
Gelatin silver print (enlargement
with photogram) with crayon
16 × 20 in. (40.6 × 50.8 cm)

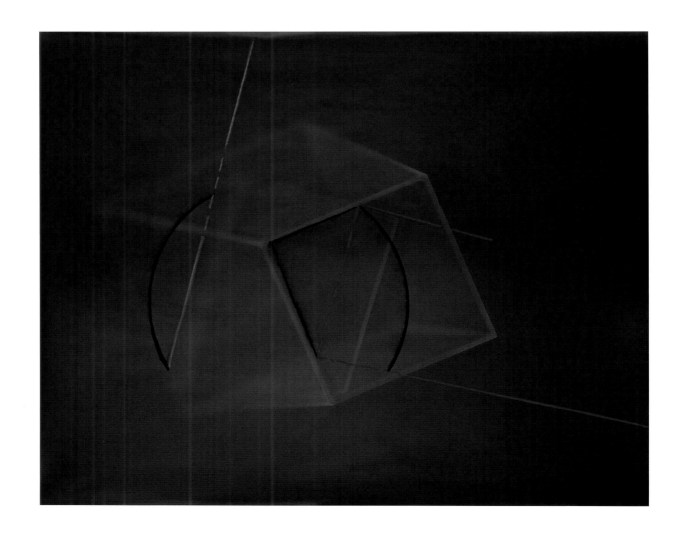

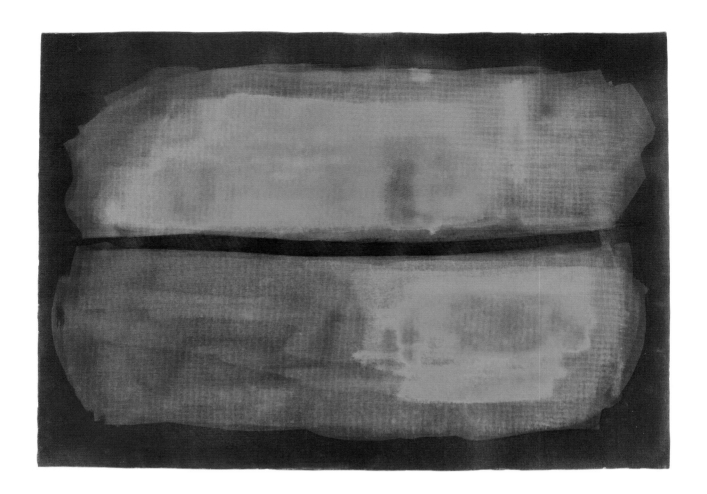

Photogenic Painting Untitled 76/7, 1976
Cyanotype (photogram) with
Van Dyke and ink on BFK Rives paper
30 × 40 in. (76.2 × 101.6 cm)

Photogenic Painting, 74/1, 1974
Cyanotype (photogram) on
BFK Rives paper
22 × 30 in. (55.9 × 76.2 cm)

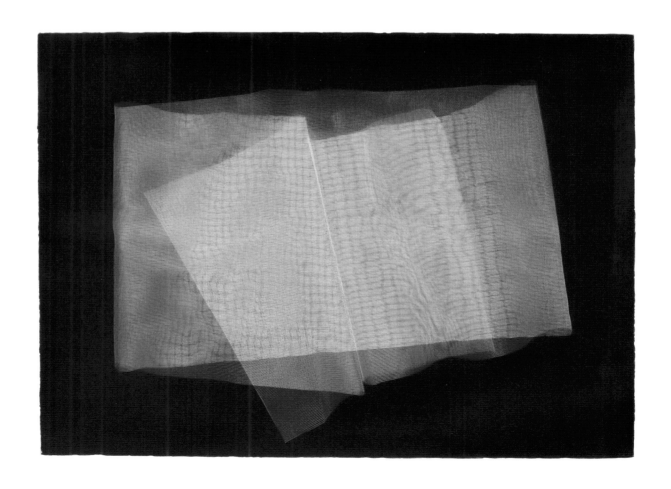

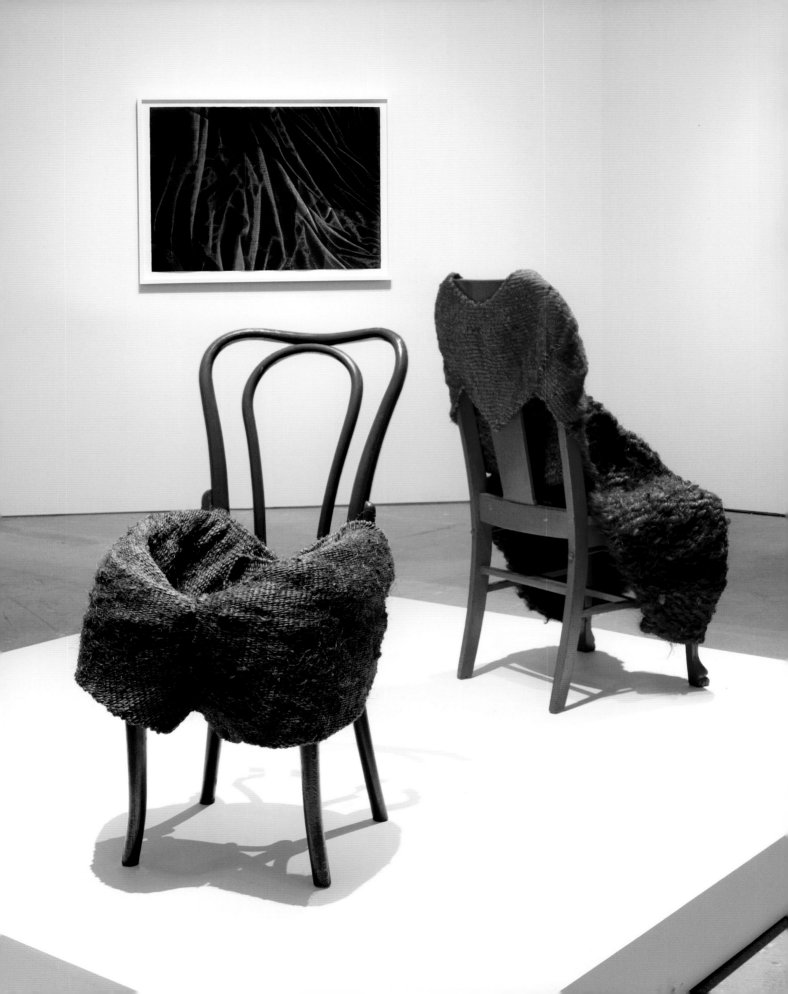

Steeped in the hard edges of a soft medium, Barbara Kasten began her professional artistic career working in fiber. Weaving is based upon an unseen architecture: building and refining a textile before it is ever woven, using a coded grid known as a weave draft. Like architectural modeling, this is the planning stage that allows a weaver to map a pattern, diagramming the way the loom is threaded, or dressed, in order to produce the textile's basic structure. The two-dimensional flatness of a woven textile is thus preceded by a three-dimensional process of structuring its basic building unit: the complexity of designing the threads of the warp (vertical) and weft (horizontal) in order to ensure the continuity of a repeatable pattern.

Handweaving is laborious all around, but is particularly notorious for its methodical setup. Yet it is precisely this process of staging form that foreshadows the photographic constructions that characterize Kasten's mature practice. While Kasten did not make classic weavings, instead improvising and using many mixed-media processes, her early works— in particular, her fiber sculptures and early curatorial projects—emerge from the specific context of the 1970s and have critical material implications for her later work.

A painter by training, Kasten received her BFA in 1959 from the University of Arizona and worked in the fashion industry in San Francisco, doing window dressing and styling until 1962, before setting her sights on traveling abroad. Kasten took a position working for the Armed Forces in Germany from 1964 until 1966, and it was there that she first encountered the emergent studio fiber movement. As she has said, "I had decided when I saw a crafts show in Europe that the possibilities of texture and color achieved in fiber would be a good transition from my painting."[1]

The 1960s saw an explosion in experimental textile practice throughout Western and Eastern Europe, the United States, and Canada. A break with the rigors of formal weaving and its virtues of regularity and flatness is characteristic of what artists like Magdalena Abakanowicz and Sheila Hicks sought in their large-scale, expressionistic works. Others, such as Ritzi and Peter Jacobi, rejected weaving altogether, turning to alternative techniques to create substantial cloth yardage, such as felting, knotting, looping, twisting, and wrapping through knitting, crochet, and even macramé. Such techniques had historically conferred an association with the ornamental and the decorative, but the transition from the flatness of weaving to three-dimensional sculpture is documented through the heady exhibition practice of the era: a slew of exhibitions across Europe and the United States, mainly on the West Coast.

Kasten's early work is embedded in this history of experimental textiles. Upon her return from Europe in 1967, she began investigating fiber sculpture and making rudimentary weavings. Having decided to return to graduate school, Kasten was accepted at the California College of Arts and Crafts (now California College of the Arts) in Oakland, where she matriculated in the weaving department.

Kasten's mentor at CCAC was Trude Guermonprez (1910–1976), who became a very important influence, both personally and professionally. As Leland Rice, a fellow faculty member teaching photography and later Kasten's husband, commented:

Trude Guermonprez in an undated photograph

> Barbara was a lot older than many of the other students, so Trude really embraced her… Trude taught in the tradition of the Bauhaus, with an artist-apprenticeship type of relationship to her students. She was very warm and emotional, very strong. When she liked someone she really took them in, and that is how it probably was with Barbara. It was beyond just an MFA-student type of relationship.[2]

A distinguished weaver who had trained in the Netherlands, Guermonprez had a long and varied career, teaching at Black Mountain College alongside Anni Albers and at Pond Farm with ceramist Marguerite Wildenhain, before joining CCAC in 1954 as the first faculty member in their new textiles program. She served as chair of the department from 1960 until her death in 1976.[3] One of the clear lessons Guermonprez imparted was her tolerance for a relentlessly experimental process, encouraging Kasten's own interest in sculptural work, as she viewed weaving itself as a three-dimensional process of construction.

From early 1969 to late 1970, Kasten made weavings in order to manipulate the warp, pulling it so that it creased or bunched up, or stuffed the resulting fabric to create a sculptural form onto which she could silk-screen photographic imagery. *Stuffed Blue Torso*, 1970, for instance, is a repeated print, alternating right side up and upside down, of the length of a woman's back (identifiable from the narrowness of the shoulders, the slender waist, and the roundness of the buttocks). There is a built-in exchange, not only in the flipped imagery but also in the fact that "torso" is a term that usually refers to the front of the body, not the back. Further, the torsos themselves are set facing each other, a witty reference to the infinite possibilities if the body is demoted to just a simple shape, deprived of its sexuality.

Barbara Kasten, *Stuffed Blue Torso*, 1970

Yet in turning the print upside down, Kasten indicates that gender is impossible to ignore: in a flagrant reversal, the fleshiness of the buttocks doubles as the head of a penis. Such a binary becomes a witty permutation suffusing the entirety of the object—front/back, female/male, visual/tactile—and sexually charging the imagery. Other works from this period, such as *Woven Torso*, 1970, also have a corporeal presence, suggestive of the female body, in which the undulating fabric and the shadowy image of a partial nude merge, the raised texture of the wool literally fleshing out the hollows in the body. Exhibited hanging off the wall, the work has a projection-like quality, as though the weaving itself is a scrim,

offering an illusion of transparency. This is echoed in the silkscreen banners Kasten made around the same time, utilizing repeated imagery of the fragmented body, overlapping and printed in vivid greens and oranges and on different weights of fabric, such as red corduroy.

When Kasten returned to California from Europe in the late 1960s, the Bay Area was in the nascent stages of what would be a decade-long textile revival. Barbara Shawcroft and Kay Sekimachi, both pioneers in large-scale off-loom practices, had earlier been students of Guermonprez. The year 1963 heralded the first American studio fiber group exhibition, *Woven Forms,* at the Museum of Contemporary Craft in New York. This was followed by a flurry of exhibitions during the period of 1969 to 1972, beginning with *Wall Hangings*, curated by Mildred Constantine at the Museum of Modern Art in New York.[4] As her MFA thesis exhibition, Kasten initiated the first West Coast fiber exhibition, *Dimension of Fiber*, held March 4–29, 1971, at the CCAC Gallery, in Oakland. Kasten's exhibition preceded the better-known traveling exhibition *Deliberate Entanglements*, curated by Bernard Kester at the University of California, Los Angeles. Kester was himself an artist, and on the fiber faculty at UCLA.

Barbara Kasten, *Woven Torso,* 1970

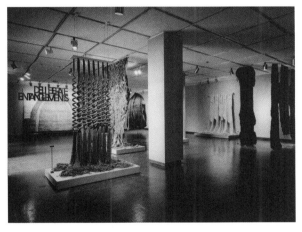

Deliberate Entanglements at the Dickson Art Center, University of California, Los Angeles, November 16–December 12, 1971

But Kasten's exhibition is a crucial one: it represents an emerging artist's interpretation of a movement still taking shape, a dedicated exhibition to works in fiber at a time when most Bay Area institutions ignored the medium. Further, she utilized the paradigm of her own MFA thesis exhibition—meant to be a first solo show—as an aspirational strategy, showcasing a pantheon of admired artists and her own placement among them, including exactly one of her own works, a large-scale off-loom weaving known as *Carcass*, 1971, which, at ten feet tall, became a larger-than-life bodily form. In her curatorial statement Kasten commented upon the deliberate choices the artists had made in terms of the medium's structural properties, masses or expanses of textile material spilling off the wall, onto the floor, or ceiling, and its relationship to gravity, or as she wrote, "The work elicits an exaggerated physical response… As the size of the work increases, the spectator's responsibilities are increased proportionately. With the ability to experience the work from all angles and to sense himself within its physical orbit, the observer assumes the role of participant."[5] Kasten's point of departure, then, was the conceptualization of space and its material transformations.

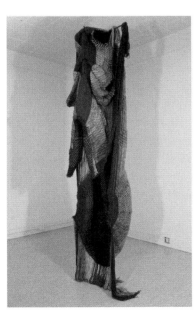

Barbara Kasten, *Carcass,* 1971

One of the key differences in the exhibitions is a varying degree of aestheticism. *Deliberate Entanglements* had a subtitle: "an exhibition of fabric forms." Fabric, rather than textile sculpture, was the presiding terminology. Kester's hang emphasized the dramatic potential of the large-scale works, as though they were stage sets, using lighting to enhance the shadows and painting the walls of the gallery a bright orange hue. Ultimately, Kester's exhibition received a great deal more attention than Kasten's, including a photographic spread in a 1972 issue of *Life Magazine*.[6] Still, Kasten's and Kester's exhibitions have a nearly identical roster of artists—including Abakanowicz, Hicks, Sekimachi, and Claire Zeisler, as well as two former students of Kester's, recent UCLA graduates Neda Al-Hilali and Françoise Grossen—and during 1971 Kasten taught for the spring quarter at UCLA as a replacement for Kester. During this time, she trained sculpture students who would go on to produce in diverse media, including the photographer Jo Ann Callis and the performance artist Maren Hassinger.

Ultimately, *Dimension of Fiber* allowed Kasten to work out some of the ideas she would continue to pursue long after the fiber work fell away, particularly, a distinction between how a work is made and the image it produces. As she wrote, "The gestalt of each piece makes the process subservient to the completed image."[7] Further, the exhibition provided an opportunity for Kasten to connect with Abakanowicz, who became another important mentor. Kasten won a Fulbright Hays Fellowship for the 1971–72 academic year to study with Abakanowicz at the Poznań Academy of Fine Arts, in Poland.[8]

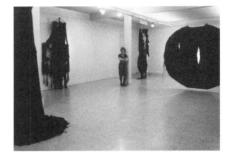
Barbara Kasten in *Dimension of Fiber*, CCAC, 1971

Whereas Albers and Guermonprez represented an older generation of weavers renowned for their complex bodies of two-dimensional work, Abakanowicz was part of a younger, more radical generation, a leading figure in the international studio fiber movement who pioneered fiber-based installation and off-loom, sculptural techniques. Having begun her formal studies as a painter at the Academy of Fine Art in Warsaw, Abakanowicz trained briefly as a weaver but disliked the rigidity of technique. Beginning in 1965, Abakanowicz created a highly influential series of three-dimensional woven structures known as *Abakans*. The term "Abakan" was coined by Polish critic Hanna Ptaszkowska in 1964 to invoke both the artist and her signature works.[9] Architectural in scale, Abakanowicz's constructions are characterized by their enormity and materiality: they comprise dense, coarse natural fibers such as flax, jute, horsehair, hemp, and found sisal rope, their texture and dimensionality amplified by the irregularity of the handspun and hand-dyed yarns.

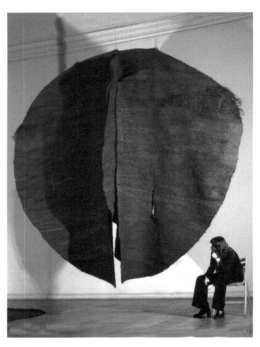
Magdalena Abakanowicz, *Red Abakan*, 1960

In 1971, just before she left for Poland, Kasten made her first seated form, a series that she continued to expand while abroad. Under Abakanowicz's influence, Kasten began working with heavy found rope dredged from the harbor in Gdańsk, unwinding it and dyeing it in an array of bright, primary colors: red, yellow, blue-green. The resulting series is provocative: off-loom weavings that manipulate a classic chair as a stand-in for the female body. The weavings themselves are built upon found chairs as the structure for a dimensional textile that reads as a foreshortened figure. One reviewer of the period described the works as "the body in the chair. Each woven form… spoofs an aspect of seated humanity."[10]

In *Seated Form (yellow)*, 1972 (pp. 168–69), canary yellow and chartreuse surfaces are woven into a bulbous cylindrical shape that resembles a neck, with a concave upper region, suggesting space for a head or a face. The neck slopes outward, toward the articulation of a fringed seam that borders the split into two distinct protrusions that angle upward, like bony collarbones, then descend again into soft breastlike pouches. The space between allows a peek at the chair's ribs, but in fact, it is a prominent hollow, like the pit of the neck, an erotic cleft known as the jugular notch, a depression at the top of the sternum where a woman's neck meets her chest. These bony projections stand aloft, held up by dainty chair legs that lean and brace slightly, as though they might sigh and shift their top-heaviness. In contrast, *Seated Form (red)*, 1972, engulfs its supporting structure. Red on red, one sliver of the chair's scarlet back peeks out from between the slight shoulders that round into a fully costumed surface. It is also a headless form, with undulating areas that mimic convex breasts and thighs and concave stomach.

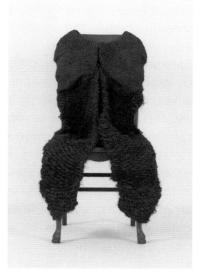

Barbara Kasten, *Seated Form (red)*, 1972

While there are only three known extant, Kasten made numerous *Seated Forms*. The series was first exhibited in 1972 at Galeria Rzerźby in Warsaw, in a show that Abakanowicz helped arrange. Eight chairs were installed in a circle, one without a corporeal garment. With their fibrous flesh, the chairs read as a circle of women, nearly like a consciousness-raising (C-R) group, a technique central to second-wave feminism that utilized the circle as an equal-power structure to verbalize the ways in which the private dimensions of women's lives could be used as a tool of social control and repression. But Kasten's *Seated Forms* are entirely mute: they are headless, limbless figures, bound to their chairs as captives—too "feminist" for either the Polish context or the fiber medium as it existed internationally.

While *Seated Forms* was an overt work about the female body, there would have been little precedent for its reception as a feminist work of art. As the Polish art historian Izabela Kowalczyk writes: "In the 1970s and even 1980s the Polish socio-political background was not favorable to feminism. The feminist art that appeared was influenced by Western feminist tendencies… that did not refer to issues rooted in Polish reality."[11] Such an observation wholly applies to Kasten: she was an American abroad on a fellowship, creating abstract sculpture that was not site-specific. Moreover, she was working under the auspices of Abakanowicz, whose own practice was humanist but not necessarily feminist. Abakanowicz's work is distinguished by its sensitivity to form and materials, as well as its psychological complexity in relation to the body. Kasten's work shares these concerns. The majority of artists connected to the studio fiber movement, Abakanowicz included, were wholly invested in seeing their practice achieve parity with modernist sculpture, which would, as art historian Elissa Auther writes, "release their work from the confines of fiber's historically subordinated position in the art world."[12] Arguably, then, Abakanowicz and her female peers were not interested in a feminist reading of their material concerns, as this would only further marginalize their practice.

Barbara Kasten in her exhibition *Fiber Sculpture*, Galeria Rzerźby, Warsaw, Poland, 1972

Yet the resemblance between Kasten and Abakanowicz's own body-based works is noteworthy: in 1973, Abakanowicz began working in

burlap, making casts of human backs that would be placed in rows, or scattered on the floor, held up with metal supports. As Kasten concurs, "I always felt my work influenced Abakanowicz's floor figures that she did right after that [era]."[13] The more senior artist even made a similarly named series, *Seated Figures*, 1974–79, in cast burlap and resin. Kasten's figures were seated in a circle; Abakanowicz worked in rows. But such a similarity between the two bodies of work, one made by a mature post-graduate student, the other by an established artist with an international reputation, demonstrates that influence does not conform to the hierarchies presupposed by traditional notions of student and teacher. The body itself is indeed one of the earliest forms of sculpture, but the way in which both artists, working in tandem for a brief time, brought sensuality and pathos to their respective renderings of the fibrous body is a fascinating and forgotten moment.

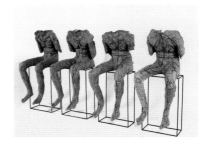

Magdalena Abakanowicz, *Four Seated Figures,* 1974–2002; burlap, resin, and iron rods; 53 ½ × 24 ¼ × 99 ¼ in. (135.9 × 61.6 × 252.1 cm); National Museum of Women in the Arts, Washington D.C.; Gift of the artist

Upon her return to the United States in 1973, Kasten exhibited the *Seated Forms* at the CCAC Gallery in Oakland, and then several other venues. She also set about expanding the series into photographic works on paper that translated elements from the sculptures into the space of a picture plane. Here, the woven form morphed into a nude female model, and the artist utilized the two-dimensional grid rather than the three-dimensional loom as a way of structuring space. Simply titled *Figure/Chair*, 1973 (pp. 166–67), the resulting works are diazotypes, a commercial product that results in a "blueline" developed by ammonia and exposed by UV light. A similar process is used to create architectural blueprints.

Playful and uninhibited, the works disrupt the traditional figure/ground arrangement: in one, a bare feminine back is hunched over, perched on top of a bentwood chair set in an outdoor landscape. A grid is superimposed over the image, and a faint blue square—the color of blank, exposed photo paper—hovers like a shadow. In another, three related photographs are arranged in a grid: a pair of buttocks is encased prominently in a chair with no seat—the seat becoming the seat—and then, reading the grid left to right, two small, intensely erotic images are hidden by two grids-within-grids: two nudes, one with closed legs, the other with splayed legs entangled in an open-backed chair, the body's orifices becoming openings-within-openings. *Torso*, 1974, is a familiar shape, albeit with a new process: cyanotype, another hand-coated emulsion process developed in water that creates a blue cast, turning blue positive to negative, then printed onto thick watercolor paper to enhance the haptic quality of the image. The female subject's narrow ribcage is cast in shadow, an irregular blue diagonal highlighted by daubs of silver paint.

Barbara Kasten, *Torso,* 1974

By this time Kasten already had some rudimentary training in running a darkroom. During the mid-1970s, she began to gravitate toward the fringes of photographic processes, experimenting with painterly techniques that resulted in an array of tactile effects: coating, tracing, layering, building thin coats of liquid emulsion as washes and stains, a way of injecting the medium with the delicacy of color and the spontaneity she had previously found in textile sculpture. Fiberglass also became a transitional material between the mediums, its fiber-like pliability allowing it to be molded into abstract shapes. Kasten hung these in her Los Angeles

studio and experimented with the way lighting could intensify the effects of the shape, improvising absence and presence by multiplying and distorting the object's configurations through the angle of its shadows. In 1974, Kasten showed a new series of screen wallpieces, in elliptical, geometric, and U-shapes, interspersed with photographic work at the Brand Library and Art Center in Glendale, California. These cyanotype prints, known as *Photogenic Painting*, 1974–77, became an ongoing series; they combined cyanotype with ink, paint, silkscreen, and other laborious early photo processes like Van Dyke, which produces a brown tint. Kasten was continuing to explore the illusionistic potential of photography as a painterly process. The momentum of the three-dimensional screen works — initially improvised as a teaching tool — proved a crucial moment in her artistic development, connecting the object and its fluid architecture to the displacements possible in image making.

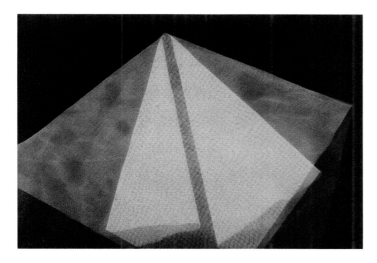

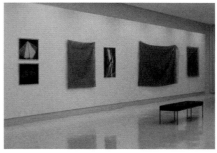

Left Barbara Kasten, *Photogenic Painting Untitled 74/13*, 1974

Above Barbara Kasten solo exhibition, Brand Library and Art Center, 1974

The "photogenic" is therefore ironically intended, as the attractive subject of each photo is the medium itself. Further, these works strongly resemble the organic textures found in textiles: they look like the wrinkles and deep creases found in taffeta silk, or casual linens, as though a sumptuous fabric was sampled or photographed up close. There is a three-dimensional effect, for instance, in *Photogenic Painting Untitled 75/21*, 1975 (pp. 158–59), as lush indigo folds radiate upward and outward, resembling a fabric with a dense pile, like velvet drapery. Kasten's photogenic surfaces are laboriously constructed and seem to hover, in places, between cloth and low-relief sculpture.

In Kasten's oeuvre, the 1970s was ripe for experimentation; the body-based works made in the first half of the decade ceded to more abstract expressions of texture and shape, sensuous formalist experiments with non-silver photographic processes. Kasten's work is distinguished by its rigorous and consistent investment in exploring the paradoxes of space and its material transformations. Her early works combining the effects of light with woven form became antecedents to mixed-media artists like Beverly Semmes, who have consistently used cloth as a template for metaphors of embodiment. Kasten's early interest in illusionism established a lifelong exploration of the contradictory nature of phenomenology: her two-dimensional work aggregates depth through texture, color, and the repetition of images, which often function as indexical traces of the body.

A decade later, in her mature photographic works, she inverted her approach, rendering three-dimensional objects and even architecture as flat, projecting colored lights onto hard-edged sculptural assemblages in the studio (*Construct* series, 1979–86) and onto buildings (*Architectural Site* series, 1986–90). While the rendering of the two-dimensional into the three- was, and remains, a requisite step for many emerging sculptors, it is the latter approach, fully manipulating the three-dimensional into appearing as a flat surface, that is an extraordinary contribution, causing an architectural photograph to appear as a painterly, nearly Futurist abstraction. This is a reversal of the phenomenological qualities executed historically in trompe l'oeil painting: a post-modern demotion, in effect, of optical illusion, a way of magnifying the distortions and limits of human perception.

The physical staging of form within Kasten's artworks—the incremental techniques that rely on an intensive layering process to build up densities, textures, and an ambient luminosity—is rooted in her work in fiber. As an artist shifting between flat and dimensional surfaces within the same frame, and between architectural and human scale within the studio, Kasten merges the nuances of painterly abstraction with the precise capture of color, light, and space made possible by photography. As a result, she has emerged in recent years as an important precedent for artists investigating opticality, architectural space, and the material conditions of photography, such as Eileen Quinlan, Liz Deschenes, and Walead Beshty. Kasten's career-long immersion in materiality can thus be seen as bilateral: continuously pointing forward, engaged in a sustained process of experimentation that prefigures the digital image, and simultaneously sourced back to her tactile beginnings.

1 Barbara Kasten, e-mail to the author, August 14, 2014.

2 Alex Klein, Interview with Leland Rice, August 14, 2014, unpublished notes.

3 See Finding Aid, "Guide to the Papers of Trude Guermonprez, 1947-1976," http://www.oac.cdlib.org/.

4 For an excellent analysis of *Wall Hangings*, see Elissa Auther, "Mildred Constantine and the Battle for Fiber Art," in *String, Felt, Thread: The Hierarchy of Art and Craft in American Art* (Minneapolis: University of Minnesota Press, 2009), 32-46.

5 Barbara J. Kasten, *Dimension of Fiber*, exh. cat. (1971), unpaginated. Barbara Kasten Papers, Chicago.

6 "Rope Art: A New Form Fit to Be Tied," *Life Magazine* 73, n. 22 (December 1, 1972): 86-90. Additionally, Kester and design curator Eudorah Moore of the Pasadena Art Museum organized

a weeklong symposium comprising panel discussions, lectures, and workshops by leading artists and designers. *Deliberate Entanglements* was also planned to coincide with other area fiber shows, including a solo show of Magdalena Abakanowicz at the Pasadena Art Museum in 1972.

7 Kasten, *Dimension of Fiber*.

8 Department of State Award Letter to Barbara Kasten, July 20, 1971. Barbara Kasten Archive, Chicago.

9 Jasia Reichardt, "Magdalena Abakanowicz," in *Magdalena Abakanowicz*, exh. cat. (Chicago: Abbeville Press and the Museum of Contemporary Art, Chicago, 1982), 46-47.

10 Marilyn Hagberg, "Fiber: Barbara Kasten," *Craft Horizons* (December 1973): 60.

11 Izabela Kowalczyk, "Feminist Art in Poland Today," *n.paradoxa: international feminist art journal* 11 (October 1999): 17. http://www.ktpress.co.uk/pdf/nparadoxaissue11_Izabela-Kowalczyk_12-18.pdf.

12 Elissa Auther, ibid, xxii .

13 Barbara Kasten, e-mail to the author, August 14, 2014.

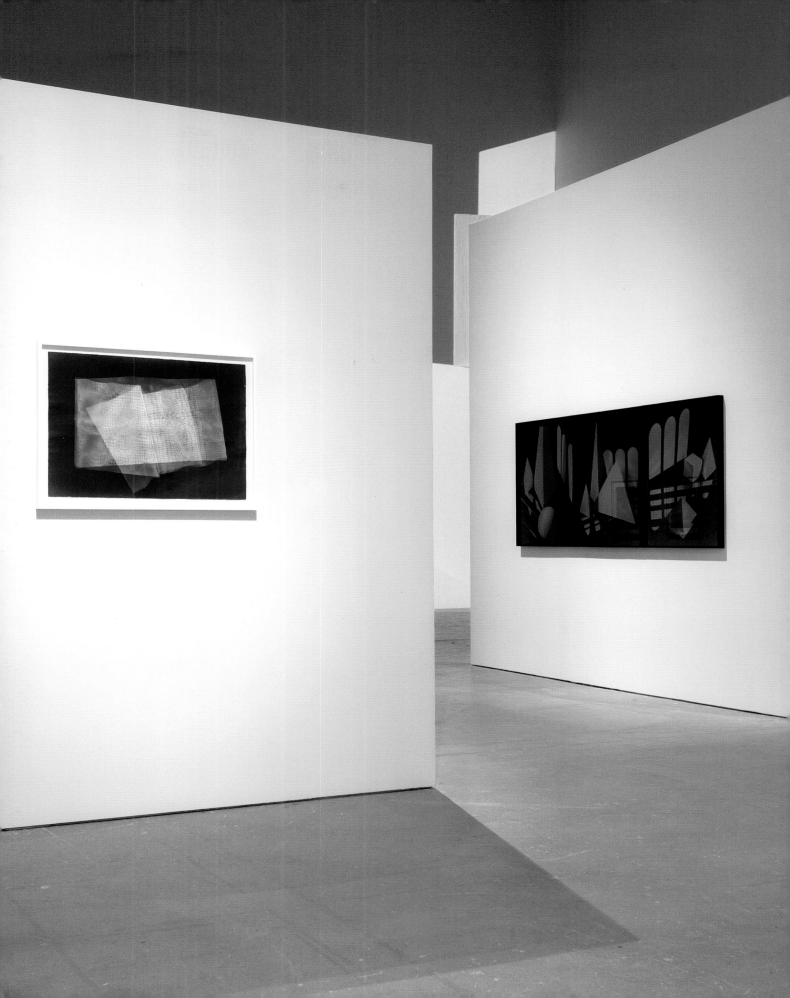

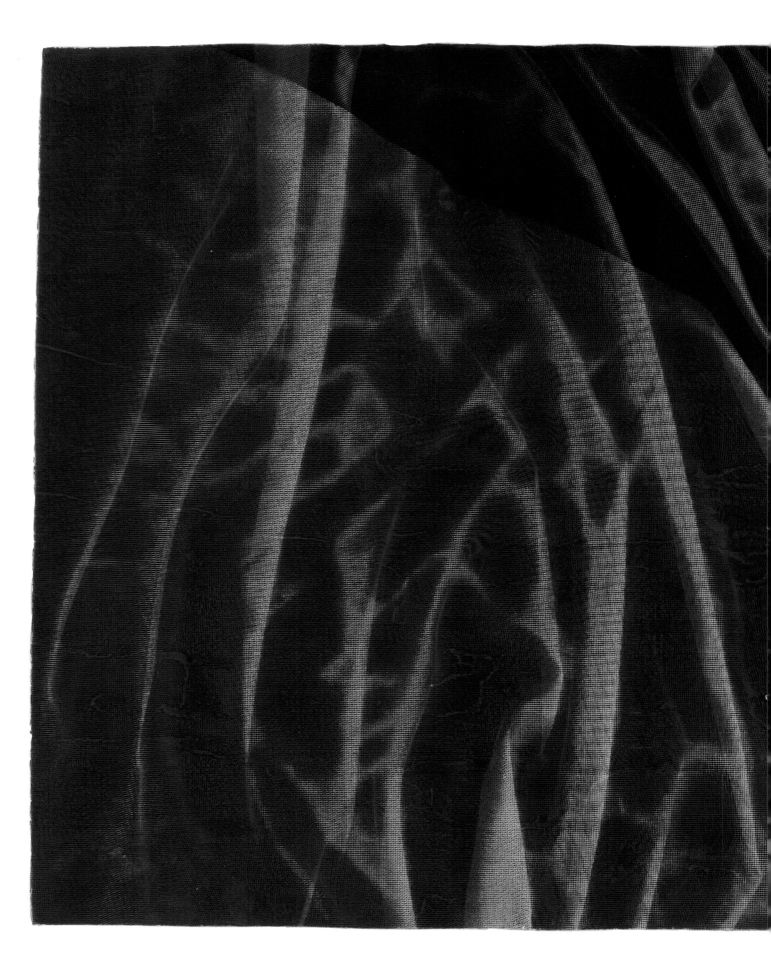

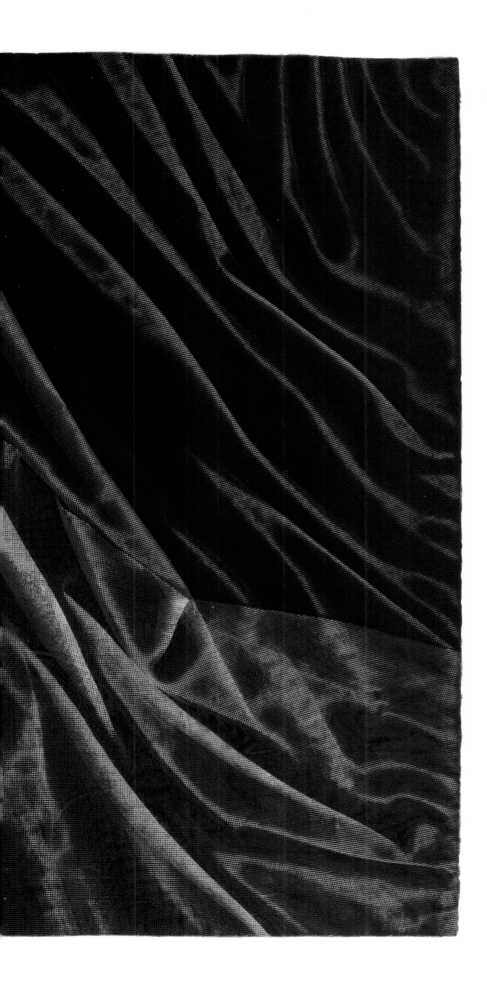

Photogenic Painting Untitled 75/21, 1975
Cyanotype (photogram) on BFK Rives paper
30 × 40 in. (76.2 × 101.6 cm)

Photogenic Painting Untitled 75/32, 1975
Cyanotype (photogram) on BFK Rives paper
30 × 40 in. (76.2 × 101.6 cm)

Photogenic Painting Untitled 75/11, 1975
Cyanotype (photogram) on BFK Rives paper
30 × 40 in. (76.2 × 101.6 cm)

162

Photogenic Painting Untitled 76/19, 1976
Cyanotype (photogram) with
Van Dyke and ink on BFK Rives paper
30 × 40 in. (76.2 × 101.6 cm)

Torso, 1974
Cyanotype with pencil and
silver paint on BFK Rives paper
30 × 22 in. (76.2 × 55.9 cm)

Figure/Chair, 1973
Diazotype on newsprint
22 × 17 in. (55.9 × 43.2 cm)

Figure/Chair, 1973
Diazotype on newsprint
22 × 17 in. (55.9 × 43.2 cm)

Figure/Chair, 1973
Diazotype on newsprint
17 × 22 in. (43.2 × 55.9 cm)

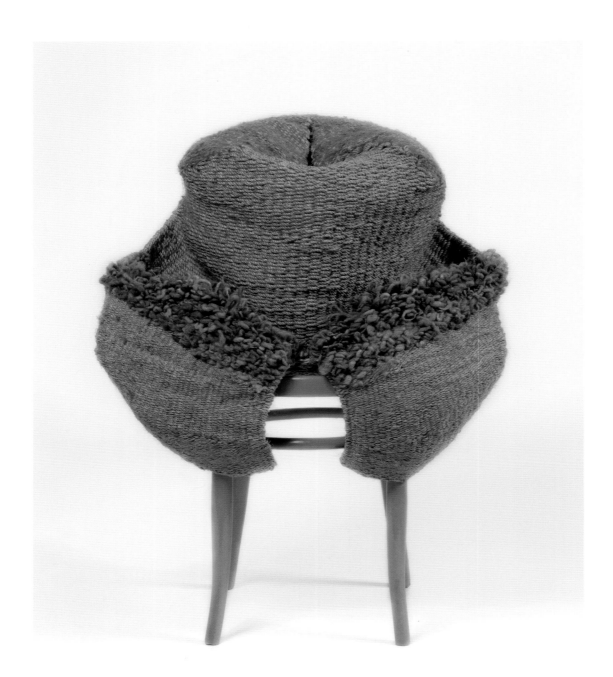

Seated Form (yellow), 1972
Handwoven sisal and Thonet chair
Approximately 35 × 28 × 28 in.
(88.9 × 71.1 × 71.1 cm)

Seated Form (green), 1972
Handwoven sisal and Thonet chair
Approximately 35 × 25 × 25 in.
(88.9 × 63.5 × 63.5 cm)

Seated Form (red), 1972
Handwoven sisal and wooden chair
Approximately 42 × 24 × 24 in.
(106.7 × 61 × 61 cm)

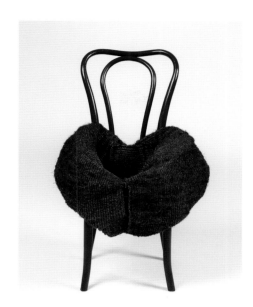

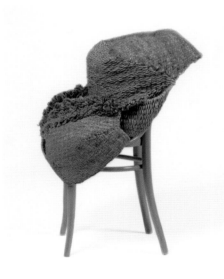

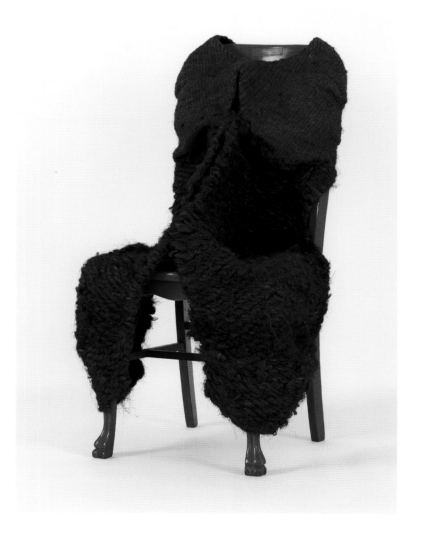

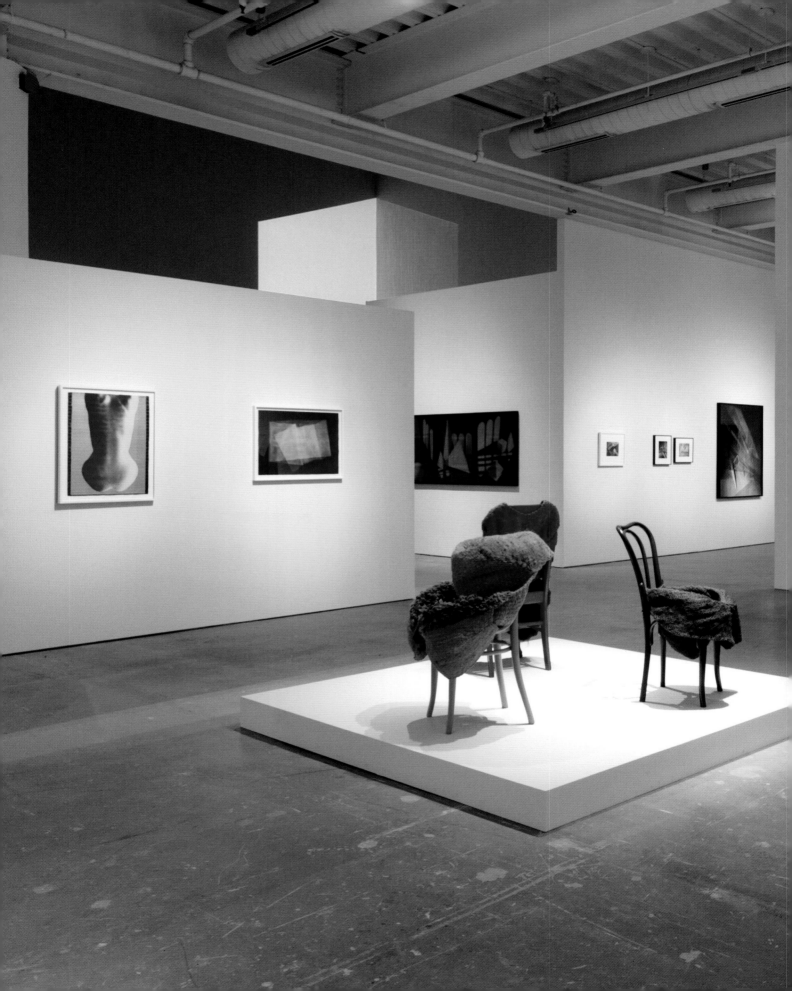

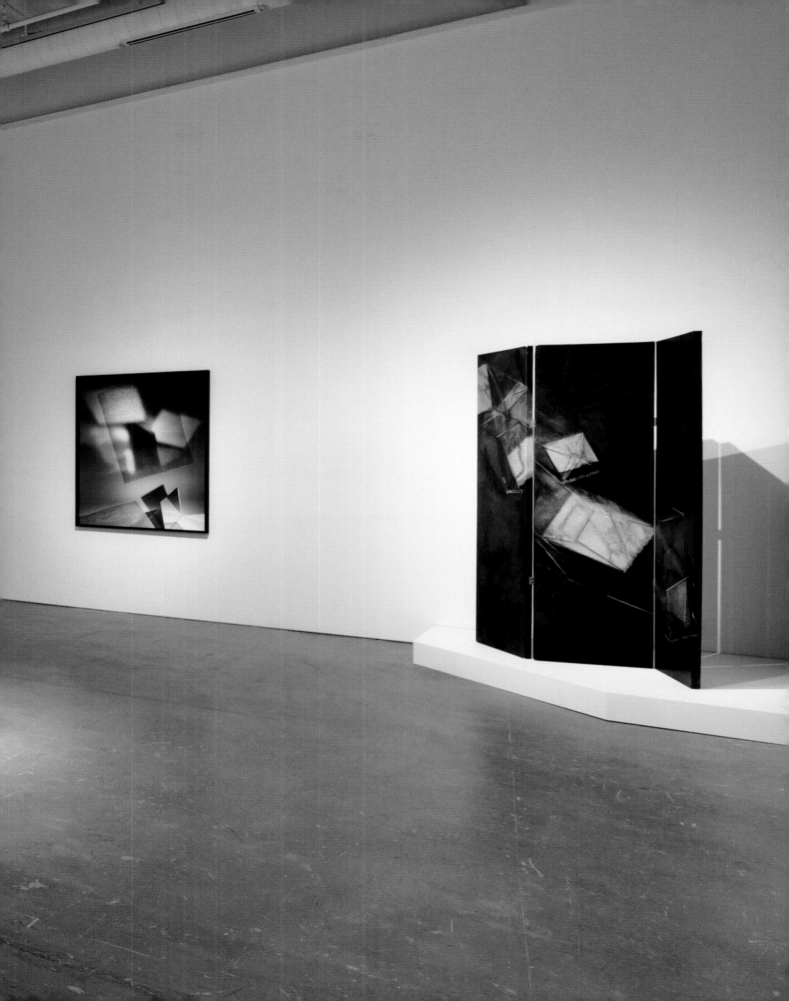

Barbara Kasten was born on June 29, 1936, in Chicago, Illinois, and grew up amid modern skyscrapers within a stone's throw of Moholy-Nagy's New Bauhaus. Raised in the Bridgeport section of the city by her father, a police officer, and her mother, a homemaker, Kasten and her older brother were brought up in a traditional, tight-knit, Catholic Lithuanian household. In 1954, her parents moved to Phoenix, Arizona, to aid her father's recuperation after he suffered an injury in the line of duty. Barbara soon followed, transferring from the University of Illinois (1954–55) to attend the University of Arizona in Tucson, where she pursued a degree in painting; she graduated with her BFA in 1959.[1] Over the next several years, Kasten searched for a career that would complement her interest in art. After a short stint working on layouts at an advertising firm, she headed to San Francisco with a group of friends and landed a job as a stylist and display dresser at the Union Square location of the department store H. Liebes & Co., where she "assisted in the creation and setup of props and display materials."[2] Although her time in the fashion industry would last only two years, it is noteworthy that even in the earliest moments of her working life, she was drawn to moving objects around behind a glass frame.

By 1964 Kasten had left the fashion world and worked briefly as a junior high school teacher, but she was eager for travel and new experiences. She successfully applied to be a recreation specialist and club director on U.S. Army bases in Europe, overseeing community centers and arts recreation in cities across Southeastern Germany, including Landshut, Munich, Neu-Ulm, and Ludwigsburg. Over the next two and half years, Kasten sought out works of art and architecture in person that until then she had seen only in books and slides. She recalls being particularly struck by the colors in German Expressionist painting and Kandinsky's canvases and by the radical architecture of Le Corbusier's Notre Dame du Haut in Ronchamp. At the time, she was still working as a painter, but a visit to an exhibition of American crafts made a distinct impression that prompted her to think seriously about shifting gears.[3]

In 1967 Kasten resigned her post, put aside her paint and canvases, and in search of a more direct means of building form and working with color, she apprenticed herself to a weaver in Scottsdale, Arizona. After acquiring the necessary skills and assembling a portfolio, she decided to pursue her MFA and headed back to Northern California, where the craft scene was undergoing a seismic shift from design to art, and from industry to independent production. This transformation was part and parcel of the general excitement, spirit of experimentation, and radical political climate of the Bay Area.[4] Kasten arrived at San Francisco State University in the fall of 1968, just in time for the turbulent student strike led by the Black Students Union and the Third World Liberation Front, which resulted in the suspension of classes and an effective lockdown of the campus. Now thirty-two, Kasten was anxious to move forward with her degree, so she applied for a scholarship to attend the California College of Arts and Crafts (CCAC) in nearby Oakland, where she heard that a Bauhaus-trained weaver, Trude Guermonprez, was running a new graduate program.[5] To her delight, Kasten was accepted into CCAC's program with financial support and began working with Guermonprez in early 1969. Concurrently, she applied for a job at the military base at the Presidio of San Francisco that required her to operate the "photography hobby shop," as it was called. Having never previously set foot in a darkroom, she enrolled in an introductory class at CCAC that was taught by a new young professor, Leland Rice. It was the only photography class she would ever take, but it would have a profound effect on both her artwork and her personal life.[6]

From Faktura to Photography

Trude Guermonprez was part of a wave of Bauhaus-influenced pedagogues who had a massive effect on arts education in the U.S. in the postwar years and has been credited as an important link between the European avant-garde and the formation of California Modernism.[7] Born in 1910 in Danzig, Germany (now Gdańsk, Poland), Guermonprez studied at the School of Fine and Applied Arts, Halle/Salle, often referred to as "the Little Bauhaus," as well as at the School of Textile Engineering, Berlin, with Bauhaus-trained textile student Benita Koch-Otte.[8] Following the tragedy of her husband's execution by the Nazis at the end of World War II, Guermonprez

Barbara Kasten c. 1965–66

1　Although the University of Arizona would eventually become the home of the Center for Creative Photography, at the time photography was not even part of the school's curriculum.

2　From an "Application for Federal Employment" written by Kasten in January 1968, found in the artist's archive.

3　Kasten recounts that she shipped her paintings back to the United States, but that they were lost in transit. No known work exists from this period.

4　Melissa Leventon observes, "The shift from design-craftsman to artist-craftsman took place statewide, but Northern California became a particularly important center for fiber art, in no small part because of the counterculture, with its do-it-yourself ethos, and because of artists and teachers like Guermonprez, Rossbach, and Westphal, whose work had already made the transition from modernism to fiber art." "Distinctly Californian: Modernism in Textiles and Fashion," in *Living in a Modern Way: California Design 1930–1965*, ed. Wendy Kaplan (Cambridge, Mass.: MIT Press, 2011), 244.

5　The graduate program in weaving at CCAC was formalized in 1967.

6　Kasten recounts that the only other photographic training she received was when she sat in on a short workshop conducted by Paul Caponigro that had been organized by Rice.

7　Leventon, "Distinctly Californian," 238.

8　The School of Fine and Applied Arts, Halle/Salle, was directed by former Bauhaus Master Gerhard Marcks, and it included former Bauhaus student Marguerite Wildenhain among its teachers. In her unpublished dissertation, T'ai Smith discusses Koch-Otte's instruction manual, with which Guermonprez would most likely have been familiar, in which "handweaving is used to create new alternatives—to locate functions specific to textiles that had previously been unthought. The instruction manual in effect raises the question for its students: How can the relationship between the fabric's 'look' and its use within architectural space be coordinated?" "Weaving Work at the Bauhaus: The Gender and Engendering of a Medium, 1919–1937" (unpublished dissertation, University of Rochester, 2006), 120.

relocated to the States in 1947 to join her parents, Heinrich and Johanna Jalowetz, at Black Mountain College, where they taught. Guermonprez's arrival coincided with Anni Albers's leave of absence from the school, and Albers invited her to head Black Mountain College's weaving area along with Franziska Mayer. In 1949 Guermonprez left for California with Marguerite Wildenhain to become one of the professors at the artists' colony Pond Farm, and in 1954 she became full-time faculty at CCAC. Like Albers, Guermonprez was interested in pictorial weaving, which incorporated painting into the weft and a greater nuance of color. While her teaching philosophy was rooted in the Bauhaus, she emphasized the importance of being responsive to contemporary art and design.[9] Her student Kay Sekimachi reminisced:

> She stressed the importance of understanding materials according to the origin of the fibers, and urged us to get to know and love materials by touching, seeing, listening, tasting and smelling them… We studied weaves and drafted tactile charts… She impressed upon us the importance of being flexible, of having an open mind, and not starting with preconceived ideas.[10]

This ethos of process and material experimentation would prove formative for Kasten's own practice.

Upon entering CCAC, Kasten had thought she was going to be making big painterly tapestries, but instead focused on making laborious three-dimensional sculptural forms.[11] She declared in her graduate statement:

> My aim is to create a woven object that perpetuates its own existence shaped by its content… I intend to bend and extend these limitations toward the greatest potentialities of developing shapes and creating relationships. The content and the technique become an integral and vital part of the form. By manipulation off and on the loom, weaving takes its form through its own inner necessity.[12]

This investigation of materials resulted in architectural-scale sculptural weavings that mimicked bodily contours and orifices; she also experimented with photo-silk-screening techniques. By this time Kasten's relationship with Rice had taken a romantic turn. As head of the photography program at CCAC, Rice was actively plugged into the scene around the Society for Photographic Education and the independent Bay Area-based Visual Dialogue Foundation, which included photographers such as Jack Welpott, Michael Bishop, Linda Connor, and Judy Dater. Although Kasten found her inspiration in painters such as Agnes Martin, Dorothea Rockburne, and Lynton Wells and sculptors such as John McCracken and Robert Irwin, her affiliation with Rice led to close friendships with figures such as Dater and the inclusion of her own photo-media experiments in the craft and photography exhibitions that abounded in the era.

Barbara Kasten, *Untitled*, 1969

Numerous artists on the West Coast were traversing the boundaries among craft, design, photography, and fine art. At the same time that Kasten was pursuing her fiber studies, she also participated in exhibitions such as *California Photographers* (1970), alongside artists including Lewis Baltz, Ellen Brooks, Robert Flick, Robert Heinecken, Anthony Hernandez, and Rice. The show traveled to three venues along the coast and featured Kasten's *Untitled*, 1969, a large, stuffed photo-silkscreen softly reminiscent of one of Carl Andre's floor pieces; it was displayed on a low plinth and depicts an inexact grid of what appear to be segments of breasts, swollen tummies, hands, and nipples. Simultaneously in New York, curator Peter C. Bunnell's better-known, and more focused, MoMA exhibition *Photography Into Sculpture*, with its bicoastal view, hybridization of media, and spatialization of darkroom experiments, prompted critic A. D. Coleman, writing in *The New York Times*, to observe that now straight photography was but one of many options within the medium.[13]

Although Coleman found excitement in the blurring of boundaries emblematized by these exhibitions, perhaps more acerbically, Hilton Kramer panned MoMA's show, also in *The New York Times*, for its seemingly bilateral approach, stating that it left "photography and sculpture pretty much where it found them — separate entities."[14] If the new hybrid objects did not fit comfortably within the traditional photography world, the craft scene embraced the potential opened up by the intermingling of mediums. For example, the 1971 exhibition *Photo-Media*, organized at the Museum of Contemporary Crafts in New York, placed Kasten's woven textile *Torso* alongside artists ranging from Heinecken and William Larson to Anthony McCall and Kenneth Josephson.[15] It was in this atmosphere of experimentation and interdisciplinarity that Kasten entered the art world.

9 See Bobbye Tigerman, "Fusing Old and New: Émigré Designers in California," in *Living in a Modern Way*, 96–98. For additional biographical information on Trude Guermonprez, see Mary Emma Harris, *The Arts at Black Mountain College* (Cambridge, Mass.: MIT Press, 1987).

10 Kay Sekimachi, in *The Tapestries of Trude Guermonprez*, exh. cat. (Oakland, Calif.: The Oakland Museum, 1982), 22.

11 Barbara Kasten, lecture at the Center for Creative Photography, Tucson, AZ, 1983.

12 Barbara Kasten, graduate statement, ca. 1970.

13 A. D. Coleman, "California Report: A Break with Tradition," *The New York Times* (July 5, 1970). Coleman notes that *California Photographers 1970* was one of some forty similar exhibitions on view in the Bay Area in the month of June alone, and argues that the diversity and scope of the work being produced meant that it was time for New Yorkers both to take notice and to differentiate this younger generation from the legacy of Edward Weston and Ansel Adams. "The West Coast was witnessing a resurgence of photographic activity, a renewal of energy so significant that even now, though it has not yet fully coalesced, its impact on the medium promises to be as strong as was that of the 'f/64' group several decades ago… In fact, California now rivals New York in terms of the importance of the work being done." See also Fred Parker, introduction to *California Photographers 1970*, exh. cat. (Davis, Calif.: UC Davis, 1970), 3.

14 Hilton Kramer, "Modern Museum Displays Photography as Sculpture," *The New York Times* (April 9, 1970).

15 See the brochure for the exhibition as well as Leland Rice's review, "Photo-Media, New York," *Artweek* vol. 2 no. 42 (December 4, 1971). In a 1983 talk at the Center for Creative Photography, Kasten mentions that although many of the artists in the exhibition would go on to become good friends, she did not know many of them at the time of the show.

Upon graduating, in December 1970, Kasten headed to Los Angeles to be a substitute teacher for Bernard Kester's fiber course at UCLA. Although through Rice she was quickly welcomed into a scene that included a who's-who of photography, Kasten saw herself as an artistic outsider whose interests lay more in sculptural form, process, and materiality.[16] As her MFA exhibition (held in March 1971), she organized *Dimension of Fiber* at the CCAC Gallery, which presented her own work alongside that of eight other artists who tackled the medium as a sculptural form. It was a curatorial gesture to contextualize her aspirational peers, including Magdalena Abakanowicz, Neda Al-Hilali, Francoise Grossen, Sheila Hicks, Peter & Ritzi Jacobi, Kay Sekimachi, and Claire Zeisler.[17] An installation photograph shows Kasten standing near her own work, a "walk-in" labia-like woven hanging piece entitled *Carcass*. Arms crossed, she leans against a column in the space, addressing the camera with a relaxed confidence. Alongside the other biomorphic and architectonic works, one of Abakanowicz's *Abakans*—enormous fiber sculptural hangings reminiscent of female anatomy—is visible in the foreground.

Well known in Europe, Abakanowicz's work had not been widely seen in the United States. Ultimately, Kasten's exhibition gave her an opportunity to connect with the Polish fiber artist, and in 1971 Kasten was awarded a Fulbright Hays Fellowship to spend the next year working with Abakanowicz at the Poznań Higher School of Fine Arts.[18] Although Kasten's mature work would ultimately take a different turn, her experience in Poland would prove formative, and the series that came out of the experience provides clues to some of the underlying concerns within her oeuvre. With only a modest command of the Polish language, Kasten set about producing a series of brightly colored chairs with woven appendages made from ropes she had sourced from the port town of Gdańsk (coincidentally the hometown of Guermonprez), going through a laborious process that involved unwinding them, washing them, and dyeing them by hand. The *Seated Forms* oscillated between utilitarian object and psychic subject, and between humor and provocation, while also providing Kasten with a sense of surrogate "friends." They were exhibited in her first major solo show in 1972, *Fiber Sculpture*, at the Galeria Rzerźby in Warsaw.[19]

At the conclusion of her Fulbright, Kasten returned to Los Angeles and Rice; they married in 1972. The following year she debuted her *Seated Forms* in the U.S. in a solo exhibition at the CCAC Gallery. In this iteration, Kasten staged a mise-en-scène in which the chairs formed a procession on Astroturf that would seem to mimic the photographs she had taken of her chairs arranged on grass in Poznań. Kasten also

added a new element to the installation: a complementary photographic body of work. Mimicking and emphasizing the abject anatomies of her *Seated Forms*, Kasten enlisted a female student to pose for photographs in which the model appears naked and truncated, splayed and twisted on a chair, sometimes overlaid with clouds and proportioned by a grid. These prints, produced using a diazotype, similar to an architectural blueprint, not only presaged her interest in the mediated body but underscored her core concern for the relation between two-and three-dimensional form. The show met with a positive reception in *Artweek*, which lauded the way in which each woven form "superbly summarize[s] or satirize[s] an aspect of seated anatomy from spraddled legs and oversize, bulbous buttocks to a supremely sensuous, elegantly relaxed torso. Kasten's works are consistently warm, vibrant and intense."[20] When the prints appeared in a two-person show with Rice in 1974, another reviewer commented, "Due to the high degree of abstraction, the photographs are perhaps even more ambiguous than the sculptural pieces."[21] The chairs, diazotypes,

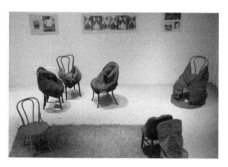

Barbara Kasten, solo exhibition at CCAC, 1973

Barbara Kasten, *Figure/Chair*, 1973

and stuffed photo works continued to be exhibited throughout the early to mid-1970s in shows reflective of the era, such as the all-women exhibitions *Super Cream* (1973) and *Heavy-Light* (1974), and also in fiber exhibitions such as *Fiber Works* (1973), and they were presented in publications such as Dona Z. Meilach's compendium *Soft Sculpture and Other Soft Art Forms with Stuffed Fabrics, Fibers and Plastics* (1974), which featured works by artists

16 "I was intrigued by the process, the idea of photography, not the technique of making a photograph with a camera. I liked the recording possibilities of the material and how I could use it in textiles. That always seems to be where my interest comes from: what's the essence of this material and what can I make it do for me. I just treated it as another one of those possibilities." Barbara Kasten, interview by the UCR California Museum of Photography, March 22, 1982. Refer to https://player.fm/series/ucr-california-museum-of-photography/ucrcmp-podcasts-collections-series-barbara-kasten.

17 It is worth noting that *Dimension of Fiber* preceded the better-known exhibition *Deliberate Entanglements*, organized by Bernard Kester (UCLA), and the accompanying symposia organized by Kester and Eudora Moore (California Design Office of the Pasadena Art Museum), *Fiber as Medium*. In her introduction to her exhibition catalogue, Kasten writes that the goal was to assemble "textile constructions by nine artists who share some of the same concerns as their contemporaries in sculpture... Nothing is hidden. The entirety of the work is exposed presenting its possible dichotomies of inside/outside, surface/interior, hanging/resting. This provokes simultaneous experiences of elements ordinarily perceived separately... As the size of the work increases, the spectator's responsibilities are increased proportionately. With the ability to experience the work from all angles and to sense himself within its physical orbit, the observer assumes the role of participant. He is forced to dismiss the dogmatic image of weaving in order to conceive the concrete reality of the textile object."

18 The Fulbright ran from September 24, 1971, to October 1, 1972.

19 Kasten recounted, "When I was in Poland I found that there were lots of reasons I turned to this form. I was interested in human form; I was interested in it in conjunction with an object like a chair, a utilitarian object, and also it was small enough so that I could actually maybe get them back to the U.S. after I had spent this year making them in Poland. And they served as my surrogate friends while I was in Poland." Barbara Kasten, CCP lecture, 1983.

20 Marilyn Hagberg, "Barbara Kasten's Seated Forms," *Artweek* vol. 4 no. 31 (September 22, 1973): 16.

21 Melinda T. Wortz, *Artweek* (March 23, 1974): 3. Wortz also remarked on the overt sexuality of the work: "Kasten's woven fiber sculptures are large, bulky, and essentially sexual. In a tableau of two painted wooden chairs, each occupied with a fiber presence, the woven forms suggest very large-scale sexual organs— female genitals and a uterus. In the former sculpture the form is full. In the latter, a green basket-like form waits like an empty receptacle. Other woven pieces are distinctly phallic... Because Kasten's work has a strong emotional quality, the terms 'empty' and 'full' seem more descriptive of the feelings suggested by the work than the more formalist terminology of positive and negative space."

from Robert Morris and Claes Oldenburg to Abakanowicz as well as woven body ornaments. Perhaps it was seeing her work in these various contexts that led Kasten to realize that her interest lay in the relationship between physical material and its optical representation rather than in the process of weaving.[22]

Francis Bruguière, cut paper abstraction, c. 1927; toned gelatin silver print; 9 ¼ × 7 5/16 in. (23.5 × 18.6 cm); The J. Paul Getty Museum, Los Angeles

As an alternative, she began to experiment with the fiberglass screening she had been using as a demonstration tool to teach her students at UCLA how to construct three-dimensional sculptures. Attracted by the particular properties of the material, she began producing simple, folded, and melted forms that played with moiré patterns, shadows, and light that were enhanced by their placement on the wall. By this point Kasten had definitively left the fiber milieu behind and was consciously thinking about her work in relation to the emerging practices of artists including Irwin, De Wain Valentine, Craig Kauffman, and James Turrell. Turrell in particular was on Kasten's radar through a 1973 history of photography exhibition that he had co-curated as a graduate student with Rice, who was then teaching at Pomona. For Kasten these Light and Space artists, with their experiments in plastics and other materials associated with the "finish fetish" look and their invitations to viewers to engage in a perceptual form of participation, symbolized the ethos of the Southern California art world with which she saw herself in dialogue. Simultaneously, Kasten and Rice had begun to amass a collection of photography that included avant-garde figures such as Francis Bruguière, Man Ray, and Xanti Schawinsky, whose manipulated photographs resonated with the interests of the contemporary photography scene.

Inspired by these historical works and contemporary artists, Kasten realized that she could further push the optical and painterly properties of her sculptures by committing their effects to paper. Working in the outdoor area of her Inglewood live-work space, she laid fiberglass molds down on large sheets that she had coated with cyanotype chemicals. She reminisced in a 1983 talk, "It was natural for me to be out in the sunshine. I don't like darkrooms, and I was still working with the materials,

I was still folding it, I was still touching it, I was laying it down on top of the paper, and there was a direct contact with it."[23] What resulted were the first of her *Photogenic Paintings*, a beautiful series of cyanotype prints in which her folded screens shift fluidly between foreground and background and among shadow, impression, and mark. In a 1974 exhibition at the Brand Library and Art Center, Kasten paired these prints with her draped and folded fiberglass wall sculptures; the juxtaposition gestured to her textile background while advancing her minimal forms via translucent luminous effects that required another way of viewing altogether.

As Kasten worked through the material, manipulating her forms and performing, in a sense, on top of the emulsion-coated paper, the results fused the ambition of her multidimensional fiber sculptures with the planar field of the photographic image at an ever-greater architectural scale. For a 1975 exhibition at Scripps College, *Gallery as Studio*, in which eight artists were invited to treat the gallery as a space of production, making works on site while students and visitors watched, Kasten created a giant cyanotype mural of "hand-formed abrasions and marks" whose scale was determined by the walls of the space. In the catalogue accompanying the exhibition, the gallery's associate director Ann LeVeque observed:

> Kasten is especially conscious of the similarity of her work to painting. She talks like a painter and is concerned with the formalist ideology of painters, with considerations of composition, boundary, surface, rhythm and texture. The images she uses are recognizable as rock or fiber but they serve as abstract elements of line and form in her "photogenic paintings." The work functions on another level beyond its abstract formal beauty. The photo images have a startling three-dimensionality which gives the work an intriguing, haunting presence.[24]

The oscillation between depiction and abstraction, the real and the representational, mark-making and image-making, optical and tactile effects, foreground and background, and architectural space and pictorial flatness continues to preoccupy Kasten. Indeed she described her work as a "magical confusion of reality."[25]

By the mid-1970s Kasten had perfected her *Photogenic Paintings*, producing a stunning series of 30 × 40" cyanotypes, scaled like medium-size paintings, in various shades of blue, white, and brown, in which the paper's surface seems to undulate and ripple as if one were looking at a mass of drapery. The material and optical complexity of Kasten's work was growing as Rice was embarking on a major exhibition project, with artist William Larson, on the photographs of

Barbara Kasten c. 1972
Photo: Judy Dater

22 "One other thing I discovered while I was in Poland is that I didn't like to weave. It was too time consuming, it was too hard, I was ruining my hands. It was all those real practical reasons for not wanting to do that. And also I was making sketches like crazy and I had a million ideas and weaving is a very slow process and so there wasn't any way that I could accomplish everything very quickly." Barbara Kasten, CCP lecture, 1983.

23 Ibid.

24 Ann LeVeque, *The Gallery as Studio* (Claremont, Calif.: Galleries of Claremont Colleges, 1975).

25 Ibid.

László Moholy-Nagy.[26] Rice had first been introduced to Larson's extensive collection of Moholy-Nagy's photographs in Philadelphia in 1973, and in 1974, after Rice finished teaching a summer session at Penland School of Arts and Crafts, where Kasten had accompanied him, they set off on a road trip to pick up over seventy photographs. Encountering the contrasty geometric abstract photograms and material exploration of works such as *Diagram of Forces*, 1920, for which Moholy-Nagy crumpled up a piece of light-sensitive paper and exposed it back on itself, was revelatory. From Kasten's earliest artist statements, she expressed a commitment to a kind of self-referential form-making that could be both perceived and experienced, and with the work of Moholy-Nagy and other artists from the early-twentieth-century avant-gardes, she discovered a new pathway that could help her escape the bounds of representation and express a painterly sensibility without oils and acrylics. On their drive back across the country, Kasten and Rice made a stopover in Chicago to visit Henry Holmes Smith, who had been recruited in 1937 to teach photography at the New Bauhaus, a school founded by Moholy-Nagy in Chicago and which based its curricular model on the original Bauhaus (now known as the IIT Institute of Design at the Illinois Institute of Technology). Kasten and Smith traded works, and one imagines that in Smith's essay for the Moholy-Nagy catalogue, it was with Kasten and her contemporaries in mind that he called upon a younger generation to pick up the revolutionary mantle of what he deemed an unfinished project.[27]

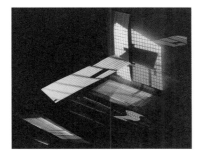

Henry Holmes Smith, *Untitled*, 1951

Diagram of Forces
Taking cues from Moholy-Nagy and from the painters she admired, between 1976 and 1977 Kasten began to apply washes of pastel-hued ink over her screen impressions. Her delicate works became more forceful as she began handling her cyanotype prints more assertively: crumpling her exposures, relishing the material traces of rips and tears, and eventually making diagrammatic drawings on the paper's surface and on large-scale photo-canvas works. In a review of curator Melinda Wortz's 1978 exhibition *Interchange*, which considered contemporary artists working in a hybridized space between photography and painting, artist James Welling wrote, "Kasten's compositional elements

and somber tonalities evoke the incongruous sensations of curtains and lace and Duchampian futurist machines and devices."[28] Indeed Welling's formulation perfectly sums up the tension between her sensuous materials and analytical rigor.

László Moholy-Nagy, *Diagram of Forces,* 1938–43; gelatin silver print, photogram; 7 15/16 × 9 15/16 in. (20.2 × 25.2 cm); The Museum of Fine Arts, Houston, Museum purchase funded by the S. I. Morris Photography Endowment.

Although the representation of the body, specifically the female body, had clearly preoccupied Kasten in her earlier works, she was becoming increasingly conscious of not wanting to be labeled a "woman artist." Instead of a representation of the body, she now turned to a bodily relationship to her materials:

I made a change from using a more lyrical sort of form to trying to really get in tune with the things I was looking at and what I was being affected by. I wanted to try it myself in other words. So I would use glass bricks and I would do these exposures, there was still the screening material there, but by now I was ripping and tearing it and doing all sorts of things to it so it was no longer the beautiful material, it had some abrasion to it, it had some deformities to it and I liked that. It was in and out of focus because the paper was crumpled and I was able to just draw on top of the print after it was processed.[29]

Of course, the notion of "process" here takes on metaphorical significance given the lineage of Kasten's investigations, both in terms of the alchemical transformation that takes place in photography and the physical act of working through a concept. For Kasten, who found herself at the intersection of several mediums and artistic milieus, the Bauhaus's investment in interdisciplinarity, its dissolution of the boundary between craft and art, its mysticism amidst a systemized grid logic, and a philosophy rooted in what Josef Albers deemed "contact with material," proved foundational.[30]

Thus, in tandem with the large-scale paintings on photosensitized canvas that emblematized Kasten's work from the late 1970s, she made a seemingly unexpected decision: she headed into the darkroom for the first time since her days working at the Presidio. The result was

26 *Photographs of Moholy-Nagy from the Collection of William Larson* was the first major exhibition in the U.S. to bring together a significant number of photographs by Moholy-Nagy and consider him from the perspective of a photographer. The exhibition opened in spring 1975 at the Galleries of Claremont Colleges and traveled through 1979 to more than twenty venues. Larson came into his collection through Moholy-Nagy's former printer, Helmut Francke, who had rescued the photographs from the trash. For a detailed account see Leland D. Rice, "Picturing László Moholy-Nagy: The Anatomy of an Exhibition," in *Photograms by László Moholy-Nagy from the Collection of Eugene and Dorothy Prakapas* (New York: Sotheby's, 2005), 14–17. Also recounted in separate interviews conducted by the author with William Larson, Barbara Kasten, and Leland Rice.

27 William Larson notes that after the extensive tour of the exhibition, he noticed a ripple effect. He reminisced, "The general mood at the time was that it was there for the taking because there wasn't the formal pressure that you would encounter with the conservative side of things. It was wild and it felt unconstrained about what you could do." Interview conducted by the author, March 13, 2014.

28 James Welling, "Working Between Photography and Painting," *Artweek* (February 4, 1978). It is important to note that Kasten was not alone in this manner of working. Alternative processes and photogram experiments were also being conducted around the same time by artists such as Sheila Pinkel.

29 Barbara Kasten, CCP lecture, 1983. Also refer to the recording of Kasten's 1982 UCR interview, in which she recounts how she was thinking about not just Moholy-Nagy but also the Russian avant-garde and Rayonism. She states that the hard edge of these works was a way for her to push against a perception of her work as "feminine."

30 Scholars such as Leah Dickerman and Michael W. Jennings have noted that for Bauhaus artists photograms offered a mode of production, as opposed to reproduction, and were employed as a record of action, process, and "physical contact." See Barry Bergdoll and Leah Dickerman, *Bauhaus 1919–1933: Workshops for Modernity* (New York: Museum of Modern Art, 2009).

a series of large gelatin silver prints she dubbed *Amalgams*: solarized prints from negatives of simple setups that depicted her screening materials now combined with geometric Plexiglas forms that cast patterned shadows. Using the enlarger, she further abstracted her black-and-white prints by placing clear acrylic cubes on top of her exposures to create an additional photogram layer, as seen, for example, in *Amalgam (Untitled 16)*, 1979. In some works she added yet a third layer of diagrammatic drawings in paintstick, as seen in A*malgam (Untitled 4)*, 1979.[31] The luminous shapes and applied lines created a sense of movement and an optical confusion with regard to both how to look at them and how they were made.

Ultimately, as if to clarify this gesture, Kasten took a step back: in *Amalgam (Untitled 34)*, 1979, she lifted the curtain to reveal her setup in the studio. Here, for the first time, her screens and cubes are made recognizable as objects that give way to shadows from the light source just out of the frame. Meanwhile, the legs of the light stand are clearly seen behind the configuration, as if they were a part of the installation. But perhaps most tellingly, a socket is visible in the far left corner with a plug attached to a cord trailing up the wall. At once the viewer is made aware that Kasten could unplug her light and extinguish the illusion at any time. It is fitting that this picture, along with *Amalgam (Untitled 35)*, 1979, with its overt acknowledgement of the artifice of image-making itself, would be the last in the *Amalgam* series; it presaged her next body of work, which would come to define her career.

In the *Construct* series, having definitively returned to the space of the studio, Kasten simultaneously described her sculptural forms and emphasized her physical role in their construction.[32] Of course, "construct" — like "amalgam," an economic and multivalent word — had the advantage of pointing to Constructivism, the historical avant-garde that had greatly inspired her, while resonating with the kind of deconstructive questions around the photographic image that would come to be most closely associated with the younger group of artists working on the opposite coast, often referred to as the Pictures Generation.[33] At once Kasten's title leads in linguistic circles: does she want us to privilege her sculptural actions, or to acknowledge that a photograph is, after all, not a reflection of reality, but smoke and mirrors?

Role Models

Kasten had been teaching classes on alternative processes in the photography program at Orange Coast College since 1975. The school was a hotbed of photographic pedagogy under the leadership of photographer and historian John Upton, who attracted a stellar roster

of up-and-coming adjunct faculty such as Lewis Baltz, Martha Rosler, and Allan Sekula, and renowned lecturers such as Garry Winogrand, Sam Wagstaff, and Barbara Morgan.[34] Working with students in the classroom, Kasten became increasingly troubled by the lack of information available about the contributions made by female photographers. With the realization that many of these artists were still living, in 1979 she applied to the NEA for a grant to interview figures ranging from Berenice Abbott to Lucia Moholy. The resulting short documentary, *High Heels and Ground Glass* (which ultimately included Louise Dahl-Wolfe, Gisele Freund, Lisette Model, Eiko Yamazawa, and Maureen Loomis), took Kasten and the art historian Deborah Irmas ten years to produce. Early on, the project afforded Kasten the opportunity to meet Florence Henri, a figure who had taken on a growing importance for her.[35] Upon receiving the grant in 1980, Kasten flew to Paris to meet Henri, who by this time was ill and confined to a hospital bed. Henri's photographs represented an artist within the Bauhaus milieu for whom formal exploration was rooted more within a tradition of "art-for-art's sake" than a remapping of the social order.[36] As Rosalind Krauss observed, Henri's abstractions with mirrors and balls reflected back on the position of the woman artist within a male optical field and emphasized the role of the camera as a tool of mediation and selection.[37] For Kasten, Henri thus provided both a direct link to the Bauhaus and an independent female role model.[38]

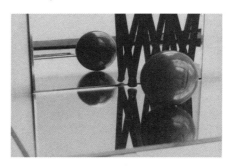

Florence Henri, *Composition No. 76*, 1928; gelatin silver print; 10 ½ × 14 ⅝ in. (26.7 × 37.1 cm); John Parkinson III Fund; The Museum of Modern Art, New York, NY

There is a wonderful synergy between Kasten's and Henri's work and attitudes. In *Construct I-A* from 1979, Kasten redeploys some of her familiar materials, many sourced from the hardware store, to newly theatrical and disorienting effects, in the artificial and controlled space of the studio. She threaded thin metal wires through tiny eyelets and stretched them between black wooden rods she had fashioned together. The space is dissected by the rods and wires, which look like etched lines, while angular shadows are cast in the background. In the upper-right corner sits one of Kasten's clear cubes, in front of which is a square mirror that creates a luminous node. The mirror in turn reflects the wires and rods, allowing the lines to continue

31 "These new works are a continuation of my intrigue with and use of the photogram. Influenced by Moholy-Nagy and other early innovators of light modulators and camera-less images, I have created temporary constructions to be photographed and combined with photograms. The potentialities of this combination are further extended by the addition of geometric, diagrammatic painted shapes and lines. The play between painted surface and photographic illusion has always been an important issue in my work." Barbara Kasten, statement in *Nine Contemporary Photographers* (New York: Witkin Gallery, Inc.).

32 The *Constructs* are often titled according to where they were made. For example, PC = Polaroid Corporation; LB = Long Beach; NYC = New York; while no initials usually indicate that the photographs were produced in Kasten's studio in Los Angeles.

33 See Douglas Eklund, in *The Pictures Generation, 1974–1984* (New York: Metropolitan Museum of Art; and New Haven: Yale University Press, 2009).

34 John Upton recalls that according to a survey conducted by Kodak in the 1970s, Orange Coast College had the largest photography program in a public institution in the U.S. John Upton, interview by the author, August 13, 2014.

35 Barbara Kasten and Deborah Irmas, interview by the author, conducted on October 24, 2013. Upon its completion, the video was subsequently screened at the International Center of Photography in New York, and the film remains available for distribution. The raw footage from the project is housed in the collection at the Center for Creative Photography, Tuscon, Arizona.

36 "Her aesthetic was a hybrid between the School of Paris idea of art for art's sake and the Bauhaus concept of pictorial research that encouraged the examination of form, process, and material." Diana C. Du Pont, *Florence Henri: Artist-Photographer of the Avant-Garde* (San Francisco: San Francisco Museum of Modern Art, 1990), 11.

37 Rosalind Krauss, "Jump over the Bauhaus" (review of *Avant-Garde Photography in Germany 1919–1939*, Van Deren Coke and Ute Eskildsen's exhibition at the San Francisco Museum of Modern Art and the accompanying publication), *October* vol. 15 (Winter 1980): 102–10.

38 See Kasten's tribute to Henri in Barbara Kasten, "Women in Photography," *Exposure 19:3* (Evanston, IL.: Society for Photographic Education, 1981), 31.

deeper into the scene. Meanwhile, a hint of red peeks through the otherwise muted palette, and another mirror laid on the ground provides a glimpse of the ceiling. This inclusion of the studio architecture within this early image cannot be over-emphasized. Providing a rupture within her otherwise self-contained, labyrinthian model, the inclusion of the ceiling reminds a viewer that the artist and the architecture are always just outside the frame. This refracted view of real and imagined space would come to be emblematic of Kasten's mature work.

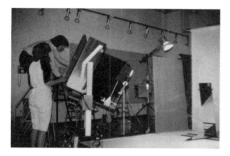

Kasten and Reuter in the 20 × 24" Polaroid studio, 1982

Kasten's new engagement with space was made possible by Polaroid's instant film and enabled by the generosity of the Polaroid Artist Support Program.[39] Essential to the Polaroid mission was its relationship with artists, whom it supplied with copious amounts of film and equipment; the artists in turn provided Polaroid with invaluable technical feedback and works of art for their growing collection.[40] Initially it was Rice who was the beneficiary, but the camera did not gel with the kind of photographs he was making at the time, so he gave it to Kasten, who had never worked with a large-format camera before and began to experiment voraciously. It may be difficult to look back from this era of digital instantaneity and grasp the exciting, indeed revolutionary avenues that the Polaroid medium opened up for artists. For Kasten, Polaroid's lush color, the print's uniqueness as an object, its distinct material surface, and the immediacy of its results ended her quest for a way to effectively fuse painterly, sculptural, and conceptual concerns.[41]

Chromophilia
The impact of Polaroid on Kasten's work was immediate and thorough. Her images took on a more sophisticated syntax as she moved her life-size props around in her studio to create new vantage points and illusionistic effects incorporating moiré patterning, light, shadow, and color. For Kasten, color had always been a primary interest, but here it begins to burst through backlit scrims, peek around corners, seep out from slivers of mirror, and pop out of the frame as the artist activated her otherwise minimal palette with accents and bright hues.[42] As art historian Kevin Moore suggests, even as Kasten adopted a seemingly modernist language, it is precisely through her use of color and form that she

was able to complicate the veracity of the picture.[43] However, when Kasten debuted her *Constructs* in New York, in June 1980 at Robert Freidus Gallery, the reviewers in the *Village Voice* and *Soho News* framed her photographs with another set of reference points, seeing them as indebted to the campy setups of Paul Outerbridge and the au courant aesthetics of "High-Tech" architecture and design.

This reading of the work also stemmed from Kasten's particular employment of photographic abstraction within the New York art world. Critic Andy Grundberg remarked, "Her sleight of hand is neat and accomplished, but one longs for something recognizable to hang on to."[44] Just three years prior, Jan Groover's color photographs of formal arrangements of utensils, *Kitchen Still Lifes*, had made a decisive splash at Sonnabend Gallery, fitting neatly into feminist critiques while simultaneously paying homage to Edward Weston. The following year, in 1981, James Welling's intimate and compellingly opaque photographs of foil would be exhibited at Metro Pictures, tapping into the debates within the art community about representation. Thus, if Kasten's positive, albeit initially cool, reception was perhaps a partial result of her investment in abstraction, it also was a result of her association with the photography scene in California. Just a few months later, Grundberg, along with *Modern Photographer* editor Julia Scully, would feature Kasten, who was described as "part sculptor, part painter and part photographer," alongside other artists from the West Coast, such as John Divola and Jo Ann Callis, extolling them as indicative of a new and exciting color photography milieu.[45]

By 1981 color had taken center stage in Kasten's Constructivist-inspired Polaroids, their palette becoming bolder and more closely associated with the postmodern aesthetics of the moment. Furthermore, the formal and technical potential in Kasten's narrow yet deep investigation of industrial materials grew exponentially when she became one of the select artists invited by Polaroid to work in their mammoth 20 × 24" format, using a camera operated in Cambridge, Massachusetts, by the photographer John Reuter.[46] As Reuter focused the camera on the scene and helped with complicated lighting, Kasten found a new freedom working in a directorial mode. Concentrating on arranging her objects in space and shaping the mood of her frames, she was also able to express more complex color than she had imagined in her preparatory sketches. While these early large Polaroids still relied on color scrims and backdrops, within the year, and with Reuter's expertise, she was able to build individual layers of color within each image using gels and multiple strobes that would be popped at different intervals within a single exposure. When she returned to her studio in California she

39 For an overview of the history of Polaroid's relationship with artists, see Mary-Kay Lombino, *The Polaroid Years: Instant Photography and Experimentation* (Poughkeepsie, N.Y.: Vassar College; and Munich: Prestel Verlag, 2013).

40 With the bankruptcy of Polaroid, its important collection of artists' experiments was dispersed. Many of Kasten's Polaroid works from these years are now housed in the WestLicht Collection in Vienna.

41 Barbara Kasten, interview by Constance Glenn, 1981.

42 In 1980 debates about the merits of color photography were still alive, even as its use was prevalent among artists. For an in-depth discussion of the history of color photography in the U.S. and how Kasten contributed to this landscape, see Katherine A. Bussard and Lisa Hostetler, *Color Rush: American Color Photography from Stieglitz to Sherman* (New York: Aperture), 2013; and Kevin Moore, *Starburst: Color Photography in America 1970–1980* (Ostfildern: Hatje Cantz, 2010).

43 Moore writes, "This deconstruction of photographic vision as practiced by Groover, Kásten, and Divola, in which the medium of photography itself became part of the content of the image, hinged on the transparency of the color photographic image and assumptions about the act of seeing based on conditioning by the medium… If artists were questioning assumptions of representation during the late 1970s, aided by the color photograph's resemblance to and divergence from the visible world, they were also often proposing a way forward through a rejuvenated appreciation of traditional values of modernism." Moore, *Starburst*, 2010, 30–32.

44 Grundberg continued, "It's still possible for things to happen out in the boondocks (especially California) without New York starting them or having anything to say about them… What's curious about all this work is that the confusion one experiences in viewing it is purposeful. I doubt very much if any of these artists intended for anyone to 'decode' the layers of ambiguity built into the prints. Instead, the point seems to be that a photograph is capable of holding such an abundance of material—more in fact than we could ever deal with. Our eyes are not only fooled, they are stretched beyond their limits. At last, here are photographs that come armored with the question, 'Is it a mirror, or is it a window?'" Andy Grundberg, *Soho News* (July 2, 1980).

45 "Taken together, what distinguishes the photographers we have discussed isn't so much that they live in California, but that they use color in various ways, that they make prints designed to 'hold' the wall in a manner that derives from art's decorative impulse, and that they pay homage in their work to Hollywood, commercial photography and art styles such as Cubism. Most importantly, they are taking risks by challenging the very notion of what a photograph is supposed to look like—traditionally a small, delicate, subtly toned, precious object that reports on the world." Andy Grundberg and Julia Scully, "Currents: American Photography Today," *Modern Photography* (October 1980): 168.

46 From an interview with Barbara Kasten and John Reuter conducted by the author on May 7, 2014. The stunning resolution of the large-format Polaroid prompted one critic to observe that the "colors and details of the pictures it produced sometimes seem richer than those of direct vision." Kenneth Baker, "Their Own Instants: A Candid Look at Polaroid's Collection of Photographs," *Connoisseur* 1983: 102.

began to apply what she had learned in her sessions with Reuter.[47]

Size in photography mattered; if the 8 × 10" Polaroids were beginning to feel modest, the 20 × 24" format was still considered large, and they garnered big attention. There were museum acquisitions, invitations, and opportunities for Kasten to exhibit her work on both coasts — including at MoMA — and a major solo museum exhibition at the International Museum of Photography at George Eastman House. In the catalogue for that show, curator Robert Sobieszek wrote insightfully on Kasten's large-scale theatrical installations as well as her diverse influences:

> Photographically, Kasten's work exhibits a partial flirtation with such masters of the mechanomorphic still life as László Moholy-Nagy, Florence Henri and Paul Outerbridge, yet her metalized gloss, spatial gymnastics and post-modern colors are distinctly fresh. If there is a historicism in her work, it is a retributive historicism, honoring a set of traditions while adapting them to the present. Kasten's images are largely in tune with a Los Angeles of the 1980s, a Los Angeles found in The Roxy, The China Club and the Hotel Bonaventure.[48]

Kasten's clear indebtedness to the early avant-gardes, shot through with a highly contemporary, West Coast sense of materials and aesthetics, was distinctly different from the provocations and media critiques produced by the artists associated with the Pictures Generation in New York. Nevertheless, Kasten's destabilization of the picture plane did contain a deconstructive impulse, which caught the attention of gallery director John Weber, who included Kasten in a group show in 1981 entitled *Media Relief*. Kasten quickly felt at home amid Weber's stable of artists, which revolved around postminimal and conceptual practitioners such as Carl Andre, Sol LeWitt, and Robert Smithson.[49] Not only were these artists closer in age to Kasten than those on the scene at Metro Pictures, where many of the Pictures Generation artists showed, but Weber also allowed her work to be positioned outside photo-specific debates.

Of course, this was already a familiar context for Kasten's work on the West Coast, where photography was still crossing boundaries freely. For example, curators Timothy Druckery and Marnie Gillett's exhibition *Reasoned Space* (1980) at the Center for Creative Photography in Tucson explored the imposition of "an intellectually derived spatial system upon the world," and placed Kasten's diagrammatic "photogenic" drawings alongside the work of artists such as Jan Dibbets, Douglas Huebler, and Barry Le Va.[50] In California, Rice and Wortz's *Siuational Imagery* (1980)

at UC Irvine considered the relationship between sculpture and photography and featured Kasten in dialogue with artists ranging from Robert Cumming and Jan Groover to John Baldessari and Donald Judd. Here, Kasten not only displayed her *Constructs* for the first time, but also a sculptural installation made from many of the same materials seen in the photographs. In an adjacent corner to her four small, framed and matted Polaroids, Kasten affixed a gray backdrop to the wall and overlaid it with a large swatch of fiberglass screening material, producing a moiré effect. In the foreground, a black rod structure — reminiscent of sculptures by Constructivists such as the Stenberg Brothers — sat atop slabs of mirrors and metal that threw upwards an array of angular reflections. Smack dab in the middle of the gallery, a large studio light illuminated the scene and, as in Kasten's final *Amalgam*, the cord was left to trail through the installation, ending in a plug unceremoniously jacked into the gallery floor. With theatrical flair, Kasten was playing upon several connotations of the term "construct."

Opticality vs. Tactility

For the same reasons that she did not wish to be pigeonholed as a "woman artist," Kasten also resisted the outright label of "photographer." Rather, as she remarked to curator Constance Glenn in 1981 as they prepared for her exhibition at California State University Long Beach, she embraced a more porous identity: when she was arranging her objects in space she was a "sculptor"; behind the camera a "photographer"; and when she was blending her colors through reflection, backlighting, and exposure, she was more proximate to a "painter."[51] Indeed, it is less productive to situate Kasten within an art versus photography debate than it is to consider the multiplicity of her project with regard to her influences, training, and processes. The Long Beach show, titled simply *Barbara Kasten, installation/photographs*, made declarative the interdisciplinary nature of Kasten's process and underscored the role of bodily experience as a way to enter into and read her photographic images.[52] A common misperception when encountering Kasten's photographs on their own is that the objects in the frame seem arranged in miniature or as tabletop compositions and the colors added with paint or through post-production. Quite the opposite, Kasten's setups are always fabricated and scaled to the body, and the colors are built up through the experiential and compositional layering of light and reflection on the otherwise neutral forms in real time and physical space. In Long Beach, alongside a grouping of her spectacular 20 × 24" Polaroids, Kasten created a stage-set-like installation, from which she produced six distinct 8 × 10" Polaroids, which were displayed nearby. Documentation images of Kasten working in the galleries (reproduced

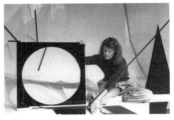

Barbara Kasten, California State University Long Beach, 1982

47 Kasten notes that although she often creates sketches in advance, she sees them more as guidelines and is open to changing them once she sets them up and looks at them through the back of the view camera. Barbara Kasten, interview by Constance Glenn, 1981.

48 Robert Sobieszek, curatorial statement, November 1981.

49 Joyce Nereaux, interview by the author, July 2, 2014. Nereaux, Weber's former wife and gallery director, recounted that she and Weber had first become aware of Kasten's work through Sobieszek. She recalled that her impression at the time was that Kasten seemed to be doing new things with the photograph and that she was a natural fit for the gallery.

50 See Timothy Druckery and Marnie Gillett, *Reasoned Space* (Tucson: Center for Creative Photography, University of Arizona, 1980).

51 Barbara Kasten, interview by Constance Glenn, 1981, from a recording in Glenn's archive.

52 The exhibition, organized by Constance Glenn, was the second in the museum's *Centric* series, which focused on up-and-coming artists. Glenn remembers spending a lot of time with Kasten in her studio in Inglewood and encouraging her to display both the photographs and sculptures as a way to emphasize both poles of her practice. She recalls, "I saw the images, and then when I saw the sculptures, that was when I understood that the sculpture had to be shown. I didn't understand that until I saw it. I felt at the time, and one of the reasons I was so adamant about showing it, was I think it's hard to take that body of work at face value unless you have some idea of what its origin is. And maybe that's just me. In other words, process was always important to me." From a conversation with Glenn conducted in person by the author on October 27, 2013.

in the catalogue and found in the artist's archive) are suggestive of performance. They depict Kasten caught in the midst of activities such as unfurling her screening material, crouching over large Plexiglas shapes, adjusting a delicate sculptural form made out of wires and rods, and standing on tiptoe to look through her view camera.

Although the reception of Kasten's work often privileged the optical over the tactile, and the fixed veneer of the image over the physical experience of the body in space, for Kasten these two poles were equally important. Her finished photographs reflected her own unique perspective, while the installation was meant to change with each viewer's encounter. It is precisely this tension between the perceptual and the phenomenological that is at the heart of Kasten's practice.[53] As one reviewer observed, "The distinction between simply *looking* and photographic *interpretation* are brought sharply into focus... This translation of the installation into imagery is more than the documentation of Kasten's process of involvement with the materials, for it establishes the distinction between human and photographic vision."[54] The *LA Weekly* simply called the show "some of the hottest cool work to come along in some time."[55]

Although she had been working with a camera for only three years, Kasten was embraced by the photography world; she was included in exhibitions such as John Upton's *Color as Form* at the Corcoran Gallery and Eastman House and a mid-career group show organized as the debut exhibition by the new department of photography at LACMA. The biggest breakthrough came when the 45-year-old artist learned that she had received a coveted Guggenheim award. The grant allowed Kasten to return to the East Coast and work more intensively with Reuter and the 20 × 24" Polaroid camera. Initially meant to be temporary, the move became final with her divorce from Rice, especially as New York's booming art market began to bring photography more explicitly into the fold.[56] This new environment and access to resources had an immediate and dramatic effect on the direction of Kasten's work.

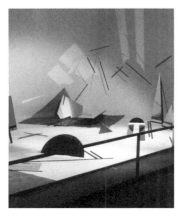

Barbara Kasten, installation at California State University Long Beach, 1982

In her first solo show with John Weber, in September 1982, Kasten exhibited a suite of thirteen *Constructs* in both 20 × 24" Polaroid and newly printed 30 × 40" Cibachrome formats. The Cibachromes (painstakingly produced with master printer Michael Wilder), with their lush, watery surfaces and plastic material base, further amplified the saturated, complex color schemes that Kasten was perfecting in the studio.[57] If the *New York Times* critic Andy Grundberg had felt some ambivalence about Kasten's work when he first encountered it two years prior, this bolder presentation left no doubt about the ambition of the artist's project and its relevance. In his review of the exhibition, Grundberg noted that while a plethora of staged imagery had been populating the landscape of contemporary art—as in the work of Sandy Skoglund and Laurie Simmons—Kasten's photographs managed to escape "the cuteness and self-consciousness that infects the pictures of so many of her peers.... [The] effect is vertiginous and engrossing; at their best (which tends to be at their biggest), the photographs remind us that what we see depends on how we choose to see it."[58]

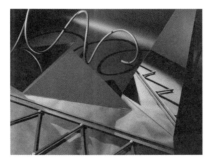

Barbara Kasten, *Construct XVII*, 1983

Pomophobia
In New York Kasten's work both absorbed and reflected the ethos and aesthetics of postmodernism. Although she continued to be in dialogue with an art discourse that insisted on the "construction" of images, her photographs increasingly resonated with the most contemporary thinking and form-making in architecture and design. As Kasten adjusted to her new environs from the perspective of her live-work space in industrial neighborhoods, first Soho and then Chelsea, the "soft fleshy tones" and the delicate hardware of her earlier structures were soon replaced by a bolder palette and chunky elements sourced from shops on Canal Street and architectural supply catalogues. She observed at the time:

> When I moved to New York in 1982 it was the height of postmodernism and I was inspired by a lot of the architecture in the city.... I would look out my window at these wonderful ornaments on windows and the tops of building... They are really beautiful, but you have to be high up to really see them. You almost have to look up like a tourist,

53 "The space becomes very ambiguous and confusing because in these photographs I am presenting to you my own selective vision of the sculpture. It's my perception, it's my photographic vision that you are seeing and in the sculpture itself you can experience your own relationship to it.... What was interesting to me about this was that as you walked by... past the sculpture your relationship to the mirror, including your personal attributes—your size—it was all so different for everybody." Barbara Kasten, CCP lecture, 1983.

54 Mark Johnstone, *Artweek* (February 27, 1982).

55 Dinah Berland Porter, "Medium Hot, Medium Cool: The Dazzle of L.A. Photography," *L.A. Weekly* vol. 4 no. 10 (February 5–11, 1982): 14–16.

56 For an overview, see Andy Grundberg, "Photography View: Crossovers with the Art World," *The New York Times* (September 12, 1982).

57 Kasten stated, "The earlier pieces were only concerned with reflecting the color in shapes and isolating certain colors within a muted grey tone. Then I was concentrating on the isolation of color and now (with the large format) it is the blending of colors—the spill-over. The multiple exposure became another tool—like learning another wash. It makes possible the layering of information. I can change elements, add or subtract color just as if I were painting. There is an on-the-spot pressure and intensity and involvement with the image and the sculpture that builds." Barbara Kasten, *In Color: Ten California Photographers*, exh. brochure (Oakland, Calif.: The Oakland Museum, 1983).

58 Andy Grundberg, "In the Arts: Critics Choices. Photography," *The New York Times* (September 19, 1982): G3.

but I happened to be on a high floor so I could look straight out at these architectural elements, so I started incorporating them into the sculpture that I was doing.[59]

Neoclassical columns, glass bricks, molded archways, curvy latticework, corrugated plastic, cornices, and ornate pedestals now accompanied her assemblages of large Plexiglas shapes, fiberglass screening, platonic solids, and geometric props. As Kasten deftly mastered her new photographic tools, the images became more theatrical, at times verging on the baroque. These scenarios played out with dazzling complexity as she experimented with mixed lighting, such as in the rainbow-hued *Construct NYC-12* and in the diptychs and triptychs she began producing in 1983, such as the techno-perfect purple and red *Triptych II*.

Yet the seeming slickness of these magazine-ready images belied the physicality of the process of creation and the traces of the artist's hand working just outside the frame. Brushstrokes, tiny rips, texturized plaster, and optical effects all stood in contrast to the image as it was circulated. When reproduced in print or online, the purposeful, rough-hewn imperfections that puncture Kasten's constructions appear smoothed out and flattened, while the physical size of the prints is reduced to the scale of an illustration. These are works that at once invite mass circulation and demand to be encountered in person and up close. Their crucial dualisms—between handmade and machinic, object and image, craft and commodity, and indeed between modern and postmodern—can be construed as a symptom of the "both/and" condition that shaped postmodernist discourse.[60] Even as Kasten's most opulent works were often described as "stylized" or a "hairline away from kitsch," they were perfectly in sync with the exaggerated surfaces and bricolage espoused by buildings such as Frank Gehry's Santa Monica residence and the architecture of Michael Graves. This synergy was highlighted by Kasten's inclusion in the 1984 *Arts + Architecture* portfolio alongside architects and designers such as Gehry, Graves, Peter Shire, and Arata Isosaki and by her inclusion in the *Los Angeles Times*'s "Very 1985" hot list in the company of quintessential postmodern icons such as architect Richard Meier, Walt Disney Studios, and Ettore Sottsass furniture.[61]

Kasten's eye-catching Cibachromes impressed critics in her 1984 solo exhibitions at Weber in New York and at Karl Bornstein in Santa Monica. They used terms for her photographs such as "sensuous," "extravagant color," "California funk," "humor," "surreal" and "endlessly intriguing"; they wrote that the gallery seemed to "vibrate."[62] At the front of the gallery, a stark, white sculptural installation

went practically unnoted—people simply didn't pay attention to Kasten's assemblages in their natural state. Yet it was precisely in this direction that Kasten was heading. Unlike the exhibition at Long Beach, the photographs were not produced out of this particular sculptural ensemble, and when seen in concert in the gallery, her contained arrangement of photos and setup may have resembled a kind of commercial display.

Exact Seeing

Perhaps sensing that a compare and contrast effect might take place between her photographs and her sculptures, Kasten proposed a stand-alone, site-specific installation and series of architectural interventions when she was invited in 1984 to participate in a residency at Capp Street Project in San Francisco, which had been founded by Ann Hatch just one year earlier and was based in the unique house designed by artist David Ireland. Here Kasten foregrounded her interest in the tableau. Titled *Exact Seeing*, in homage to Moholy-Nagy who had used the same phrase to describe photographic vision, the exhibition set out to "deal with the issues of reorganized perspective and changed physical orientation in a three-dimensional experience."[63] The central work was an installation featuring her now familiar repertoire of black and white objects and materials including triangular mirrors and large pyramidial props sourced from the San Francisco Opera. The installation was described by critics as "an important adjunct" to Kasten's more spectacular photographs, but the experience would prove pivotal for the artist on numerous levels.[64] Not only did it provide her with the chance to theatricalize a specific and distinctive architectural site, but it also allowed her to activate her scene through motion. Noting her longstanding interest in the theater experiments of the Bauhaus, Kasten invited Margaret Jenkins, the celebrated dancer and protégée of Merce Cunningham, to dance with her troupe in the installation in select performances.

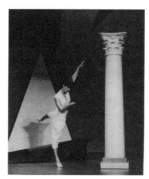

Margaret Jenkins and Barbara Kasten, *Inside Outside/Stages of Light*, 1985 Photo: Bonnie Kamin

In turn, Jenkins responded with an invitation to collaborate with her on a new performance that would test Kasten's theatrical tendencies in the studio and her interest

59 Barbara Kasten, CCP lecture, 1983.

60 "Exhilarated or critical? Commodity, or commodity critique? Both/and. This was the dichotomy that ran right through Postmodernism in the 1980s." Glenn Adamson and Jane Pavitt, "Postmodernism: Style and Subversion," in *Postmodernism: Style and Subversion*, 1970–1990 (London: V&A Publishing, 2012), 70. See also Denise Scott Brown, "Our Postmodernism," in ibid.

61 The portfolio was subsequently reproduced in *Arts + Architecture*'s July 1985 issue, "Postmodernism: The Uses of History." Notably, the issue included reviews by critics such as Michael Sorkin on Memphis and Italian design, a treatise-cum-resource guide on the use of pattern and surface in architecture, as well as an essay entitled "Pomophobia, or Fear of Change."

62 See Andy Grundberg, *The New York Times* (September 14, 1984); "Shows We've Seen," *Popular Photography* vol. 91 no. 7 (July 1984); Owen Edwards, "Shadow Play, "Making abstraction work on film," *American Photographer* vol. XIII no. 5 (Nov. 1984); Eleanor Heartney, "Barbara Kasten," Arts (November 1984); and Ron Warren, "Barbara Kasten: John Weber," *ARTS Magazine* (November 1984).

63 Press release, Capp Street Project, 1984. Kasten's initial proposal involved producing a suite of 20×24" Polaroid works from her installation, but the project was too costly, so she exhibited pre-existing Polaroids in a separate location in the building and created a new installation with the support of the residency.

64 See Alfred Jan, "Barbara Kasten," *Flash Art* (October/November 1985), and Claire Peeps, "Book Reviews," *Friends of Photography Bulletin* (Carmel, Calif.: August 1985).

in Bauhaus set design at the largest scale to date, in real time and with bodies in space. *Inside Outside/Stages of Light* featured choreography by Jenkins, a score by artist Bill Fontana, and movable sets, costumes, and lighting concept by Kasten (with the expertise of lighting designer Sara Linnie Slocum). As the colored tones subtly shifted, and as the dancers caught glimpses of themselves in the large "futuristic" mirrors as they propelled classical columns across the stage, it was possible to begin to understand what it might mean to be *inside* one of Kasten's photographs. The performance opened in San Franciso at the Herbst Theater on April 19, 1985 and traveled to several venues, making a resounding New York debut on October 22, 1985, at the Brooklyn Academy of Music's Next Wave Festival as part of a lineup that included artists such as Robert Wilson, Richard Foreman, Pina Bausch, and Steve Reich.

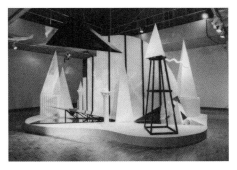

Barbara Kasten, *Toward an Interconnectedness of All Things*, Wright State University, 1985

Kasten continued to develop this approach to sculpture as set in her 1985 exhibition at Wright State University, *Toward an Interconnectedness of All Things*, where her installation, brightly lit by an assortment of colored lighting, could be seen in the round, and even regarded from a platform above. But by this point she had already brought her viewers as close as they would come to stepping into the installation. Back in the theater of her own studio, after seven years of pushing her *Constructs* to their limits, she embarked on a small series of large-scale Cibachromes entitled *Metaphase*. Inspired by her collaborations with the dancers, these new photographs imbued the most dramatic elements of her previous work with a kinetic sensibility. As if encapsulating the opulence of the era, the photographs seemed to pulse with an amplified color, and the frames could barely contain the burst of objects and patterned reflections. Kasten had by now honed her skills to the point of absolute technical perfection.

Kasten rarely lent her skills to the commercial sector, agreeing only to the occasional invitation: she shot a campaign for the new layout software Quark at the behest of Pentagram (which to this day remains one of the most prestigious promulgators of postmodern design) and a fashion

editorial for *Esquire* in 1985. No longer teaching, Kasten was living solely off the sale of her work, and these jobs, as well as the occasional licensing fee from a stock imagery company, were hard to turn down. Invitations to exhibit in Japan, purchases that placed her photographs in corporate boardrooms and luxury hotels, and commissions to produce work for the annual report of the Interpublic Group of Companies, the parent of mega-advertising agencies such as McCann-Erickson — all were facilitated by the boom of the market in the 1980s and the precariousness of a postmodern art that teetered between complicity and critique. This was perhaps best summarized by the reactions to the International Center of Photography's 1986 exhibition *Art & Advertising: Commercial Photography by Artists*, which in addition to Kasten included Robert Mapplethorpe, Cindy Sherman, Laurie Simmons, and William Wegman. Although it is arguable that today this distinction between fine art and commercial sectors has become more porous, or at least pliable, for many critics at the time, these artists had crossed an unforgivable line with client jobs that too closely resembled their personal artwork and that underscored the ambiguous status of the photograph.[65] *The New Art Examiner* attacked Kasten and her Quark ad directly, describing her as "non-critical," going on to say that her "meaningless images" of "high-tech fantasies" lent themselves to "commercial work for high-tech enterprises."[66] Curator Carol Squiers, on the other hand, argued in *Flash Art* that times were changing for both photography and the market, and that this dialogue between art and commerce reflected a savvy new generation that was able to "sell their own analytically based styles back to the marketplace that inspired them," concluding, "Evolving postmodern tactics are really the only game in town."[67]

The Directorial Mode

As if on cue, Kasten chose to step out of the studio and into media. An opportunity presented itself in the form of an invitation to create a suite of photographs to accompany an article in one of the hottest new publications, *Vanity Fair*. The text, by Kasten's friend Kurt Kilgus, a fashion writer and art director at Bergdorf Goodman, considered the extravagant "power lobbies" and atriums of the latest postmodern buildings.[68] For Kasten, the assignment offered the chance not only to operate on an actual architectural scale, but also to re-center the criticality of her project, while continuing the direction that her work was already taking. Through *Vanity Fair* she gained entry to locations that she might not have had access to otherwise, as well as the startup funds to embark on her most ambitious production to date. With the *Architectural Sites*, 1986–90, Kasten, working with an on-site crew of professionals from the Hollywood industry, fulfilled the filmic potential nascent in the

Barbara Kasten at Capp Street Project, 1985

65 "Barbara Kasten's and Victor Schrager's constructivist rational imagery also transfers handily onto editorial pages and promotions for technology. Through no real fault of the art, certain kinds of geometric and cool, intellectualized abstractions have come to be regarded as perfect for corporate collections — handsome, unthreatening, safe, prestigious. What fits comfortably on office walls evidently fits comfortably into certain branches of mass media as well. This represents a real change: Corporate America rarely managed to swallow the avant-garde whole before." Vicki Goldberg, "The Art of Salesmanship: Photography as a Tool of Advertising," *American Photographer* (February 1987): 28.

66 Andrea Silverman, "Art and Advertising," *New Art Examiner* (January 1987): 56.

67 Carol Squiers, "The Monopoly of Appearances," *Flash Art* 1987: 100.

68 It is not clear who initiated the proposal. In an article by Deborah Irmas in *Angeles* magazine that profiles Kasten's *Architectural Sites*, Irmas states that Kasten had initially proposed a story to *Vanity Fair* on "power lobbies." "Bright Lights, Big Buildings: Photographer Barbara Kasten Transforms L.A. Architecture," *Angeles*, February 1990, 85–90.

performative aspect of her practice: what critic A. D. Coleman had termed in 1976 the "directorial mode," which a decade later would become synonymous with the grand productions of artists such as Gregory Crewdson.[69]

Kasten began with the recently opened Lipstick Building, designed by Philip Johnson; Kevin Roche and John Dinkeloo's grand lobby of E. F. Hutton's headquarters (now Deutsche Bank); and César Pelli's entranceway to One World Financial Center. In each location Kasten positioned massive Plexiglas mirrors to reflect impossible vantage points and hired a gaffer and crew of assistants from the film industry to precisely illuminate her subjects in the brightest candy colors imaginable.[70] Although Kilgus's article was never published, the project launched Kasten on a trajectory that would preoccupy her for the remainder of the 1980s. With her initial photographs, printed in Cibachrome as editions measuring 30 × 40" and even 50 × 60", the largest scale possible at the time, Kasten was able to demonstrate the impressive nature of her enterprise. To continue the project with Vanity Fair's high-powered connections no longer in place, Kasten negotiated with contacts on the West Coast to gain access to sites such Gehry's Loyola Law School and subsequently approached museum directors, who, at the dawn of the starchitect craze, were eager to show off their newly commissioned structures. In retrospect, the resonance between Kasten's studio work and her architectural interventions is undeniable, rendering an image such as Construct XI PC, 1982, with its Southern California palette and triangular mirrors, a type of maquette for Architectural Site 10, December 22, 1986, 1986, which depicts Arata Isozaki's Museum of Contemporary Art in Los Angeles within days of opening to the public.

Now, instead of alluding to architectural elements, Kasten was working with actual architecture; instead of revealing the constructed nature of the photographic image, she was reflecting on the disorienting effects that were symptomatic of materialization in postmodern architecture and its consolidation of both economic and cultural capital. Writing in the LA Times, Suzanne Muchnic described Kasten's transformation of her architectural subjects into "Cubist compositions of dynamic, faceted space and sizzling color… They are startlingly imposing photographs that take the 'fabricated to be photographed' genre into a brave new world of real places in invented space."[71] In Artforum, Charles Hagen described Kasten's work as "Bauhaus on acid… The baroque opulence of the buildings and photographs is not comfortable, but undeniably spectacular."[72] More critically, Mark Johnstone wrote in Artweek, which featured Kasten's Architectural Site 8 on its cover, that these new photographs were "aggressive" and lacked the

"ambiguity" and strength of Kasten's previous studio work: "They are not about truth, social reality or cultural myths. They are also not a postmodern judgment or denial of that ethos of modernism but simply an exploitation of older twentieth-century ideas for what could be considered essentially decorative purposes."[73] Clearly, these Through the Looking-Glass images left many viewers wondering whether they were a celebration or a critique; the answer, of course, is that they were a little of both. As Kasten approached her subjects, she also reached out to the architects themselves, sharing her photographs via mail and in person. She received handwritten notes of appreciation from several, including Pelli, and recalls that when she visited Isozaki in Japan he told her that when he first saw her photographs of MOCA he was delighted to discover that did not recognize his own building.

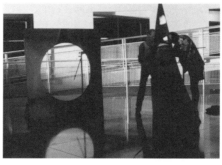

Setting up Architectural Site 18, August 29, 1988, 1988

What seemed to perturb reviewers the most were the high production values — certainly a given in today's art world, though it is difficult, from our current digitally and socially networked perspective, to comprehend the lengths to which Kasten went to achieve her final images.[74] For each shoot, Kasten invested many months in logistical negotiations, made numerous site visits in which hundreds of test Polaroids were taken, produced sketches to nail down the color schemes in advance, conducted research, hired and coordinated multi-person crews, fundraised for the approximately $10,000 that each image cost to produce, corresponded with the architects and museum directors, secured permits, and endured all-night shoots. None of it was done simply for "decorative purposes." In 1989, in preparation for an exhibition of her Architectural Sites, the inaugural show at the International Center of Photography's new home in Midtown Manhattan, Kasten wrote down her thoughts on the project. She ruminated on the various aspects of how the works pointed to the subjectivity of perception and emotional response and how they created a sense of disorientation, concluding that they allow us to "redefine our relationship to symbols of authority." Kasten's sites were selected precisely because they "stand as monuments of cultural [and economic] power."[75] As Barbara London noted, "For [Kasten] the art lies

69 Although the "directorial" was already an established mode at this time between artists such as Cindy Sherman and Jeff Wall, Kasten's employment of a film crew working out in the world to both amplify and confuse the real with the staged set her images apart.

70 It is interesting to note the ominousness of these three corporate structures that were respectively associated with Bernie Madoff's Ponzi scheme, the financial scandals of 2008, and the tragic events of 9/11.

71 Suzanne Muchnic, "The Art Galleries: Wilshire Center," Los Angeles Times (Friday, March 6, 1987): 18.

72 Charles Hagen, "Barbara Kasten, John Weber Gallery," Artforum (April 1987).

73 Mark Johnstone, "Constructivist Angles on Architecture," Artweek vol. 18, no. 14 (April 11, 1987): 11.

74 Barbara London, "Public Spaces and Private Places: Barbara Kasten's Architectural Abstracts Take Reality and Turn it Upside Down," American Photographer (September 1988): 48.

75 Exhibition announcements and revisions to statements for the ICP exhibition. In a 1997 talk at CCP, Kasten would look back on the project: "I was working on a much larger scale which made me happy and of course architecture was something that I had always followed and admired… There were a lot of exciting things going on in architecture in New York… I wanted to add color and embellish [the E.F. Hutton Building] even more. I mean it seemed to be appropriate… These buildings… were embellished to begin with… It was in a way my own kind of commentary on the kind of money and grandioseness of the architecture of the time."

in the process as well as the pictures. But the pictures are astonishing nonetheless… With her wholesale, bivouac-like appropriation of large public spaces, Kasten has also raised fine-art photography to a new level of assertiveness. It is enough to make Cindy Sherman feel small."[76]

By this time Kasten had created elaborate images of Bruce Goff's Japanese Pavilion at the Los Angeles County Museum of Art, Richard Meier's High Museum of Art in Atlanta, Marcel Breuer's Whitney Museum of American Art, and in tandem with her show at ICP, a nighttime image of the new building, in which the Empire State Building can be seen in the distance, the lights having been turned on explicitly for the shoot.[77] Presented all together at ICP, the photographs were reviewed in *Artforum* by Patricia C. Phillips, who observed, "Kasten calls into question the common experience and perception of buildings and spaces. She shakes architecture from its formal rigor mortis in order to engage the viewer in a deeper dialogue with architectural form. Her temporary occupancies of major cultural sites are quiet occasions for sabotage that challenge the final word of the architect and the inflexible authority of the monumental building."[78] Or as Kasten put it, "I look to buildings that represent power and suggest another way of perceiving them. There is humor in the way I use color on buildings that take themselves very seriously."[79] Although Kasten had plans to continue her series with buildings such as I. M. Pei's renovation of the Louvre, a combination of factors (including dwindling sponsorship) brought her investigation of architectural form and power to a close at the end of the 1980s.

New Monuments
In 1988 Kasten had traveled to Jackson Pollock's studio to produce a triptych in which the paint-splattered marks on the floor of the modest shed are juxtaposed with the illuminated trees just outside the window. This experience prompted Kasten to consider how she might approach other sites that inspired an alternative kind of "monumentality." She called up Dan Ehrenbard, her trusted gaffer from the *Architectural Sites*, and headed for the Southwest to photograph the Puye cliff dwellings of the Santa Clara Indians in New Mexico. With permission from the tribe, Kasten and her crew spent several nights out in the desert trying to stay warm and to keep the sand out of their equipment; she would later recall it was one of the most challenging shoots of her career. The Plexiglas mirrors, a hallmark of her work for over a decade, were absent, while a new, cooler palette added a sense of dramatic, ethereal spirituality. A private view of a ceremonial kiva, the exterior walls of a dwelling with an illuminated ladder, and a landscape view of trees and cliffs dappled with pastel hues suggested an outdoor stage set.

It is somewhat ironic that Kasten's move away from her earlier "high-tech" and "sci-fi" aesthetic and her gravitation towards more historical subject matter occurred in tandem with the rise of digital imaging. A pioneer of Polaroid, and lauded for the feat of her *Architectural Sites*, Kasten was invited to be one of a handful of artists to participate in several workshops to try out Apple computers and new programs; notably, on November 24, 1991, she was part of a group that gathered at artist Gretchen Bender's studio to be one of the first people to test-drive the new Adobe software programs Photoshop, Premier, and Pixelpaint. Even though many of Kasten's entirely analog works from the 1980s, with their saturated colors and complex vantage points, looked as if they had been produced through digital manipulation, Kasten used the new technologies at her disposal with discretion. As her focus shifted to ritualistic objects and ancient ruins, she tried out her new tools in conjunction with an invitation to produce a work on the occasion of the 1992 Summer Olympics in Barcelona. She selected the site of the Médol Roman quarry in Tarragona, Spain, where she photographed sarcophagi and stone cornices. She then scanned her negatives and used Photoshop to invert the colors and create solarized-like effects, which were then output onto photo-canvas and printed as Cibachromes.[80] While these works encapsulate the aesthetic of the early digital and demonstrate the artist's openness to experimentation, this mode of working would be short-lived — Kasten ultimately understood her medium as tethered to the physical properties of light and shadow rather than screen-based manipulation.

However, before she definitively set aside the digital tools, she employed them to work on a scale that otherwise would have been unimaginable. At the core of her investigation at El Médol was the quarry itself, which she illuminated in typical fashion with complementary cool and warm hues of blue and gold and output as a massive print that measured nearly five by fifteen yards. Displayed in its own hangar and illuminated, it became a literal backdrop. It was not just the historical significance of the quarry that had preoccupied Kasten, but its previous function as a site of work juxtaposed with the theater of its current role as a tourist site. As if to emphasize this aspect, Kasten took an unusual step for her and made two portraits of workers, one old and one young, whom she lit with red gels, the background fading off into black, suggesting the men's essential role as protagonists in Kasten's play and the body of labor behind her images.

With the conclusion of the El Médol project, the extravagance of the 1980s was definitively over. Kasten, never one for complacency, walked away from the style and techniques that had garnered her so much attention. In a fitting homage to her friend

76 Barbara London, "Public Spaces and Private Places: Barbara Kasten's Architectural Abstracts Take Reality and Turn It Upside Down." *American Photographer* (September 1988): 48.

77 "RE: Kasten/ICP Midtown Shoot, Empire State Building Lights," memo in ICP archive, August 18, 1989.

78 Patricia C. Phillips, "Barbara Kasten: International Center of Photography Midtown." *Artforum* 28 no. 4 (December 1989): 138.

79 Barbara Kasten, quoted in Deborah Irmas, "Bright Lights, Big Buildings: Photographer Barbara Kasten Transforms L.A. Architecture," *Los Angeles* (February 1990): 90.

80 These works were highlighted as cutting edge in an article that appeared in *The New York Times* about the encroaching threat posed to analog photography by the digital. Charles Hagen, "Reinventing the Photograph," *The New York Times* (Sunday, January 31, 1993).

Kurt Kilgus, who had passed away from AIDS in 1989, Kasten created a final classic *Construct*-like setup for an Absolut Vodka portfolio that was organized by Bill Hunt for Photographers + Friends United Against AIDS. With *Absolut Kasten*, an image that seemed to encapsulate all that Kasten's work represented in its many complicated facets, from the commercial to the critical, and with the specter of the body lingering just out of view, the artist moved on.

Barbara Kasten, *Absolut Kasten*, 1989

Full Circle

A series of artist's residencies offered Kasten a chance to recalibrate, and she returned to some of her early bodily, if metaphorical, investigations of female experience. She traveled to France to photograph cavernous, womb-like dolmens that she digitally stitched together and output at mural size, and she made cyanotype prints of celestial-looking fossils that were reminiscent of her mural in the *Gallery as Studio* exhibition nearly twenty years earlier. An invitation to be an artist in residence at Cornell University provided her with access to ancient Greek burial figurines, resulting in the *Tanagra Goddess* series. She photographed the female statuettes with a large-format camera and made Cibachrome contact prints at an intimately scaled 4 × 5" with a color scheme that reflected the cross-processed look of the moment. Another residency, in Bodrum, Turkey, prompted Kasten to create large pinhole-type impressions of ancient temples and to return more intently to the cyanotype process that had been so pivotal at the beginning of her career. While in Bodrum, she gained permission from the Museum of Underwater Archaeology to create cyanotype prints of their amphorae, which measured up to five feet. By day she would make impressions of the amphorae, while at night she cut a romantic figure, working alone in an old church illuminated solely by candlelight as she coated her paper in preparation for the next day's session in the museum. The resulting series of more than sixty-five prints is ghostly; the ancient, curvy, almost figurative vessels look as if they were actually submerged in water. Kasten exhibited them together with her other photographs of ritualistic objects and artifacts at Yancey Richardson Gallery in 1996, in a show *The New Yorker* described as "intoxicating."[81] It was almost as if Kasten had come full circle—almost.

In 1998 Kasten moved back to Chicago and took a position at Columbia College, where she redirected her energies to teaching and shifted to a more project-based approach that focused on museum collections and historical artifacts. In 2006 the school awarded Kasten their Distinguished Artist Award and provided her with a studio space and a two-year stipend, inspiring her to return to her core project. She pulled out the roll of fiberglass screening that had been in her possession since the 1970s, positioned her lights, and set up her camera. The resulting photographs, each titled *Studio Construct*, would be the first of several new, sophisticated bodies of work, including *Incidence* and *Scene*.

Now Kasten challenged herself to remove any possibility of metaphor and to make pictures with the bare minimum of material, light, and shadow. For example, in *Studio Construct 17*, 2007, two pieces of clear Plexiglas sit diagonally to each other, casting angular shadows that cut across a grayish-white field. Yet digital technology was encroaching ever more forcefully on analog processes: Polaroid was on the verge of bankruptcy, and Cibachrome paper was no longer readily available. Under this new dispensation, Kasten allowed herself to simply confront her materials and push the limits of perception. Gone are the deeply saturated gels, the colored scrims, and the platonic solids. These new "constructions" are not only more minimal in tone, but decisively brutal. If mediation had been Kasten's previous message, these new works invite confrontation. This is underscored by the artist's insistence that the prints not be framed behind glass, so as to prevent the slightest bit of interference in the extremely physical viewing experience. Whereas in her earliest *Photogenic Paintings*, Kasten had crumpled and torn her paper substrates, in the *Studio Constructs* and later series, the rips, tears, scratches, and abrasions are embedded *within* the pictures themselves rather than sitting on their surfaces. It is as if to say that the imaging of abstraction itself has been irrevocably ruptured.

The *Studio Constructs* channeled the energies of the moment; they arrived just on the eve of the global financial crisis of 2008, amidst debates around photographic abstraction and its place in the market among a younger group of artists engaged with photography and its material supports.[82] If the rumblings of the transition from analog to digital had been present ever since the early 1990s, it could be argued that it wasn't until the early-to-mid 2000s that its effects began to be fully felt. Moreover, as film and paper began to disappear along with color processors

81 "Barbara Kasten," *The New Yorker* (June 10, 1996).

82 Artists such as Liz Deschenes, Walead Beshty, Eileen Quinlan, Anthony Pearson, Leslie Hewitt, Sara VanDerBeek, and Carter Mull all began to gain recognition around this time.

and specialty photography labs, and as the computer screen became an essential complement to, if not replacement for, the darkroom, a surge of nostalgia surrounded outmoded technologies, from Polaroid and Kodachrome to 16mm film. Kasten's new work expressed this zeitgeist. Amid an anxious awareness among artists of being in the midst of a transition, concerns of process, production, hardware, and materiality—the core themes of Kasten's project all along—increasingly became the subject and object of artworks that probed the relations between the physical and the pixel and between sculpture and photography. Likewise, with the oversaturation of the image and the internalization of critical deconstructive tactics, an abstraction produced by a new generation that drew its influences equally from modernist forms and postmodern aesthetics (minus the ideological baggage) resonated strongly with many of Kasten's own experiments from the 1970s and 1980s, lending them an undeniable prescience.[83]

For Kasten, it has come as a welcome relief to no longer be asked to distinguish between mediums. In 2009, as she began exhibiting her most recent work in group exhibitions alongside younger artists such as Liz Deschenes, Anthony Pearson, and Erin Shirreff, Kasten declared that she had finally found her creative peers.[84] Although color has begun to slip back into her work, as in her most recent series *Transposition*, 2014, which places her Plexiglas in tension with imperfect swatches of transparent colored gels (harkening back to her time in Europe at Le Corbusier's chapel in Ronchamp), her process in the studio is now more stripped-down.

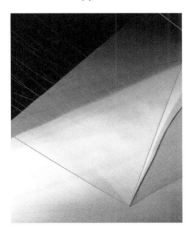

Barbara Kasten, *Studio Construct 78*, 2009

If these constructions are less immersive than her earlier sculptural environments, the opposite could be said for her latest video installations, in which the optical effects that were once reserved for the lens of the camera alone now transpire in real time and in physical space, gesturing to the inspiration she found in Moholy-Nagy, as well as the illusionistic installations of the Light and Space artists. With these latest architectural-scale installations, the

mirrors, moiré effects, and props have returned, but in a way that foregrounds the importance not just of the artist's hand but of the sentient body. Meanwhile, Kasten's Cibachromes, their watery surfaces seemingly tailor-made for the liquid-crystal display, have found new life on the internet as her works, both old and new, have been widely reproduced and circulated on blogs and online image aggregators. Of course, these earlier works also now find themselves occupying a different art world, one in which we expect that images have been manipulated and in which finish, scale, and high production values and an attention to the handmade, the intimate, and the analog are far from mutually exclusive.

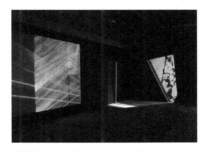

REMIX: Barbara Kasten w/ Lucky Dragons, video installation, Applied Arts, Chicago, 2011

Still, the larger implications of Kasten's work are perhaps only fully legible in light of the several decades of practice that continue to inform what she makes both inside and outside the studio. Again and again throughout her career her work has served as a bellwether that has managed to register, consolidate, and image cultural energies hiding in plain sight and on the edges of visibility: whether it be the unforeclosed potential of the material investigations of the early- twentieth-century avant-gardes, the contradictory spatial disorientations of globalized capital, or the tangible underpinnings of the new abstractions underwriting contemporary regimes of twenty-first-century image production. As this first major survey at ICA gives us the opportunity to see, Kasten's practice has traversed and synthesized both genre categories and interpretive paradigms that might have otherwise seemed incompatible: from feminism to formalism; from craft to constructivism; from the postminimal to the postmodern; and from the abstract to the actual. Focused on a remarkably consistent set of material and spatial concerns, Kasten's work has managed to square these circles, and so it should come as no surprise that she has emerged in recent years as an important touchstone for contemporary artists working across media for whom earlier disciplinary boundaries (and prejudices) have largely fallen away and questions of mediation, process, and the body have become ever more pressing. Above all, perhaps, today Kasten stands as an example of an artist whose work and practice complicates received narratives and expands our notions of both what we see and how we see it.

83 See Alex Klein, *Words Without Pictures* (Los Angeles: LACMA, 2009; and New York: Aperture, 2010). In particular, art historian Kevin Moore calls for a reevaluation of modernist form and observes how younger artists seem to channel Kasten's work, while artist Carter Mull calls for a new set of reference points and role models, with Kasten chief among them.

84 From an unrecorded conversation between the author and the artist. See also the interview by Liz Deschenes in this catalogue.

1
Seated Form (red), 1972
Handwoven sisal and wooden chair
Approximately 42 × 24 × 24 in.
(106.7 × 61 × 61 cm)
Courtesy of the artist

2
Seated Form (yellow), 1972
Handwoven sisal and Thonet chair
Approximately 35 × 28 × 28 in.
(88.9 × 71.1 × 71.1 cm)
Courtesy of the artist

3
Seated Form (green), 1972
Handwoven sisal and Thonet chair
Approximately 35 × 25 × 25 in.
(88.9 × 63.5 × 63.5 cm)
Courtesy of the artist

4
Figure/Chair, 1973
Diazotype on newsprint
17 × 22 in. (43.2 × 55.9 cm)
(Exhibition print, 2015,
archival pigment print)
Courtesy of the artist

5
Figure/Chair, 1973
Diazotype on newsprint
22 × 17 in. (55.9 × 43.2 cm)
(Exhibition print, 2015,
archival pigment print)
Courtesy of the artist

6
Figure/Chair, 1973
Diazotype on newsprint
22 × 17 in. (55.9 × 43.2 cm)
(Exhibition print, 2015,
archival pigment print)
Courtesy of the artist

7
Torso, 1974
Cyanotype with pencil and
silver paint on BFK Rives paper
30 × 22 in. (76.2 × 55.9 cm)
Courtesy of the artist

8
Photogenic Painting, 74/1, 1974
Cyanotype (photogram) on
BFK Rives paper
22 × 30 in. (55.9 × 76.2 cm)
Collection of JK Brown and
Eric Diefenbach

9
*Photogenic Painting
Untitled 75/11*, 1975
Cyanotype (photogram)
on BFK Rives paper
30 × 40 in. (76.2 × 101.6 cm)
Courtesy of the artist

10
*Photogenic Painting
Untitled 75/21*, 1975
Cyanotype (photogram)
on BFK Rives paper
30 × 40 in. (76.2 × 101.6 cm)
Courtesy of the artist

11
*Photogenic Painting
Untitled 75/32*, 1975
Cyanotype (photogram)
on BFK Rives paper
30 × 40 in. (76.2 × 101.6 cm)
Courtesy of the artist and Bortolami,
New York

12
*Photogenic Painting
Untitled 76/7*, 1976
Cyanotype (photogram) with Van Dyke
and ink on BFK Rives paper
30 × 40 in. (76.2 × 101.6 cm)
Courtesy of the artist

13
*Photogenic Painting
Untitled 76/19*, 1976
Cyanotype (photogram) with Van Dyke
and ink on BFK Rives paper
30 × 40 in. (76.2 × 101.6 cm)
Courtesy of the artist

14
*Photogram Painting
Untitled 77/3*, 1977
Cyanotype (photogram) with paint stick
on BFK Rives paper
30 × 40 in. (76.2 × 101.6 cm)
Courtesy of the artist

15
*Photogram Painting
Untitled 77/22*, 1977
Gelatin silver mural paper with oil paint
Three parts, 78 × 22 × 2 ½ in.
(198.1 × 55.9 × 6.4 cm) each
78 × 66 × 2 ½ in.
(198.1 × 167.6 × 6.4 cm) overall
(Hinged in the late 1970s)
Courtesy of the artist

16
Amalgam Untitled 79/9, 1979
Gelatin silver print (enlargement
with photogram)
with acrylic paint and crayon
16 × 20 in. (40.6 × 50.8 cm)
Philadelphia Museum of Art: Purchased
with funds contributed by Barbara B.
and Theodore R. Aronson and Richard
L. and Ronay Menschel, 2014

17
Amalgam Untitled 79/16, 1979
Gelatin silver print (enlargement
with photogram)
16 × 20 in. (40.6 × 50.8 cm)
Los Angeles County Museum of Art,
Gift of Robert M. and Lynda Shapiro

18
Amalgam Untitled 79/18, 1979
Gelatin silver print (enlargement
with photogram) with crayon
16 × 20 in. (40.6 × 50.8 cm)
Courtesy of the artist

19
Amalgam Untitled 79/22, 1979
Gelatin silver print (enlargement
with photogram)
20 × 16 in. (50.8 × 40.6 cm)
Courtesy of the artist

20
Amalgam Untitled 79/34, 1979
Gelatin silver print
20 × 16 in. (50.8 × 40.6 cm)
Courtesy of the artist and Bortolami,
New York

21
Construct I-A, 1979
Polaroid Polacolor ER photograph
7 ⅓ × 9 ⅓ in. (18.6 × 23.7 cm)
Courtesy of the artist and Kadel
Willborn Gallery, Düsseldorf, Germany

22
Construct II-B, 1979
Polaroid Polacolor ER photograph
9 ⅓ × 7 ⅓ in. (23.7 × 18.6 cm)
Courtesy of the artist

23
Construct IV-C (variation), 1980
Polaroid Polacolor ER photograph
7 ⅓ × 9 ⅓ in. (18.6 × 23.7 cm)
Courtesy of the artist

24
Construct III-A, 1980
Polaroid Polacolor ER photograph
9 1/3 × 7 1/3 in. (23.7 × 18.6 cm)
Collection of JK Brown and
Eric Diefenbach

25
Construct V-A, 1980
Polaroid Polacolor ER photograph
7 1/3 × 9 1/3 in. (18.6 × 23.7 cm)
Courtesy of the artist and Gallery
Luisotti, Santa Monica

26
Construct VI-B, 1981
Polaroid Polacolor ER photograph
7 1/3 × 9 1/3 in. (18.6 × 23.7 cm)
Courtesy of the artist and Kadel
Willborn Gallery, Düsseldorf, Germany

27
Construct VII-A, 1981
Polaroid Polacolor ER photograph
9 1/3 × 7 1/3 in. (23.7 × 18.6 cm)
Courtesy of the artist and Bortolami,
New York

28
Construct IX-A, 1981
Polaroid Polacolor ER photograph
9 1/3 × 7 1/3 in. (23.7 × 18.6 cm)
Courtesy of the artist and Gallery
Luisotti, Santa Monica

29
Construct PC/1A, 1981
Polaroid 20 × 24 Polacolor photograph
24 × 20 in. (61 × 50.8 cm)
Courtesy of the artist

30
Construct PC/4B, 1981
Polaroid 20 × 24 Polacolor photograph
24 × 20 in. (61 × 50.8 cm)
Courtesy of the artist

31
Construct XI-A, 1981
Polaroid Polacolor ER photograph
9 1/3 × 7 1/3 in. (23.7 × 18.6 cm)
Collection of JK Brown and
Eric Diefenbach

32
Construct XIII, 1982
Polaroid Polacolor ER photograph
9 1/3 × 7 1/3 in. (23.7 × 18.6 cm)
Courtesy of the artist and Bortolami,
New York

33
Construct XIX, 1982
Polaroid Polacolor ER photograph
7 1/3 × 9 1/3 in. (18.6 × 23.7 cm)
Courtesy of the artist

34
Construct XVIII-Y, 1982
Polaroid Polacolor ER photograph
7 1/3 × 9 1/3 in. (18.6 × 23.7 cm)
Courtesy of the artist

35
Construct LB/1, 1982
Polaroid Polacolor ER photograph
7 1/3 × 9 1/3 in. (18.6 × 23.7 cm)
Courtesy of the artist and Kadel
Willborn Gallery, Düsseldorf, Germany

36
Construct LB/5, 1982
Polaroid Polacolor ER photograph
9 1/3 × 7 1/3 in. (23.7 × 18.6 cm)
Collection of Stefania Bortolami,
New York

37
Construct LB/6, 1982
Polaroid Polacolor ER photograph
9 1/3 × 7 1/3 in. (23.7 × 18.6 cm)
Collection of the University Art
Museum, California State University
Long Beach

38
Construct PC/IX, 1982
Polaroid 20 × 24 Polacolor photograph
24 × 20 in. (61 × 50.8 cm)
Collection of Stefania Bortolami,
New York

39
Construct PC/XI, 1982
Polaroid 20 × 24 Polacolor photograph
24 × 20 in. (61 × 50.8 cm)
Courtesy of the artist and Gallery
Luisotti, Santa Monica

40
Construct XVI, 1982
Silver dye bleach print (Cibachrome)
37 × 29 1/2 in. (101.6 × 76.2 cm)
Private Collection, New Jersey

41
Construct NYC-4, 1983
Polaroid 20 × 24 Polacolor photograph
24 × 20 in. (61 × 50.8 cm)
Courtesy of the artist and Gallery
Luisotti, Santa Monica

42
Construct XXII, 1983
Polaroid 20 × 24 Polacolor photograph
24 × 20 in. (61 × 50.8 cm)
Collection of Diana Billes, Toronto

43
Triptych II, 1983
Silver dye bleach print (Cibachrome)
Three parts, 37 × 29 1/2 in.
(94 × 74.9 cm) each;
37 × 89 1/2 in. (94 × 227.3 cm) overall
Courtesy of the artist and Kadel
Willborn Gallery, Düsseldorf, Germany

44
Construct NYC-12, 1984
Silver dye bleach print (Cibachrome)
37 × 29 1/2 in. (94 × 74.9 cm)
Los Angeles County Museum of Art,
Gift of Sue and Albert Dorskind

45
Construct NYC-16, 1984
Silver dye bleach print (Cibachrome)
29 1/2 × 37 in. (74.9 × 94 cm)
Los Angeles County Museum of Art,
Gift of Sue and Albert Dorskind

46
Construct NYC-17, 1984
Silver dye bleach print (Cibachrome)
29 1/2 × 37 in. (74.9 × 94 cm)
Los Angeles County Museum of Art,
Gift of Sue and Albert Dorskind

47
Construct XXVII, 1984
Polaroid 20 × 24 Polacolor photograph
24 × 20 in. (61 × 50.8 cm)
Courtesy of the artist

48
Diptych II Construct XXX-XXIX, 1985
Silver dye bleach print (Cibachrome)
Two parts, 37 × 29 1/2 in.
(94 × 74.9 cm) each
37 × 59 in. (94 × 149.9 cm) overall
Collection of Darlene and Jorge M. Pérez

49
Inside Outside/Stages of Light, 1985
Video documentation of performance
at the Brooklyn Academy of Music.
Choreography: Margaret Jenkins;
dancers/collaborators: Melissa Rolnick,
Mercy Sidbury, Livia Blankman,
Ellie Klopp, Bryan Chalfant, and
Greg Gibble; costumes and set design:
Barbara Kasten; lighting: Sara Linnie
Slocum with Barbara Kasten; sound
score and design: Bill Fontana;
videography: Mark Robison
Courtesy of the artists and Collection
of the BAM Hamm Archives, Brooklyn
Academy of Music

50
Construct 32, 1986
Silver dye bleach print (Cibachrome)
37 × 29 1/2 in. (94 × 74.9 cm)
Collection of Marwan and Hana Dalloul

51
Construct 33, 1986
Silver dye bleach print (Cibachrome)
29 1/2 × 37 in. (74.9 × 94 cm)
Courtesy of the artist and Gallery
Luisotti, Santa Monica

52
Metaphase 3, 1986
Silver dye bleach print (Cibachrome)
37 × 29 1/2 in. (94 × 74.9 cm)
Courtesy of the artist and Bortolami,
New York

53
Metaphase 5, 1986
Silver dye bleach print (Cibachrome)
37 × 29 1/2 in. (94 × 74.9 cm)
Courtesy of the artist and Bortolami,
New York

54
Architectural Site 7,
July 14, 1986, 1986
Location: World Financial Center,
New York
Architect: César Pelli
Silver dye bleach print (Cibachrome)
60 ½ × 48 in. (153.7 × 121.9 cm)
Courtesy of the artist

55
Architectural Site 8,
December 21, 1986, 1986
Location: Loyola Law School,
Los Angeles
Architect: Frank Gehry
Silver dye bleach print (Cibachrome)
60 ½ × 48 in. (153.7 × 121.9 cm)
Collection of the Museum of
Contemporary Art Chicago,
gift of Michael J. Wong, M.D. and
Marion C. Fay 2013.20

56
Architectural Site 9,
December 21, 1986, 1986
Location: Loyola Law School,
Los Angeles
Architect: Frank Gehry
Silver dye bleach print (Cibachrome)
29 ½ × 37 in. (76.2 × 101.6 cm)
Courtesy of the artist

57
Architectural Site 10,
December 22, 1986, 1986
Location: Museum of Contemporary
Art, Los Angeles
Architect: Arata Isozaki
Silver dye bleach print (Cibachrome)
60 ½ × 48 in. (153.7 × 121.9 cm)
Courtesy of the artist

58
Architectural Site 17,
August 29, 1988, 1988
Location: High Museum of Art, Atlanta
Architect: Richard Meier
Silver dye bleach print (Cibachrome)
48 × 61 in. (121.9 × 154.9 cm)
Courtesy of the artist

59
The Cliffs, 1990
Location: Puye Cliff Dwelling,
Santa Clara Pueblo, New Mexico
Silver dye bleach print (Cibachrome)
36 ¼ × 28 ¾ in. (101.6 × 76.2 cm)
Courtesy of the artist

60
Axis Mundi, 1990
Location: Puye Cliff Dwelling,
Santa Clara Pueblo, New Mexico
Silver dye bleach print (Cibachrome)
36 ¼ × 28 ¾. (101.6 × 76.2 cm)
Courtesy of the artist

61
Tanagra Goddess IV, 1995
Silver dye bleach print (Cibachrome)
5 × 4 in. (12.7 × 10.2 cm)
Courtesy of the artist

62
Tanagra Goddess VI, 1995
Silver dye bleach print (Cibachrome)
5 × 4 in. (12.7 × 10.2 cm)
Courtesy of the artist

63
Tanagra Goddess IX, 1995
Silver dye bleach print (Cibachrome)
5 × 3 ¾ in. (12.7 × 9.5)
Courtesy of the artist

64
Tanagra Goddess X, 1995
Silver dye bleach print (Cibachrome)
5 × 3 ¾ in. (12.7 × 9.5)
Courtesy of the artist

65
6.Amphora-Aegean,
5th Century BC, 1996
Cyanotype
30 × 22 in. (76.2 × 55.9 cm)
Courtesy of the artist

66
46.Amphora-Rhodes,
2nd Century BC, 1996
Cyanotype
60 × 22 in. (152.4 × 55.9 cm)
Courtesy of the artist

67
Studio Construct 8, 2007
Archival pigment print
53 ¾ × 43 ¾ in. (136.5 × 111.1 cm)
Courtesy of the artist and Bortolami,
New York

68
Studio Construct 17, 2007
Archival pigment print
53 ¾ × 43 ¾ in. (136.5 × 111.1 cm)
Collection of Rodney Lubeznik
and Susan Goodman

69
Studio Construct 69, 2008
Archival pigment print
53 ¾ × 43 ¾ in. (136.5 × 111.1 cm)
Collection of Kathryn Fleck
Persach, Aspen

70
Incidence 3, 2010
Archival pigment print
53 ¾ × 43 ¾ in. (136.5 × 111.1 cm)
Courtesy of the artist and Bortolami,
New York

71
Studio Construct 125, 2011
Archival pigment print
53 ¾ × 43 ¾ in. (136.5 × 111.1 cm)
Courtesy of the artist and Bortolami,
New York

72
Scene I, 2012
Archival pigment print
54 ½ × 43 ½ in. (138.4 × 110.5 cm)
Collection of Gregory and
Aline Gooding

73
Scene III, 2012
Archival pigment print
54 ½ × 43 ½ in. (138.4 × 110.5 cm)
Courtesy of the artist and Kadel
Willborn Gallery, Düsseldorf, Germany

74
Scene VII, 2012
Archival pigment print
54 ½ × 43 ½ in. (138.4 × 110.5 cm)
Courtesy of the artist and Kadel
Willborn Gallery, Düsseldorf, Germany

75
Transposition 7, 2014
Fujiflex digital print
60 × 48 in. (152.4 × 121.9 cm)
Courtesy of the artist

76
Transposition 8, 2014
Fujiflex digital print
60 × 48 in. (152.4 × 121.9 cm)
Courtesy of the artist

77
Axis, 2015
HD video, color, silent,
5:20 min. loop,
masonite, paint
26 × 14 ft. (7.9 × 4.3 m)
Courtesy of the artist

Solo Exhibitions

2015

Barbara Kasten: Stages, Institute of
Contemporary Art, University of
Pennsylvania, Philadelphia, curated
by Alex Klein, February 4–August 16

Barbara Kasten, Bortolami Gallery, New
York, April 2–May 2

2013

Scenes, Kadel Willborn Gallery,
Düsseldorf, May 24–July 6

2012

Behind the Curtain, Jessica Silverman
Gallery, San Francisco, December
14–January 26, 2013

2011

*REMIX: Barbara Kasten w/Lucky
Dragons*, Applied Art, Chicago,
March 12–May 31

A Matter of Perspective, Kadel Willborn
Gallery, Karlsruhe, Germany, May
15–June 26

Ineluctable, Tony Wight Gallery,
Chicago, September 9–October 22

*Barbara Kasten: Experimental
Photography From the 1970s*,
organized in conjunction with the
Getty Foundation initiative *Pacific
Standard Time: Art in LA 1945–1980*,
Gallery Luisotti, Santa Monica, CA,
November 19–January 7, 2012

2010

Shadow = Light, Gallery Luisotti, Santa
Monica, CA, January 16–March 13

Abstracting… Light, Almine Rech
Gallery, Paris, May 6–June 19

2009

Through a Glass Darkly, SubCity
Projects, Chicago, October 9–
November 13

2007

Barbara Kasten: Constructs 1979–1983,
Stephen Daiter Gallery, Chicago,
November 2–December 22

2006

Constructs, Yancey Richardson Gallery,
New York, November 30–January 27,
2007

2004

*Abstractions and the Neo-Cubist Order:
Photographs of Barbara Kasten*,
Florida Museum of Photographic
Arts (formerly the Tampa Gallery of
Photographic Arts), Tampa, February
7–April 18

Shadow Traces, Gallery Luisotti, Santa
Monica, CA, March 27–May 15

2002

Barbara Kasten: Reflections of Egypt,
Art Museum, The University of
Memphis, November 15–January 18,
2003

2001

Constructs: Works from 1979 to 1986,
Gallery Luisotti, Santa Monica, CA,
March 24–May 12

2000

Barbara Kasten: Mythic Figures,
Smallworks Gallery, Las Vegas,
April 28–June 10

1999

Barbara Kasten, John Weber Gallery,
New York, February 13—March 13

Mythical Figures, Gallery RAM (now
Gallery Luisotti), Santa Monica, CA,
September 18–November 6

1997

Tanagra Goddesses, Yancey
Richardson Gallery, New York,
September 4–October 11

Smallworks Gallery, Las Vegas

1996

Barbara Kasten: Buried, Herbert F.
Johnson Museum of Art, Cornell
University, Ithaca, NY, curated by
Carl Schafer, January 20–March 17

*Barbara Kasten: Goddesses, Temples
& Relics*, Yancey Richardson Gallery,
New York, May 9–June 15

*Barbara Kasten: Through the lens . . .
and back*, Frederick Spratt Gallery,
San Jose, CA, September 7–
October 28

*Buried: Goddesses, Temples &
Amphoras*, Gallery RAM (now
Gallery Luisotti), Santa Monica, CA,
September 7–November 9

1995

Barbara Kasten 1992–1994,
Contemporary Art Centre, Vilnius,
Lithuania, May 19–June 18

Parchman Stremmel, San Antonio

1993

Barbara Kasten, Place Sazaby/Gallery
RAM (now Gallery Luisotti),
Los Angeles

John Weber Gallery, New York

1992

Barbara Kasten: El Médol, Tinglado 2,
Tarragona, Spain, curated by Chantal
Grande and Glòria Malé, December–
February 1993

d.p. Fong and Spratt Gallery, San Jose,
CA

John Weber Gallery, New York

1991

The Pueblos Series, URBI et ORBI
Galerie, Paris, March 23–April 22

*Barbara Kasten: A Retrospective
1980–1990*, Photo Forum, Pittsburgh,
October 30–December 4

Barbara Kasten: Works from 1986–1990,
Spirit Gallery, Santa Fe, December
21–January 21

PARCO Exposure Gallery, Tokyo

1990

Cliff Dwellings, Ehlers Caudill Gallery,
Chicago, November 16–
December 22

John Weber Gallery, New York

1989

Barbara Kasten: Architectural Sites,
International Center of Photography,
New York, September 15–November
1; traveled to: The University of the
Arts, Philadelphia, November 10–
December 22

Krygier/Landau Contemporary Art,
Santa Monica, CA

1988

Barbara Kasten: Architectural Sites, Fay
Gold Gallery, Atlanta, October 7–
November 2

1987

*Separate Realities: The Photographs
of Barbara Kasten*, John Michael
Kohler Arts Center, Sheboygan, WI,
May 17–August 9

Architectural Sites, John Weber Gallery, New York

Barbara Kasten, KiMo Theater, Albuquerque, NM, curated by Joseph Shuldiner

Fine Arts Gallery, Edward Crown Center, Loyola University of Chicago

Richard Green Gallery, Los Angeles

1986

Barbara Kasten, Yurakucho Asahi Gallery, Tokyo, curated by Akio Obigane, October 6–November 5; traveled to: Keihan Gallery of Arts and Science, Osaka, November 14–26

Foster Goldstrom Gallery, Dallas

John Weber Gallery, New York

1985

Recent Photographic Constructions, Vision Gallery, Boston, March 2–31

Barbara Kasten, Center for Creative Photography, University of Arizona, Tucson, April 28–June 20

Exact Seeing, Capp Street Project, San Francisco, May 14–June 22

Toward an Interconnectedness of All Things, University Art Galleries, Wright State University, Dayton, OH, September 23–October 24

Barbara Kasten Constructs, Port Washington Library, Port Washington, NY, November 6–December 9

G. H. Dalsheimer Gallery, Baltimore

Joe and Emily Lowe Art Gallery, College of Visual and Performing Arts, Syracuse University, NY

Santa Barbara Museum of Art, CA

1984

Karl Bornstein Gallery, Santa Monica, CA, March 20–April 21

Barbara Kasten, John Weber Gallery, New York, September 6–29

Museum of Contemporary Photography, Columbia College Chicago

1983

Barbara Kasten, Carol Taylor Art, Dallas, November 29–December 23

Barbara Kasten: New Work in Cibachrome and Polaroid, Bernie's Restaurant, Los Angeles

1982

Centric 2: Barbara Kasten, installation/photographs, The Art Museum and Galleries, California State University, Long Beach, curated by Constance W. Glenn, February 8–March 7

Barbara Kasten: Photographs, John Weber Gallery, New York, September 11–October 2

Barbara Kasten: Contemporary Photographs, Herbert F. Johnson Museum, Cornell University, Ithaca, NY, September 21–October 17

University of Bridgeport, CT

1981

Barbara Kasten: Constructions, Polaroid Photographs, International Museum of Photography at George Eastman House, Rochester, NY, curated by Robert Sobieszek, November 24–January 3, 1982

1978

Barbara Kasten: Non-Camera Blueprints, The Richard L. Nelson Gallery, University of California, Davis, January 3–25

1977

Barbara Kasten Paintings, Simon Lowinsky Gallery, San Francisco, October 11–November 19

1976

Barbara Kasten: Photogenic Drawings, Jack Glenn Gallery, Newport Beach, CA, January 10–February 6

The Phoenix Gallery, San Francisco

Visual Studies Workshop, Rochester, NY

1974

Brand Library and Art Center, Glendale, CA

1973

Barbara Kasten: Seated Forms, Isabelle Percy West Gallery, California College of Arts and Crafts, Oakland, September 5–26

1972

Fiber Sculpture, Galeria Rzeźby, Warsaw, Poland

1971

Fiber Sculpture, Anneberg Gallery, San Francisco, August 11–September 4

Two-Person Exhibitions

2013

Barbara Kasten & Sara Barker, Mary Mary, Glasgow, at Laura Bartlett Gallery, London, October 11–November 23

2012

Barbara Kasten and Justin Beal: Constructs, Abrasions, Melons and Cucumbers, Bortolami Gallery, New York, June 21–August 3

Tektonika: Barbara Kasten & Magicgruppe Kulturobjekt, Kunstverein Nürnberg, Nuremberg, Germany, July 7–October 7

2011

Constructions: Barbara Kasten and Alexandra Leykauf, Carl Freedman Gallery, London, January 27–February 26

1986

Barbara Kasten/Gwenn Thomas, Reynolds/Minor Gallery, Richmond, VA

1984

Barbara Kasten/Timothy Lamb, Film-in-the-Cities Gallery, St. Paul

1982

Stanley Bowman/Barbara Kasten, San Francisco Museum of Modern Art, August 13–September 26

1974

Barbara Kasten and Leland Rice, Ross-Freeman Gallery, Northridge, CA

1971

Fiber Sculpture by Barbara Kasten and Image Banners by Maggie Brosnan, Financial Plaza of the Pacific, Honolulu, June 17–July 15

Group Exhibitions

2015

Extended Compositions, Kunstquarter Bethanian, Radialsystem V, St. Johannes Evangelist Church, Berlin, March 6–29

Colors of the Southwest, New Mexico Museum of Art, Santa Fe, March 6–September 20

Women and Abstraction, Cornell Fine Arts Museum, Rollins College, Winter Park, FL, curated by Amy Galpin, April 18–August 2

Part Picture, Museum of Contemporary Canadian Art, Toronto, organized in conjunction with the Scotiabank CONTACT Photography Festival, curated by Chris Wiley, May 1–31

Imagine Reality—RAY 2015 Fotografieprojekte Frankfurt / RheinMain, Museum für Moderne Kunst, Museum für Angewandte Kunst, and Fotografie Forum, Frankfurt, Germany, curated by Peter Gorschlüter, June 20–September 20

2014

1980s Style: Image and Design in the Dorsky Museum, Sara Bedrick Gallery, Samuel Dorsky Museum of Art, State University of New York at New Paltz, curated by Daniel Belasco, February 5–July 13

A World of Its Own: Photographic Practices in the Studio, Museum of Modern Art, New York, curated by Quentin Bajac with Lucy Gallun, February 8–October 5

Photo Lab, New Mexico Museum of Art, Santa Fe, March 7–July 26, 2015

The Will to Architecture, Museum of Fine Arts, Houston, April 1–July 6

The Invented Image: Photographs from the Collection, High Museum of Art, Atlanta, July 29–January 4, 2015

The Material Image, Marianne Boesky Gallery, New York, curated by Debra Singer, September 13–October 25

Altarations: Built, Blended, Processed, University Galleries, Florida Atlantic University, Boca Raton, November 21–February 28, 2015

2013

Beyond the Object, Brand New Gallery, Milan, Italy, January 15–March 9

Decenter: An Exhibition on the Centenary of the 1913 Armory Show, Henry Street Settlement's Abrons Arts Center, New York, curated by Adrianna Campbell and Daniel S. Palmer, February 17–April 7; traveled to: Luther W. Brady Art Gallery, George Washington University, Washington, DC, September 11–December 20

Color Rush: 75 Years of Color Photography in America, Milwaukee Art Museum, February 22–May 19

Black Rabbit, White Hole, Samuel Freeman Gallery, Los Angeles, March 2–April 6

The Polaroid Years: Instant Photography and Experimentation, Francis Lehman Loeb Art Center, Vassar College, Poughkeepsie, NY, April 12–June 30; traveled to: Leigh Block Museum of Art, Northwestern University, Evanston, IL, September 20–December 1

The 5th Dimension, Ricou Gallery, Brussels, May 18–July 6

Think First, Shoot Later: Photography from the MCA Collection, Museum of Contemporary Art Chicago, May 18–November 10

Flow, curated by Zuzana Blochová and Patricia Talacko, Prague Biennale, June 6–September 15

Photo 3: Photography, Reconstructed, curated by Pavel Vancát, Prague Biennale, June 6–September 15

Museum of Modern Art and Western Antiquities Department of Light Recordings, Section IV: Lens Drawings, Marian Goodman Gallery, Paris, curated by Jens Hoffman, June 28–August 2

A Democracy of Images: Photographs From the Smithsonian American Art Museum, Washington, DC, June 28–January 5, 2014

The Stand In (or A Glass of Milk), Public Fiction, Los Angeles, curated by Alexandra Gaty and Lauren Mackler, September 6–November 27

Color! American Photography Transformed, Amon Carter Museum of American Art, Fort Worth, TX, October 5–January 5, 2014

Histories/Photographies, DePaul Art Museum, Chicago, October 11–December 8

See the Light—Photography, Perception, Cognition: The Marjorie and Lenon Vernon Collection, Los Angeles County Museum of Art, October 27–March 23, 2014

The Pommery Experience #11, An Odyssey: 30 Years of FRAC Champagne-Ardenne, Reims, France, November 15–June 30, 2014

2012

Construct, Mary Mary, Glasgow, February 7–April 11

Towards a Warm Math, On Stellar Rays Gallery, New York, curated by Chris Wiley, April 22–June 3

Second Nature: Abstract Photography Then and Now, deCordova Sculpture Park and Museum, Lincoln, MA, May 26–March 3, 2013

Lost Line, Los Angeles County Museum of Art, curated by Rita Gonzalez, November 25–February 24, 2013

2011

Distilled Moments, Santa Barbara Museum of Art, CA, May 28–September 18

From Polaroid to (IM)POSSIBLE, Masterpieces of Instant Photography, The WestLicht Collection, Vienna, June 17–August 21

Untitled Document, Tony Wight Gallery, Chicago, June 20–July 30

Channel to the New Image, Friedrich Petzel Gallery, New York, curated by Jason Murison, June 30–August 5

2010

Starburst: The History of Color Photography in the 1970s, Cincinnati Art Museum, curated by Kevin Moore, February 13–May 9; traveled to: Princeton University Art Museum, Princeton, NJ, July 8–September 26

Let There Be Geo, A & D Gallery, Columbia College Chicago, March 4–April 24

Karl Haendel & Walead Beshty, Sheree Hovsepian, and Barbara Kasten, Monique Meloche, Chicago, March 20–May 15

In a Paperweight, Tony Wight Gallery, Chicago, April 16–May 15

Terminus Ante Quem: Shane Huffman, Barbara Kasten, Anthony Pearson, Erin Shirreff, Shane Campbell Gallery, Chicago, curated by Anthony Pearson, May 1–June 12

Just A Matter of Time, Kadel Willborn Gallery, Karlsruhe, Germany, July 3–August 31

Immaterial, Ballroom Marfa, Marfa, TX, October 1–February 20, 2011

2009

A Twilight Art, Harris Lieberman Gallery, New York, January 17–February 28

Constructivismes, Almine Rech Gallery, Brussels, curated by Olivier Renaud-Clément, January 23–February 27; traveled to: Andrea Rosen Gallery, New York, April 24–June 10

The Edge of Vision: The Rise of Abstraction in Photography, Aperture Gallery, New York, curated by Lyle Rexer, May 15–July 9; traveled to: Center for Creative Photography, University of Arizona, Tucson, September 4–November 28, 2010; Cornell Fine Arts Museum, Winter Park, FL, January 4–March 30, 2011; Ronna and Eric Hoffman Gallery, Lewis and Clark College, Portland, OR, January 19–March 18, 2012; Schneider Museum of Art, Ashland, OR, May 10–June 15, 2012; Clay Center for the Arts, Charleston, WV, July 14–September 16, 2012; Louisiana Art & Science Museum, Baton Rouge, LA, January 16–April 14, 2013

Polaroid: Exp 09.10.09, Atlas Gallery, London, October 9–January 16, 2010

Picturing the Studio, Sullivan Galleries, School of the Art Institute of Chicago, curated by Michelle Grabner and Annika Marie, December 11–February 13, 2010

2008

Re-Considering Color: Postmodern Classical II, Olympic Tower Atrium, Onassis Cultural Center, organized in collaboration with City College, City University of New York, New York, April 21–June 1

Contemporary Abstractions, Yancey Richardson Gallery, New York, December 11–February 7, 2009

2006

Polaroid Collection, Alinari National Museum of Photography, Florence, Italy (multiple venues)

2004

In the Center of Things: A Tribute to Harold Jones, Center for Creative Photography, University of Arizona, Tucson, April 3–July 18

2002

Go On Being, Our Blue Star!, Tokyo Fuji Art Museum, Tokyo, April 16–June 2

Through the Looking Glass, Catherine Edelman Gallery, Chicago, July 12–August 30

American Perspectives: Photographs from the Polaroid Collection, Photographic Resource Center and the Boston University Art Gallery, Boston, November 22–January 26, 2003

2001

City 2000: Chicago in the Year 2000, Chicago Cultural Center

Photograms from the 20th Century, Jonson Gallery, University of New Mexico, Albuquerque

Zeros and Ones, Moser Performing Arts Center Gallery, University of St. Francis, Joliet, IL

2000

Cameraless Wonders, The Art Institute of Chicago, June 10–November 5

Architectural Constructs in Contemporary Photography, Julie Saul Gallery, New York, July 7–August 18

American Perspectives: Photographs from the Polaroid Collection, Tokyo Metro Museum of Photography, Tokyo, September 12–November 12

Thomas Joshua Cooper, Anna Fox, Barbara Kasten, Seydou Keita, Tracey Moffatt and Gary Hillberg, Museum of Contemporary Photography, Columbia College Chicago, September 23–November 22

Exhibition Highlights, 1995–2000, Yancey Richardson Gallery, New York

First Works, Glass Curtain Gallery, Columbia College Chicago

1999

Contemporary Classicism, Neuberger Museum, Purchase, NY, curated by Judy Collischam, February 21–June 6

An Eclectic Focus: Photographs from the Vernon Collection, Santa Barbara Museum of Art, CA, June 26–November 5

Ancient History, Yancey Richardson Gallery, New York

Innovation/Imagination: 50 Years of Polaroid Photography, Ansel Adams Center for Photography, San Francisco

1998

4 P: platinum, pixilated, pinhole, polaroid, Caldwell University, Caldwell, NJ

Photography's Multiple Roles: Art, Document, Market, Science, Museum of Contemporary Photography, Columbia College Chicago

1997

New Realities: Hand-Colored Photographs 1839 to the Present, University of Wyoming Art Museum, Laramie, curated by Lee Marks and Gerald Lang, February 8–May 18; traveled to: Boise Art Museum, ID, June 26–August 17; James A. Michener Museum of Art, Doylestown, PA, November 22–February 8, 1998; DeCordova Museum and Sculpture Park, Lincoln, MA, March 28–May 24, 1998; Yellowstone Art Center, Billings, MT, August–September 1998

Connexions and Disconnexions: Manuela Filiaci, Barbara Kasten, Susanna Tanger, Gwenn Thomas, Nuova Icona, Venice, Italy, March 27–April 20

Eye of the Beholder: Photographs from the Avon Collection, International Center of Photography, New York, September 12–November 13

Masterpieces of Photography from the Merrill Lynch Collection, James A. Michener Museum of Art, Doylestown, PA, December 13–March 8, 1998

1996

This Is A Set-Up: Fab Photo/Fictions, Dorothy Uber Bryn Gallery, Bowling Green State University, OH, October 4–November 8

Image de la Mère, Le Forum des Halles, Paris

1995

Bit by Bit: Postphotographic Imaging, Hunter College, City University of New York, October 10–November 22

Targeting Images, Objects + Ideas, Museum of Contemporary Photography, Columbia College Chicago

1994

Experimental Vision: The Evolution of the Photogram Since 1919, Denver Art Museum, January 15–March 27

Tradition and the Unpredictable: The Allan Chasanoff Photographic Collection, Museum of Fine Arts, Houston, January 16–March 27

Metamorphoses: Photography in the Electronic Age, The Museum of the Fashion Institute of Technology, New York, September 8–October 29; traveled to: Blaffer Gallery, University of Houston; Tampa Museum of Art; Philadelphia Museum of Art, June 22–August 18, 1996; San Jose Museum of Art, CA; Kemper Museum of Contemporary Art, Kansas City, MO; Ackland Art Museum, Chapel Hill, NC

Defining Color, TZ Art & Co., New York

Portrait of My Mother, French Institute, Edinburgh, Scotland; traveled to: London

Seurat Grows Up: Large Scale Digital Prints, Maine Coast Artist, Rockport, ME

Stilled Pictures—Still Life, University of Rhode Island, Kingston

1993

American Made: The New Still Life, Isetan Museum of Art, Tokyo, curated by Patty Carroll, June 3–15; traveled to: Hokkaido Obihiro Museum of Art, Hokkaido, Japan, November 13–December 19; Royal College of Art, London

1992

20th Century Photography, Boca Raton Museum of Art, FL, curated by Timothy Eaton, February 21–March 29

Proof: Los Angeles Art and the Photograph, 1960–1980, Laguna Art Museum, Laguna Beach, CA, curated by Charles Desmarais, October 31–January 17, 1993; traveled to: deCordova Museum and Sculpture Park, Lincoln, MA, February 13–April 11, 1993; The Friends of Photography, Ansel Adams Center, San Francisco, June 19–August 22, 1993; Montgomery Museum of Fine Arts, AL, September 12–November 7, 1993; Tampa Museum of Art, November 21–January 16, 1994; Des Moines Art Center, March 5–June 5, 1994

California, The Cultural Edge, Directors Guild of America, Los Angeles, November 10–22

New Acquisitions/New Work/New Directions, Los Angeles County Museum of Art

San Jose Art in Public Places Program, Hilton Hotel and Tower, San Jose, CA, organized by Frederick Spratt Gallery

Set and Setting, Berland Hall Gallery, New York

1991

Focus on Photography 1980-1990, Maier Museum of Art, Randolph College (formerly Randolph-Macon Woman's College), Lynchburg, VA, February 24–March 31

To Collect the Art of Women: The Jane Reese Williams Photography Collection, New Mexico Museum of Art, Santa Fe, December 21–May 24, 1992

20th Anniversary Exhibition, John Weber Gallery, New York

Site Work: Architecture in Photography Since Early Modernism, The Photographers' Gallery, London

1990

Constructed Spaces, Photographic Resource Center, Boston, March 9–April 22, curated by Anita Douthat, in collaboration with the Boston Architectural Center, March 19–April 27

John Weber Gallery, New York

1989

Art of the '80s from the Collection of Chemical Bank, Montclair Art Museum, NJ, January 29–April 9

The Modernist Still Life—Photographed, Gallery 210, University of Missouri–St. Louis, curated by Jean S. Tucker, February 20–March 17; traveled to: Gallery of Art, University of Missouri–Kansas City, April 21–May 19; Museum of Art and Archaeology, University of Missouri–Columbia, June 3–July 2

Artists of the '80s: Selected Works from the Maslow Collection, Sordoni Art Gallery, Wilkes University, Wilkes-Barre, PA, April 9–May 7

The Photography of Invention: American Pictures of the 1980s, Smithsonian American Art Museum (formerly the National Museum of American Art), Washington, DC, curated by Joshua P. Smith and Merry A. Foresta, April 28–August 13; traveled to the Museum of Contemporary Art, Chicago; Walker Art Center, Minneapolis

Decisive Monuments, Ehlers Caudill Gallery Limited, Chicago, May 9–June 24

Six Ideas in Photography: A Celebration of Photography's Sesquicentennial Drawn from the Collection of Frederick P. Currier, Grand Rapids Art Museum, Grand Rapids, MI, June 2–July 30

Benefit for the Pollock-Krasner House and Study Center, Vered Gallery, East Hampton, NY, August 12–31

Constructed Realities: The Art of Staged Photography, Kunstverein München, Munich, Germany, October 28–December 9; traveled to: Kunsthalle Nürnberg, Nuremberg, Germany; Forum Böttcherstrasse, Bremen; Badischer Kunstverein, Karlsruhe, Germany

Abstraction in Photography, Zabriskie Gallery, New York

Beyond Photography, Krygier/Landau Contemporary Art, Los Angeles

Decade by Decade: Twentieth-Century American Photography from the Collection of the Center for Creative Photography, Center for Creative Photography, University of Arizona, Tucson

Photographs from Private Twin Cities Collections, Minneapolis Institute of Arts

1988

M. Anwal Kamal Collection of Art, Cummer Gallery of Art, Jacksonville, FL, curated by Margaret Koscielny, March 10–April 3

The Art of Persuasion: A History of Advertising Photography, International Museum of Photography at George Eastman House, Rochester, NY, curated by Robert Sobieszek; traveled to: International Center of Photography, New York, March 19–May 7

Contemporary Icons & Explorations: The Goldstrom Family Collection, Figge Art Museum (formerly the Davenport Museum of Art), Davenport, IA, curated by Daniel E. Stetson, April 13–June 21

Lorrin and Deane Wong Collection, Ettinger & Reynolds Galleries, Art Institute of Southern California, Laguna Beach, October–November 18

8 Visions: Works by 8 Contemporary American Women, Tokyo
John Weber Gallery

Selections 4, Photokina 1988, Polaroid Gallery, Cologne, Germany

1987

Through the Lens: Forty Years of Photography, Fresno Arts Center and Museum, CA, curated by Kathryn Funk, May 17–August 16

Photography and Art: Interactions Since 1946, Los Angeles County Museum of Art, curated by Kathleen McCarthy Gauss and Andy Grundberg, June 4–August 30; traveled to: Fort Lauderdale Museum of Art, FL

A Visible Order: Recent Photographic Still Lifes, Gallery 400, College of Architecture, Art, and Urban Planning, The University of Illinois at Chicago, curated by Paul Laster and Renée Riccardo, October 28–December 4; traveled to: Otis Art Institute of Parsons School of Design, Los Angeles, April 5–30, 1988

The Spiral of Artificiality, Hallwalls, Buffalo, curated by Paul Laster and Renée Ricardo, November 7–December 19

28 Great Photographers of the World in Tokyo, Espace Printemps, Ginza, Tokyo

ART AGAINST AIDS, benefit for The American Foundation for AIDS Research, John Weber Gallery, New York

Fabrications: Staged, Altered, and Appropriated Photographs, International Center of Photography, New York, curated by Anne H. Hoy; traveled to: Sert Gallery, Carpenter Center for the Visual Arts, Harvard University, Cambridge, MA

Light, Olympia & York, Park Avenue Atrium, New York

Selections from the John Weber Gallery, New York, Fay Gold Gallery, Atlanta

The Composed Exposure, Jeffrey Linden Gallery, Hollywood, CA

1986

Photographic Fictions, Whitney Museum of American Art, Fairfield County, Stamford, CT, April 4–May 28

Artists in Mid-Career, San Francisco Museum of Modern Art, curated by Dorothy Vandersteel, May 29–July 20

CrossCurrents II, San Francisco Museum of Modern Art, curated by Van Deren Coke, August 15–November 23

Art and Advertising: Commercial Photography by Artists, International Center of Photography, New York, September 14–November 9

Poetics of Space: Contemporary Photographic Works, New Mexico Museum of Art (formerly the Museum of Fine Arts), Santa Fe, curated by Steven A. Yates, December 19–March 22, 1987

A Southern California Collection, Cirrus Gallery, Los Angeles

A Visible Order, Lieberman & Saul Gallery, New York

Context as Content, The Catskill Center for Photography, Woodstock, NY

Out of the Darkroom, Art of the Darkroom, Euphrat Gallery, De Anza, Cupertino, CA

The Back Room, Saxon-Lee Gallery, Los Angeles

Vital Space, Mokotoff Gallery, New York

1985

Images of Excellence, International Museum of Photography at George Eastman House, Rochester, NY, January 1–April 26

Paris, New York, Tokyo, Tsukuba Museum of Photography, Tokyo, curated by Etsuro Ishihara, March 9–September 16; traveled to: Miyagi Museum of Art, Sendai, Japan, November 9–December 22

Extending the Perimeters of 20th Century Photography, San Francisco Museum of Modern Art, August 2–October 6

Illuminating Color: Four Approaches in Contemporary Painting and Photography, Pratt Manhattan Center Gallery, New York, curated by Donna Stein and Lynn Zelevansky, September 9–October 5; in collaboration with the Pratt Institute Gallery, Brooklyn, October 15–November 7

Beautiful Photographs: Work by Twenty-Two Photographers, curated by Gene Thornton, One Penn Plaza, New York

Messages from 1985, Light Gallery, New York

PHOTOGRAMS, John Michael Kohler Arts Center, Sheboygan, WI

1984

Photography in California: 1945–1980, San Francisco Museum of Modern Art, curated by Louise Katzman, January 12–March 13; traveled to: Akron Art Museum, OH, April 6–June 10; Corcoran Gallery of Art, Washington, DC, June 28–August 19; Los Angeles Municipal Art Gallery, September 7–October 21; Herbert F. Johnson Museum of Art, Cornell University, Ithaca, NY, November 9–December 30; High Museum of Art, Atlanta, February 15–April 14, 1985; Museum Folkwang, Essen, West Germany, June 7–August 4, 1985; Musée National d'Art Moderne, Centre Georges Pompidou, Paris, September 6–November 3, 1985; Museum of Photographic Arts, San Diego, CA, January 8–February 24, 1986

Contemporary Constructs: 20 Los Angeles Photographers, Los Angeles Center for Photographic Studies and the Otis Art Institute of Parsons School of Design, Los Angeles, curated by Dinah Berland and David Fahey, March 14–April 18; traveled to: Canon Gallery, Amsterdam, The Netherlands

101 Photographs: Selections from the Arthur and Yolanda Steinman Collection, Santa Barbara Museum of Art, CA

Selections 2, Photokina 1984, Cologne, Germany

1983

Photographers Invite Photographers, N.A.M.E. Gallery, Chicago, curated by Joyce Neimanas and Robert Heinecken, February 18–April 1

Habitats, The Clocktower, New York, curated by Robert Littman, March 9–April 9

Big Pictures By Contemporary Photographers, Museum of Modern Art, New York, curated by John Szarkowski, April 14–June 28

In Color: Ten California Photographers, Oakland Museum, CA, curated by Therese Heyman, May 21–July 17

Photography: The Constructed Image, Castle Gallery, College of New Rochelle, NY, curated by Robert Worth, July 11–September 2

The Alternative Image II: Photography on Nonconventional Supports, John Michael Kohler Arts Center, Sheboygan, WI, curated by Anita Douthat, December 4–February 12, 1984

The Big Picture: 20 × 24 in. Polaroids, Museum of Photographic Arts, San Diego, CA; traveled to: Delaware Art Museum, Wilmington; Akron Museum of Art, OH

Art, Science, and Creativity in Instant Photography, Studio Bordiga, Sforzesco Castle, Milan, Italy

Three-Dimensional Photographs, Castelli Graphics, New York

1982

California Photography, Museum of Art, Rhode Island School of Design, Providence, January 8–February 7

20 × 24 Polaroid, National Academy of Sciences, Washington, DC, February–May

New New York, University of Fine Arts Galleries, School of Visual Arts, Florida State University, Tallahassee, curated by Albert Stewart, March 17–April 17; traveled to: Metropolitan Museum and Art Centers, Coral Gables, FL, July 9–August 30

Color as Form: History of Color Photography, Corcoran Gallery of Art, Washington, DC, April 9–June 6; traveled to: International Museum of Photography at George Eastman House, Rochester, NY, July 2–September 5

An Artistic Conversation, 1931–1982: Poland–USA, ARC Musée d'Art Moderne de la Ville de Paris, curated by Pontus Hultén and Suzanne Pagé, June 24–September 6; traveled to: Ulster Museum, Belfast, Ireland; Douglas Hyde Gallery, Dublin, Ireland; Museum of Modern Art, Lodz, Poland

Studio Work: Photographs by Ten Los Angeles Artists, Los Angeles County Museum of Art, curated by Kathleen McCarthy Gauss, July 22–October 31

Still Life, Clarence Kennedy Gallery, Cambridge, MA, October 19–November 24

6 American Photographers, Friends of Photography, Photokina 1982, Cologne, Germany

Selections 1, Photokina 1982, curated by Manfred Heiting, Cologne, Germany

1981

Altered Images, Center for Creative Photography, University of Arizona, Tucson, curated by Jeanne C. Finley, March 22–May 7

Media Relief, John Weber Gallery, New York, curated by Ronny Cohen and John Weber, June 6–27

Form As Content, Visual Studies Workshop Galleries, Rochester, NY, September 18–November 14

Still Life: Photographs from the Collection of the Museum of Modern Art, Museum of Modern Art, New York, October 8–January 3, 1982

Fabricated to be Photographed, Wright State University, Dayton, OH

Verbatim: Light Dialogues, Grossmont College Gallery, El Cajon, CA

1980

Situational Imagery, Fine Arts Gallery, University of California, Irvine, February 15–March 15

NEA Purchase Award Artists, Center for Creative Photography, University of Arizona, Tuscon, March 2–April 10

Photography's Response to Constructivism, San Francisco Museum of Modern Art, March 21–June 8

Reasoned Space, Center for Creative Photography, University of Arizona, Tucson, curated by Timothy Druckery and Marnie Gillette, April 12–May 22

Color Photographs: Fernandez, Fulton, Kasten, Rome, Robert Freidus Gallery, New York, June 24–July 25

Alternative Visions, The Santa Fe Gallery of Photography

Contemporary Photographs, Fogg Museum, Harvard University, Cambridge, MA

Photographic Scale, Sonoma State University, Sonoma, CA, curated by Marcia Bailey

1979

L.A. Drawing, Teaching Gallery, University of New Mexico, Albuquerque, February 26–March 30

Southern California Invitational 1979, University of Southern California, Los Angeles, curated by Robert Flick, February–April 27

The Altered Photograph, The Institute for Art and Urban Resources, PS 1, Long Island City, NY, April 22–June 10

Attitudes: Photography in the 1970s, Santa Barbara Museum of Art, CA, curated by Fred Parker, May 12–August 5

The New Season: Nine Contemporary Photographers, Witkin Gallery, New York, September 5–October 13

Prints: New Points of View, Western Association of Art Museums and the Crocker Art Museum, Sacramento, CA

Uniquely Photographic, Honolulu Academy of Arts, Honolulu, curated by William Larson

1978

Interchange, Fine Arts Gallery, Mount St. Mary's College, Los Angeles, curated by Jim Murray, January 16–February 26

Wall to Wall, Center for Contemporary Photography (now the Museum of Contemporary Photography), Columbia College Chicago

1977

A Women's Exhibition, Cedars-Sinai Medical Center, Los Angeles, January 9–February 19

A Point of View: Recent Work by Four Los Angeles Artists, Los Angeles Institute of Contemporary Art, curated by Audrey Sanders, June–July 21

Callis, Kasten, Zimmerman, Fisher Art Gallery, University of Southern California, Los Angeles, June 16–July 22

American Art Movements, 1875–1975, University Art Museum, University of New Mexico, Albuquerque

Photogram, Center for Contemporary Photography (now the Museum of Contemporary Photography), Columbia College Chicago

1976

New Acquisitions, University Art Museum, University of New Mexico, Albuquerque

1975

The Gallery as Studio, Florence Rand Lang Art Gallery, Scripps College, Claremont, CA, curated by Ann LeVeque, October 7–November 14

1974

Heavy-Light: Women's Photographic Exhibit, Pasadena City College Gallery, CA, curated by Sylvia Paulus, February 13–March 1

1973

Super Cream: An Invitational Women's Photographic Exhibit, Mackenthaler Cultural Center, Fullerton, CA, curated by Sylvia Paulus, February 25–March 25

Fiber Works: An Exhibition of Works by Twenty Fiber Artists, Lang Art Gallery, Scripps College, Claremont, CA, curated by Neda Al-Hilali, April 3–May 10

1971

Photography Invitational 1971, Arkansas Arts Center, Little Rock, AK, curated by Murray Riss, January 14–February 11; traveled to: The Memphis Academy of Arts, March 1–31

San Francisco Art Institute Centennial Exhibition, The California Palace of the Legion of Honor, San Francisco, January–February 28

Dimension of Fiber, California College of Arts and Crafts Gallery, Oakland, CA, curated by Barbara Kasten, March 4–29

Photo Media, Museum of Contemporary Crafts of the American Crafts Council, New York, curated by Ray Pierotti, September 24–January 2, 1972

Photo Image in Printmaking, San Francisco Museum of Modern Art, October 28–December 12

Edition '71, Walnut Creek Civic Arts Center, CA

Fetish Show, Edward Sherbeyn Gallery, Chicago

Master of Arts/Master of Fine Arts 1971, California College of Arts and Crafts, Oakland, CA

Object Makers 1971, Utah Museum of Fine Arts, Salt Lake City

1970

California Photographers 1970, Memorial Union Art Gallery, University of California, Davis, curated by Fred Parker, April 6–May 9; traveled to: Oakland Museum, Great Hall, Oakland, CA, May 26–June 28; Pasadena Art Museum, CA, July 14–August 23

Concord 7th Art Annual, Concord, CA

Media '70, Walnut Creek Civic Arts Center, CA

National Decorative Arts Invitational, Wichita, KS

Southwest '70, Los Angeles

1969

Reflections Gallery, Oakland, CA

Special Projects

1999

Mein Dualis, 20×24" Polaroid membership print, Museum of Contemporary Photography, Columbia College Chicago

1997

Printed Moments, marketing promotion, LEXMARK International

Temple VIII, membership print, Museum of Contemporary Photography, Columbia College Chicago

The Splendor of Tenochtitlan, photograph, *LIFE Magazine*, Special Issue: The Millennium (Fall 1997)

1995

El Medol as an Iris Print, MUSE-X Editions, Los Angeles

1994

Metamorphoses: Photography in the Electronic Age, *Aperture* portfolio

Tarentella, Photography Consultant, ITVS feature film directed by Helen De Michiel (1995 Release)

1993

The Visit, Art Director and Lighting Designer, Women of the Calabash Music Video, Conduit Communications, Atlanta

Absolut Images portfolio, Photographers + Friends United Against Aids, *American Photo* (May/June 1993)

1992

San Jose, mural, Art Program Commission, Hilton Hotel and Towers and The City of San Jose, CA

House Without Walls, portfolio for New York City Relief, The Buhl Family Foundation, New York

1991

High Heels and Ground Glass, video, 29 minutes, produced by Deborah Irmas and Barbara Kasten, June 29th Productions

1989

Juxtaposition: Pollock-Krasner Triptych, Pollock Krasner House and Study Center, East Hampton, NY, edition of 50

1988

The Interpublic Group of Companies, Inc. Annual Report, New York

1985

"Esquire Collection," *Esquire* 104 no. 3 (September 1985): 47–119

Inside Outside/Stages of Light, choreography with dancers by Margaret Jenkins, costumes and set design by Barbara Kasten, music by Bill Fontana, lighting by Sara Linne Slocum; premiered April 19, 1985, Herbst Theatre, San Francisco Museum of Modern Art; "Next Wave Festival," Brooklyn Academy of Music, October 22–27; KiMO Theatre, Albuquerque, NM, March 20–21, 1987; Theatre Artaud, San Francisco, April 18–26, 1987

1984

Arts + Architecture Portfolio, produced by Freidenrich Contemporary Art for *Arts + Architecture Magazine*, edition of 50

"Margaret Chesney's Affair of the Heart," *Esquire* 102 no. 6 (December 1984): 74–75

"Sins of Our Fathers," *Esquire* 102 no. 6 (December 1984): 264–65

The Photographic Vision, interview, KOCE-TV Telecourse, Coast Community College District, Costa Mesa, CA

1980

Carryl Curran with Robert Flick and Judith Golden, *L.A. Issue: A Portfolio of Photography from Los Angeles* (Los Angeles: Los Angeles Center of Photographic Studies)

Publications

2015

Klein, Alex. *Barbara Kasten: Stages.* Exh. cat. Zurich: JRP/ Ringier; Philadelphia: Institute of Contemporary Art at the University of Pennsylvania.

2014

Mackler, Lauren, and Alexandra Gaty, eds. *The Stand In (or A Glass of Milk).* Exh. cat. With essays by Cara Benedetto, Joseph Mosconi, and Jibade-Khalil Huffman. Los Angeles: Public Fiction.

Philadelphia Museum of Art: Handbook of the Collections. New Haven, CT: Yale University Press; Philadelphia: Philadelphia Museum of Art.

2013

Bussard, Katherine A., and Lisa Hostetler. *Color Rush: American Color Photography from Stieglitz to Sherman.* Exh. cat. New York: Aperture; Milwaukee: Milwaukee Art Museum.

Dong-sun, Jin. *The Scenes of Photo Art.* Seoul: JoongAng Books.

Rohrbach, John. *Color! American Photography Transformed.* Exh. cat. With an essay by Sylvie Pénichon. Austin, TX: University of Texas Press.

The Polaroid Years: Instant Photography and Experimentation. Exh. cat. With essays by Mary-Kay Lombino and Peter Buse. Poughkeepsie, NY: The Frances Lehman Loeb Art Center, Vassar College; New York: DelMonico Books-Prestel.

Trigg, Sarah. *Studio Life: Rituals, Collections, Tools, and Observations on the Artistic Process.* New York: Princeton Architectural Press.

2011

Keinholz, Lyn, Elizabeth Belinski, and Corrine Nelson. *L.A. Rising: SoCal Artists Before 1980.* Los Angeles: The California/International Arts Foundation.

From Polaroid to (IM)POSSIBLE: Masterpieces of Instant Photography—The WestLicht Collection. Exh. cat. Ostfildern: Hatje Cantz.

2010

Immaterial. Exh. cat. Marfa, TX: Ballroom Marfa.

Klein, Alex, and Anthony Pearson. *Terminus Antequem.* Exh. cat. Chicago: Shane Campbell Gallery.

Moore, Kevin. *Starburst: The History of Color Photography in the 1970s.* Exh. cat. With essays by Kevin Moore, Leo Rubinfien, and James Crump. Ostfildern: Hatje Cantz.

2009

Rexer, Lyle. *The Edge of Vision: The Rise of Abstraction in Photography.* Exh. cat. New York: Aperture.

2008

Re-Considering Color: Postmodern Classical II. Exh. cat. New York: Onassis Cultural Center.

2005

Jäger, Gottfried, Rolf H. Krauss, and Beate Reese. *Concrete Photography = Konkrete Fotografie.* Bielefeld: Kerber Verlag.

2004

Through Wider Windows, 170-Year Breakthroughs in Photography: Selections from the Tokyo Fuji Art Museum. Tokyo: Tokyo Fuji Art Museum.

2002

Go On Being, Our Blue Star!. Exh. cat. Tokyo: Tokyo Fuji Art Museum.

Reflections of Egypt. Exh. brochure. Memphis: University of Memphis.

Rexer, Lyle. *Photography's Antiquarian Avant-Garde: The New Wave in Old Processes.* New York: Harry N. Abrams.

2000

American Perspectives: Photographs from the Polaroid Collection. Exh. cat. Tokyo: Tokyo Metro Museum of Photography; Waltham, MA: The Polaroid Collection.

1999

Collischan, Judy. *Contemporary Classicism.* Exh. cat. Purchase, NY: Neuberger Museum of Art, Purchase College, State University of New York.

Kao, Deborah Martin. *Innovation/Imagination: 50 Years of Polaroid Photography.* Exh. cat. New York: Harry N. Abrams; Friends of Photography.

1998

Friedman, Robert. *The Life Millennium: The 100 Most Important Events and People of the Last 1000 Years.* New York: Time Life Books; Boston: Bulfinch Press.

Peterson, Bryan H. *Masterpieces of Photography From The Merrill Lynch Collection.* Exh. cat. Doylestown, PA: James A. Michener Art Museum.

Photography's Multiple Roles: Art, Document, Market, Science. Exh. cat. Chicago: Museum of Contemporary Photography, Columbia College Chicago; New York: DAP, Inc.

1997

New Realities: Hand-Colored Photographs 1839 to the Present. Exh. cat. With an essay by Lee Marks. Laramie, WY: University of Wyoming Art Museum.

Stelle, Margaret, and Cindy Estes. *The Art of Shapes: For Children and Adults.* Los Angeles: Museum of Contemporary Art.

1996

Buried. Exh. brochure. With an introduction by Carl Schafer. Ithaca, NY: Herbert F. Johnson Museum of Art, Cornell University.

Dupre, Judith. *Skyscrapers.* New York: Black Dog & Levinthal.

Esders, Viviane, ed. *Our Mothers: Portraits by 72 Women Photographers.* New York: Stewart, Tabori, & Chang.

Rosenblum, Naomi. *A World History of Photography*. New York: Abbeville Press.

This Is a Set-Up: Fab/Photo Fictions. Exh. cat. Bowling Green, OH: Dorothy Uber Bryn Gallery, Bowling Green State University.

1994

Neusüss, Floris M., and Charles Hagen, eds. *Experimental Vision: The Evolution of the Photogram Since 1919*. Exh. cat. With essays by Floris M. Neusüss, Charles Hagen, and Thomas Barrow. Niwot, CO: Roberts Rinehart Publishers and Denver Art Museum.

Rosenblum, Naomi. *A History of Women Photographers*. New York: Abbeville Press.

Sand, Michael, ed. *Metamorphosis: Photography in the Electronic Age*. With an introduction by Mark Haworth-Booth and essays by Timothy Druckery, Jonathan Green, Vincent Katz, Geoffrey Batchen, Ben Davis, Michael Sand, and Rebecca Busselle. New York: Aperture Foundation.

Tradition and the Unpredictable: The Allan Chasanoff Photographic Collection. Exh. cat. With essays by Peter C. Marzio, Charles H. Traub, Vince Aletti, and Anne W. Tucker. Houston, TX: Museum of Fine Arts.

1993

Caroll, Patty. *American Made: The New Still-Life*. Exh. cat. Tokyo: Isetan Museum of Art; Japan Art and Culture Association.

1992

Desmarais, Charles. *Proof: Los Angeles Art and the Photograph, 1960–1980*. Exh. cat. Laguna Beach, CA: Fellows of Contemporary Art, Laguna Art Museum.

Eaton, Timothy. *20th Century Photography, Boca Raton Collector's Annual*. Exh. cat. Boca Raton, FL: Boca Raton Museum of Art.

Grande, Chantal, and Glòria Malé. *Barbara Kasten: El Mèdol*. Exh. cat. With an essay by Glòria Picazo. Tarragona, Spain: Tinglado 2.

San Jose Art in Public Places Program, Hilton Hotel and Tower, San Jose, CA: The Pinnacle Company.

1991

Barbara Kasten: 1986–1990. With essays by Deborah Irmas, Meg Perlman, and Michele Druon. Tokyo: RAM (Research of Art Media).

Caiger-Smith, Martin, and David Chandler, eds. *Site Work: Architecture in Photography Since Early Modernism*. Exh. cat. London: The Photographers' Gallery.

To Collect The Art of Women: The Jane Reese Williams Photography Collection. Exh. cat. With an essay by Eugenia Parry Janis. Santa Fe: New Mexico Museum of Art.

1990

Freeman, Phyllis. *New Art*. New York: Harry N. Abrams.

Sullivan, Constance, and Eugenia Parry. *Women Photographers*. New York: Harry N. Abrams.

1989

Artists of the '80s: Selected Works from the Maslow Collection. Exh. cat. Wilkes-Barre, PA: Wilkes University; Llewellyn & McKane.

Decisive Monuments. Exh. brochure. Text by Colin Westerbeck. Chicago: Ehlers Caudill Gallery, Ltd.

Enyeart, James, ed. *Decade by Decade, Twentieth-Century American Photography From the Collection of the Center for Creative Photography*. Exh. cat. With essays by Estelle Jussim, Van Deren Coke, Martha A. Sandweiss, Naomi Rosenblum, Helen Gee, Terence Pitts, Charles Desmarais, and Nathan Lyons. Boston: Bulfinch Press; Tucson: Center for Creative Photography, University of Arizona.

Garner, Gretchen. *Six Ideas in Photography: A Celebration of Photography's Sesquicentennial Drawn from the Collection of Frederick P. Currier*. Exh. cat. Grand Rapids, MI: Grand Rapids Art Museum.

Köhler, Michael, ed. *Constructed Realities: The Art of Staged Photography*. Exh. cat. Munich: Kunstverein München; Zurich; Edition Stemmle.

Oresman, Janice C. *Art of the '80s From the Collection of Chemical Bank*. Exh. cat. Montclair, NJ: Montclair Art Museum.

Smith, Joshua P. *The Photography of Invention: American Pictures of the 1980s*. Exh. cat. Cambridge, MA: MIT Press.

The M. Anwar Kamal Collection of Art. Exh. cat. Jacksonville, FL: The Cummer Gallery of Art.

Tucker, Jean S. *The Modernist Still-Life—Photographed*. Exh. cat. St. Louis: University of Missouri–St. Louis.

1988

Contemporary Icons & Explorations: The Goldstrom Family Collection. Exh. cat. Davenport, IA: Davenport Museum of Art.

Lorrin and Deane Wong Collection. Exh. cat. Laguna Beach, CA: Ettinger & Reynolds Galleries and the Art Institute of Southern California.

Separate Realities: The Photographs of Barbara Kasten. Exh. brochure. With text by Robert T. Teske. Sheboygan, WI: John Michael Kohler Arts Center.

SmithKline & French Research & Development Art Collection. Tennyson Schad & Associates.

Sobieszek, Robert. *The Art of Persuasion: A History of Advertising Photography*. Exh. cat. New York: Harry N. Abrams; International Museum of Photography at George Eastman House.

Suzuki, Gyoh. *8 Visions: Works by 8 Contemporary American Women*. Exh. cat. Tokyo: PARCO Co., Ltd.

1987

Capp Street Project 1985–86. Annual Report. San Francisco.

Gauss, Kathleen, and Grundberg, Andy. *Photography and Art: Interactions Since 1946*. Exh. cat. New York: Abbeville Press.

Hoy, Anne H. *Fabrications: Staged, Altered and Appropriated Photographs*. Exh. cat. New York: Abbeville Press.

Laster, Paul, and Renée Riccardo. *The Spiral of Artificiality*. Exh. cat. With an essay by Deborah Bershad. Buffalo: Hallwalls.

Sullivan, Constance, ed. *Legacy of Light*. With an introduction by Peter Schjeldahl and essays by Gretel Ehrlich, Robert Stone, Richard Howard, and Diane Johnson. New York: Alfred P. Knopf; The Polaroid Corporation.

Turner, Peter. *History of Photography*. London: Bison Books, Ltd.

1986

Art and Advertising: Commercial Photography by Artists. Exh. brochure. New York: International Center of Photography.

Barbara Kasten. Exh. cat. Tokyo: Asahi Shimbun.

Barbara Kasten: Toward an Interconnectedness of All Things. Exh. cat. Dayton, OH: Wright State University.

Booth-Clibborn, Edward. *American Photography Two: The Second Annual of American Editorial, Advertising and Poster, Book, Promotion and Unpublished Photography*. New York: Harry N. Abrams.

Coke, Van Deren. *CrossCurrents II: Recent Additions to the Collection*. Exh. cat. San Francisco: San Francisco Museum of Modern Art.

Douthat, Anita Sherwood. "Tracing with Light: A Critical and Historical Investigation of the Photogram." MFA Thesis, University of New Mexico.

Photographic Fictions. Exh. cat. With an introduction by Roni Feinstein. Stamford, CT: Whitney Museum of American Art.

Poetics of Space. Exh. brochure. With text by Steven A. Yates. Santa Fe: Museum of Fine Arts, Museum of New Mexico.

Vandersteel, Dorothy. *Artists in Mid-Career.* Exh. cat. San Francisco: San Francisco Museum of Modern Art.

1985

Booth-Clibborn, Edward. *American Photography One: The First Annual of American Editorial, Advertising and Poster, Book, Promotion and Unpublished Photography.* New York: Harry N. Abrams.

Constructs: Barbara Kasten. With an essay by Estelle Jussim. Boston: New York Graphic Society; The Polaroid Corporation.

Extending the Perimeters of 20th Century Photography. With an introduction by Dorothy Vandersteel. San Francisco: San Francisco Museum of Art.

Illuminating Color: Four Approaches in Contemporary Painting and Photography. Exh. brochure. With an essay by Donna Stein and Lynn Zelevansky. New York: Pratt Institute.

London Upton, Barbara, and John Upton. *Photography.* 3rd ed. Boston: Little, Brown and Company.

Paris, New York, Tokyo. Exh. cat. Tokyo: Tsukuba Museum of Photography.

Sobieszek, Robert. *Masterpieces of Photography: From the George Eastman House Collections.* New York: Abbeville Press.

1984

101 Photographs: Selections From the Arthur and Yolanda Steinman Collection. Exh. cat. Santa Barbara, CA: Santa Barbara Museum of Fine Arts.

Art, Science, and Creativity in Instant Photography. Exh. cat. Milan: Massimo Baldini; The Polaroid Corporation.

Contemporary Constructs: 20 Los Angeles Photographers. Exh. brochure. With an introduction by Dinah Berland. Los Angeles: Los Angeles Center for Photographic Studies.

Katzman, Louise. *Photography in California: 1945–1980.* Exh. cat. With an introduction by Van Deren Coke. New York: Hudson Hills Press; San Francisco Museum of Art.

Naef, Weston. *The Gallery of World Photography: New Directions in Photography.* New York: Dai Nippon Printing Company; Tokyo: Sueisha Publishing.

Selections 2. Exh. cat. Cologne: Photokina.

The Alternative Image II. Exh. cat. With an introduction by Anita Douthat. Sheboygan, WI: John Michael Kohler Arts Center.

1983

Big Pictures by Contemporary Photographers. Exh. cat. New York: Museum of Modern Art.

KOCE-TV. *Guide to the Photographic Vision.* New York: Holt, Reinhart & Winston.

In Color: Ten California Photographers. Exh. brochure. Oakland, CA: Oakland Museum.

Neimanas, Joyce, and Robert Heinecken. *Photographers Invite Photographers.* Exh. cat. Chicago: N.A.M.E. Gallery.

Sealfon, Peggy. *The Magic of Instant Photography.* Boston: CBI Publishing Company, Inc.

Sullivan, Constance, and Pamela Duffy. *Storing, Handling, and Preserving Polaroid Photographs: A Guide.* Boston: Boston Focal Press; The Polaroid Corporation.

1982

20 × 24 Polaroid. With an introduction by Sherry Lassiter. Washington, DC: Annual Meeting, The National Academy of Sciences.

Barbara Kasten: Photographs. Exh. brochure. San Francisco: San Francisco Museum of Modern Art.

Glenn, Constance W. *Centric 2: Barbara Kasten, installation/photographs.* Exh. cat. Long Beach, CA: The Art Museum and Galleries, California State University.

Gauss, Kathleen McCarthy. *Studio Work: Photographs by*

Ten Los Angeles Artists. Exh. brochure. Los Angeles: Los Angeles County Museum of Art.

Hultén, Pontus, and Pagé, Suzanne. *Échange Entre Artistes 1931–1982: Pologne–USA.* Exh. cat. Paris: ARC Musée d'Art Moderne de la Ville de Paris.

Johnson, Deborah, ed. *California Photography.* Exh. cat. Providence: Museum of Art, Rhode Island School of Design.

Sobieszek, Robert A. *Color as Form: A History of Color Photography.* Exh. cat. Rochester, NY: International Museum of Photography at George Eastman House; Washington, DC: Corcoran Gallery of Art.

Stewart, Albert. *New New York.* Exh. cat. Tallahassee, FL: University of Fine Arts Galleries, School of Visual Arts, Florida State University.

1981

Altered Images. Exh. cat. Tucson: Center for Creative Photography.

1980

NEA Purchase Award Artists. Exh. brochure. Tuscon: Center for Creative Photography.

Photography's Response to Constructivism. Exh. cat. San Francisco: San Francisco Museum of Modern Art.

Reasoned Space. Exh. cat. With an essay by Timothy Druckery. Tuscon: Center For Creative Photography.

1979

Becotte, Michael, and William Larson, eds. Exh. cat. *Uniquely Photographic.* Published in a special issue of *Quiver,* vol. 1 no. 5. Philadelphia: Tyler School of Art.

Parker, Fred. *Attitudes: Photography in the 1970s.* Exh. cat. Santa Barbara, CA: Santa Barbara Museum of Art.

Prints: New Points of View. Exh. brochure. San Francisco: Western Association of Art Museums.

Witkin, Lee D. *The New Season: Nine Contemporary Photographers.* Exh. cat. New York: The Witkin Gallery, Inc.

Witkin, Lee D., and Barbara London. *The Photograph Collector's Guide.* Boston: The New York Graphic Society.

1978

Interchange. Exh. cat. With an introduction by Melinda Wortz. Los Angeles: Mount St. Mary's College.

1977

Exhibitions '76, '77: A Catalogue of Exhibitions Presented at the Cedars-Sinai Medical Center. Exh. cat. With an introduction by Melinda Wortz. Los Angeles: Advisory Council for the Arts, Cedars-Sinai Medical Center.

1975

Heavy-Light: Women's Photographic Exhibit. Exh. brochure. Pasadena, CA: Pasadena City College.

LeVeque, Ann. *The Gallery as Studio.* Exh. cat. Claremont, CA: The Galleries of the Claremont Colleges.

Meilach, Donna. *Soft Sculpture and Other Soft Forms.* New York: Crown Publishers, Inc.

1973

Al-Hilali, Neda. *Fiber Works: An Exhibition of Works by Twenty Fiber Artists.* Exh. cat. Claremont, CA: Lang Art Gallery, Scripps College.

Super Cream: An Invitational Women's Photography Exhibit. Exh. brochure. Fullerton, CA: Muckenthaler Cultural Center; Orange County Art Association.

1972

Mielach, Dona Z. *Creating Art from Fiber and Fabrics.* Chicago: Regnery. Reprint, New York: Galahad Books, 1974.

1971

Kasten, Barbara. *Dimension of Fiber*. Exh. cat. Oakland, CA: California College of Arts and Crafts Gallery.

Master of Arts/Master of Fine Arts, 1971. Exh. brochure. Oakland, CA: California College of Arts and Crafts.

Photo Image in Printmaking. Exh. brochure. San Francisco: San Francisco Museum of Art.

Photo Media: Elements and Technics of Photography Experienced as an Artistic Medium. Exh. brochure. New York: Museum of Contemporary Crafts of the American Crafts Council.

Riss, Murray. *Photography Invitational 1971*. Exh. cat. Little Rock, AR: Arkansas Arts Center.

1970

Parker, Fred R. *California Photographers 1970*. Exh. cat. Davis, CA: The Memorial Union Art Gallery, University of California, Davis.

Articles and Reviews

2015

Campbell, Adrianna. "500 Words: Barbara Kasten." Artforum. com (January 31, 2015). http://artforum.com/words/id=49975.

"Casting Light." PIN-UP Magazine (February 11, 2015). http://pinupmagazine.org/2015/02/casting-light/.

Coghlan, Niamh. "Form and Photography." *Aesthetica* 63 (February/March 2015): 28–33.

Cotton, Charlotte. "Barbara Kasten: Stages." *Artforum* 53 no. 5 (January 2015): 122.

Hewitt, Leslie. "Barbara Kasten." *BOMB* 131 (Spring 2015): 136–44.

Kasten, Barbara. "Architectural Light." *Art in America* 103 no. 1 (January 2015): 32–33.

Martin, Hannah. "The Institute of Contemporary Art at the University of Pennsylvania Showcases Barbara Kasten's Photography." Architectural Digest: Daily Ad (February 9, 2015). http://www.architecturaldigest.com/blogs/daily/2015/02/barbara-kasten-at-the-institute-of-contemporary-art-at-the-university-of-pennsylvania.

"Portfolio." *Document Journal* (Spring/Summer 2015).

Rexer, Lyle. "Interview: Barbara Kasten." *photograph magazine* (March/April 2015). https://www.photographmag.com/columns?type=8.

Tavecchia, Elena. "Agenda." *Mousse* 47 (February/March 2015): 198-201.

2014

"Art 50 2014: Chicago's Artists' Artists." *Newcity Art* (September 18, 2014). http://art.newcity.com/category/artist-profiles/art-50/.

Goldstein, Andrew M. "Picks: 8 of the Best Artworks at EXPO Chicago 2014." *Artspace* (September 20, 2014). http://www.artspace.com/magazine/news_events/the-best-art-of-expo-chicago-2014.

Klein, Alex. "In Her Own Words." *Hillman Photography Initiative*, Carnegie Museum of Art. February 11, 2014. http://www.nowseethis.org/blog/in-her-own-words.

—. "Studio Visit: Photographers at Work—With Barbara Kasten in Chicago." *Aperture* 214 (Spring 2014): 23–24.

Musteata, Natalie. "Critics Picks: New York: The Material Image." Artforum.com (September 2014). http://artforum.com/picks/section=nyc&mode=past#picks48398.

2013

Akel, Joseph. "Barbara Kasten." *Frieze* 154 (April 2013): 168.

C Photo 7: Photographicness. With an essay by Barbara Kasten. Madrid, Spain: Ivory Press.

Kröner, Magdalena. "All the Postmodern Stuff." *Frankfurter Allgemeine Zeitung* (June 6, 2013): 35.

Messinger, Kate. "12 Artists to See at Frieze London." *The WILD Magazine* (October 18, 2013). http://staging.thewild-magazine.com/blog/12-artists-to-see-at-frieze-london/.

Weiping, Dai. "Barbara Kasten: Geometric Abstraction in Photography." Translated by JiaJing Liu. *Vision Magazine* (2013).

2012

"Art 50: Chicago's Artist's Artists." *Newcity Art* (September 19, 2012). http://art.newcity.com/2012/09/19/art-50-chicagos-artists-artists/.

Fiske, Courtney. "Reality at the Core: Q&A with Barbara Kasten." *Art in America* (July 27, 2012). http://www.artinamericamagazine.com/news-features/interviews/barbara-kasten-bortolami/.

Frank, Peter. "Haiku Reviews: From Vivaldi to Vivid Pop Art." *The Huffington Post Arts* (January 6, 2012). http://www.huffingtonpost.com/2012/01/06/haiku-reviews-from-vivald_n_1190309.html.

"Interview: Creative Constructs." *A Magazine* 61 (August/September 2012). http://www.aishti.com/13341.

Muckl, Christian. "Stellenweise Stolperfallen." *Nürnberger Zeitung* (July 6, 2012): 8.

"Short List: Barbara Kasten/Justin Beal." *The New Yorker* 88 no. 19 (July 2, 2012): 13.

Stillman, Nick. "Barbara Kasten, Gallery Luisotti." *Artforum* 50 no. 7 (March 2012): 285–86.

2011

Golden-McNerney, Regan. "Eye Exam: Concrete Light." *Newcity Art* (September 27, 2011). http://art.newcity.com/2011/09/27/eye-exam-concrete-light/.

Ise, Claudine. "Barbara Kasten." Artforum.com (September 30, 2011). http://artforum.com/archive/id=29082.

Norton, Heidi. "Barbara Kasten Talks with Heidi Norton." *Bad At Sports* (October 21, 2011). http://badatsports.com/2011/barbara-kasten-and-heidi-norton/.

Pearson, Anthony. "Interview: Set Pieces." *Frieze* 143 (November/December 2011): 114–19.

Pies, Daniel. "Barbara Kasten, Galerie Kadel Willborn." *Frieze d/e* 2 (Autumn 2011): 118–19.

Robertson, Rebecca. "Building Pictures." *ARTnews* 110 no. 3 (March 2011): 76–83.

Vélez, Pedro. "Gallery Weekend Chicago." Artnet.com (September 28, 2011). http://www.artnet.com/magazineus/reviews/velez/gallery-weekend-chicago-9-28-11.asp.

Waxman, Lori. "Meeting at the Intersection of Blue and White." *Chicago Tribune* (September 21, 2011).

2001

McGovern, Thomas. "Los Angeles: Barbara Kasten." *ART PAPERS* 25 no. 4 (July/August 2001): 54–55.

2000

Loke, Margaret. "Manipulated Images Toy With Facets of What Is." *The New York Times* (July 28, 2000): E30.

1998

Bridges, Thomas. "Moments of Grace: Spirit in the American Landscape." *Aperture* 150 (Winter 1998).

1997

Eilers, Michael. "An Interview with Barbara Kasten." *Arizona Daily Wildcat* (April 10, 1997). http://wc.arizona.edu/papers/90/131/25_1_m.html.

1996

Aletti, Vince. "Barbara Kasten." *The Village Voice* 41, no. 25 (June 18, 1996): 8.

Glasson, Katherine. "Barbara Kasten Sees the Light." *Flatiron News* (1996): 23–25.

Muchnic, Suzanne. "Hot Off the Inkjet." *Los Angeles Times* (June 6, 1996): F1–F6.

"Photography: Barbara Kasten." *The New Yorker* 72 no. 15 (June 10, 1996): 23.

1994

Enyeart, James L. "Pathways to the Future of Digital Imaging." *Image* (International Museum of Photography and Film Magazine) 37 no. 1–2 (Spring/Summer 1994): 27–36.

1993

Hagen, Charles. "Reinventing the Photograph." *The New York Times* (January 31, 1993): 1, 29.

Hugunin, James R. "From 'Catop-Tricks' to 'Cliff Dwellings': The Art of Barbara Kasten." *Art Criticism* 8 no. 2 (1993): 1–15.

MacKinlay, Helen. "Colour in the Camera." *Silver Kris* (Singapore Airlines inflight magazine) (October 1993): 40–45.

Muchnic, Suzanne. "Proof Positive." *Los Angeles Times* (January 10, 1993): 8–9, 81.

1991

Barak, Ami. "Les Expositions: Barbara Kasten, Galerie Urbi et Orbi." *Art Press* 159 (June 1991): 106–7.

Roegiers, Patrick. "Savoureux vestiges: Pour Barbara Kasten, la lumière n'est pas une matière mais une sensation." *Le Monde* (April 9, 1991): 15.

Villani, John. "Photographer Sheds Light on the Cliffs at Puye." *The Santa Fe New Mexican* (December 20–26, 1991): 23–32.

1990

"Abstract Art of Lighting Up the Night." *Chicago* (October 1990): 24.

"Barbara Kasten." *Metropolitan Home* (May 1990): 115–17.

Fincher, Scott. "Loyola's Madonna della Strada Sits Patiently for a Formal Portrait." *Chicago Tribune* (July 16, 1990): Section 2, D1–4.

Foerstner, Abigail. "Photography: Barbara Kasten Finds the Mystical in Ancient Cliff Dwellings." *Chicago Tribune* (November 16, 1990): Section 7, CN95–96.

Goldstein, Deborah. "Feminine Vision: Barbara Kasten—Architectural Fantasies." *Professional Photographer* (November 1990).

Irmas, Deborah. "Bright Lights, Big Buildings: Photographer Barbara Kasten Transforms L.A. Architecture." *Los Angeles* (February 1990).

McCracken, David. "Gallery Scene: George Horner Parodies Pretensions of the Art World." *Chicago Tribune* (December 21, 1990): Section 7, CN85.

1989

Backlund, Nick. "Light Worlds." *I.D. Magazine of International Design* (March/April 1989).

Curtis, Cathy. "Galleries: Santa Monica." *Los Angeles Times* (December 1, 1989): F17.

Demirli, Oya and Don Carli. "Image-making in the 1990s." *GRAPHIS* no. 259 (January/February 1989).

Frank, Peter. "Beyond Photography: Susan Rankaitis." *LA Weekly* (April 14–20, 1989): 120.

Grundberg, Andy. "Photography: The New Hot Shots." *Metropolitan Home* (July 1989): 39–44.

Harrop, Thom. "Lights, Camera, Architecture!" *Darkroom Photography* (July 1989): 31–41.

Ingram, Leah. "Art Beat: Picture Perfect." *New York Magazine* 22 no. 37 (September 18, 1989): 27.

Muchnic, Suzanne. "A Photographer Who Does It With Mirrors." *Los Angeles Times* (July 19, 1989): Part IV, 1–7.

Phillips, Patricia C. "Barbara Kasten: International Center of Photography Midtown." *Artforum* 28 no. 4 (December 1989): 138.

Plagens, Peter. "Photography: Into the Fun House." *Newsweek* (August 21, 1989): 52–57.

Sozanski, Edward J. "Through a Lens, Altered Elements of Architecture." *The Philadelphia Inquirer* (December 7, 1989): 3E.

Wepman, Dennis. "Reassembling the City." *Daily News Magazine* (September 1989).

1988

Baker, Beverly. "High Profile: Kasten Colors Her World With Magical Photography." *The Atlanta Journal and Constitution* (October 25, 1988): 1D–6D.

Lazar, Jerry. "Making Masterpieces: An Interview with Michael Wilder, Who May Well Be the Finest Cibachrome Printer in America." *Darkroom Photography* (March/April 1988): 28–39.

London, Barbara. "Public Spaces and Private Places: Barbara Kasten's Architectural Abstracts Take Reality and Turn It Upside Down." *American Photographer* (September 1988): 48–53.

Warren-Smith, Virginia. "Photographer Bends Notions of Architecture." *The Atlanta Journal and Constitution* (August 28, 1988): 1M–10M.

1987

"Barbara Kasten: Constructs & Metaphases." In *Minolta Mirror*. Osaka, Japan: Minolta Corporation, 1987.

Goldberg, Vicki. "The Art of Salesmanship: Photography as a Tool of Advertising." *American Photographer* (February 1987): 28–30.

Hagen, Charles. "Barbara Kasten, John Weber Gallery." *Artforum* 25 no. 8 (April 1987): 127.

Huntington, Richard. "At Hallwalls: Visiting Curators to Focus on Photo/Painting Interplay." *The Buffalo News* (November 1, 1987): G1–6.

Johnstone, Mark. "Photography: Constructivist Angles on Architecture." *Artweek* 18 no. 14 (April 11, 1987): 10–12.

Kohen, Helen L. "Picture Show Develops Theory of Photography as Art." *Miami Herald*.

"Light Adventures: The Art of Barbara Kasten." *Current Exposures in Lighting/Art & Artisan* (1987): 123–26.

"Lighting." *Designers West* (October 1987).

Mazur, Carole. "Offering a Visual Treat, But Message Falters." *Albuquerque Journal* (March 21, 1987).

Muchnic, Suzanne. "The Art Galleries: Wilshire Center." *Los Angeles Times* (March 6, 1987): H18.

Silverman, Andrea. "New York: Art and Advertising." *New Art Examiner* (January 1987): 56.

Squiers, Carol. "The Monopoly of Appearances." *Flash Art* (February/March 1987): 98–100.

1986

Baker, Kenneth. "Art: Images at Midstream." *San Francisco Chronicle* (June 29, 1986): 12–13.

Grundberg, Andy. "Photography View: The Mix of Art and Commerce." *The New York Times* (September 28, 1986): H29–35.

—. "Photography View: A New Breed Puts Its Own Stamp on the Medium." *The New York Times* (December 28, 1986): H27–28.

Heartney, Eleanor. "New York Reviews: Art and the Electronic Fishbowl." *ARTNews* 85 no. 10 (December 1986): 156.

K. T. "Received and Noted: Books: Constructs" *Afterimage* 13 no. 1 (February 1, 1986): 21.

"Margaret Jenkins . . . Dance Re-Defined." *Cultural Affairs Division, City of Albuquerque* (March 1986).

Murray, Joan. "Photography—A Survey of Progress: San Francisco." *Artweek* 17 no. 3 (June 14, 1986): 11.

"Reviews: Art and Advertising—Commercial Photography by Artists." *Artforum* 25 no. 3 (November 1986): 136.

1985

"All the World Is an Abstract?" *Dayton Daily News* (September 22, 1985): 2D.

Ballerini, Julia. "New York: Barbara Kasten at John Weber." *Art in America* 73 no. 2 (February 1985): 137–38.

Belsito, Peter. "Capp Street Project: Shack Slack for the Site-specific." *High Performance* 8 no. 2 issue 30 (1985): 30–31.

Campbell, R. M. "Margaret Jenkins Dancers Sculpt Their Art From the Air." *Seattle Post-Intelligencer* (October 4, 1985): C5.

Cauthorn, Robert S. "Kasten's Talent Aimed in Wrong Direction." *The Arizona Daily Star* (May 5, 1985).

"Do Tell . . . Politics, Religion, & Blush-on in '85: Very 1985." *Los Angeles Times* (January 13, 1985): T4.

Douthat, Anita. "Cast In Light." *The Journal of Photography in New England* 6 no. 4 (Summer 1985): 12.

Dunning, Jennifer. "BAM Is a Mecca of the New." *The New York Times* (October 25, 1985): E9.

—. "Dance: Margaret Jenkins Company." *The New York Times* (October 25, 1985): C3.

Edkins, Diana. "People Are Talking About… Photography: Embraceable Hue." *Vogue* (July 1985): 44.

Gleason, Bill. "Post Modern Choreographers Try New Directions." *Journal-American* (October 6, 1985).

Jan, Alfred. "Barbara Kasten: Capp Street Project, San Francisco." *FlashArt* (1985).

Kisselgoff, Anna. "Dance View: When '60s Formalism Meets Today's Dramatic Intent." *The New York Times* (November 3, 1985): H8.

Norman, Sally. "'Big Picture' Focus Is Snap Judgment." *The Plain Dealer* (September 21, 1985): 1D–3D.

Palmer, Rebecca. "Through the Looking Glass." *Artweek* 16 no. 22 (June 1, 1985): 3.

Peeps, Claire. "Book Reviews." *Newsletter of The Friends of Photography* 8 no. 8 (August 1985).

Portwood, Pamela. "Art: Questioning Abstraction." *Tucson Weekly* (May 8–14, 1985): 11.

Tucker, Marilyn. "Jenkins Dancers Kick Off Tour in Style." *San Francisco Chronicle* (April 22, 1985): 51.

Ulrich, Allan. "This Time, the Looks Are Not Deceiving." *San Francisco Examiner* (April 20, 1985): A10.

Weiley, Susan. "New Light on Color." *ARTNews* 84 no. 8 (October 1985): 82–87.

Welsh, Anne Marie. "'First Figure' Ballet a Jenkins Choreographic Gem." *The San Diego Union* (March 16, 1985): D11.

Wise, Kelly. "Barbara Kasten: Photographic Constructions." *The Boston Globe* (March 15, 1985).

"Wright State University Galleries/Dayton: Barbara Kasten, Towards an Interconnectedness of All Things." *Dialogue Magazine* (Fall 1985): 91.

1984

"Arts + Architecture Portfolio," produced by Freidenrich Contemporary Art, *Arts + Architecture Magazine*, 4 no. 2 (July 1985).

Asbury, Dana. "Shows We've Seen." *Popular Photography* 91 no. 7 (July 1984): 17–22.

Davis, Douglas. "California by Strobe Light." *Newsweek* (March 5, 1984): 80–81.

Edwards, Owen. "Exhibitions: Shadow Play." *American Photographer* 13 no. 5 (November 1984): 30–32.

Grundberg, Andy. "Photos of Irving Penn: Sublime to the Perverse." *The New York Times* (September 14, 1984): C14.

Heartney, Eleanor. "Arts Reviews: Barbara Kasten." *Arts Magazine* 59 no. 3 (November 1984): 36.

Knight, Christopher. "'Contemporary Constructs' Steps on Photo Tradition." *Los Angeles Herald Examiner* (1984).

Muchnic, Suzanne. "'Constructs': Hip Photo Exhibition Has No Heart." *Los Angeles Times* (April 12, 1984): M1–6.

Pincus, Robert L. "The Galleries: Santa Monica." *Los Angeles Times* (March 23, 1984): G14.

1983

Anderson, John. "Photographers Often Impose Their Will on Images." *Chicago Sun-Times* (March 27, 1983).

Baker, Kenneth. "Their Own Instants: A Candid Look at Polaroid's Collection of Photographs." *Connoisseur* (June 1983): 96–103.

Barton, Rhonda. "Kasten Experiments With Large Formats." *The Polaroid Newsletter* 28 no. 3 (March 1983).

Caldwell, John. "Show, 'The Constructed Image,' Has Eight Distinct Visions." *The New York Times* (July 31, 1983): WC24.

Davis, Douglas. "Big Pix." *Newsweek* (May 2, 1983): 80–84.

Glueck, Grace. "Art: 'Habitats,' a Show By 21 at the Clocktower." *The New York Times* (March 18, 1983): C23.

Grundberg, Andy. "Photography View: Big Pictures That Say Little." *The New York Times* (May 8, 1983): H31–36.

Johnson, Joyce. "In Color: A Photographer's Choice." *The Museum of California* (1983): 13–15.

Karmel, Pepe. "Photography: Looking at the Big Picture." *Art in America* 71 no. 8 (September 1983): 35–39.

Larson, Kay. "Beyond Pure Photography." *New York Magazine* 16 no. 8 (May 2, 1983): 73–75.

Murray, Joan. "Color!" *Artweek* 14 no. 4 (July 2, 1983): 11–12.

Rathbone, Belinda. "Barbara Kasten: Picture Apparatus." *Polaroid Close-Up* 14 no. 1 (April 1983): 18–23.

Scully, Julia. "Seeing Pictures." *Modern Photography* 47 no. 6 (June 1983): 42–44.

Shore, Charles. "Art: Art Blends Into Other Art." *The Oakland Tribune* (June 12, 1983): 24.

Thompson, Barbara. "In Color: Ten California Photographers at the Oakland Museum." *Photo Metro* (July 1983): 19.

Walther, Gary. "Mirror Images: Photographs by Barbara Kasten." *Camera Arts* 3 no. 6 (June 1983): 60–67, 90.

1982

"Centric 2: Barbara Kasten." *The Art Museum News*, Long Beach, California State University (Winter 1982).

Grundberg, Andy. "Photography View: Crossovers with the Art World." *The New York Times* (September 12, 1982): H33–39.

—. "Critics' Choices: Photography." *The New York Times* (September 19, 1982): G3.

Johnstone, Mark. "Installation and Image." *Artweek* 13 no. 8 (February 27, 1982): 11.

—. "Windex Index: Barbara Kasten/Centric 2." *Afterimage* 10 no. 1–2 (Summer 1982): 33.

Kirka, Danica. "Kasten Exhibit Draws From Setting She Created." *Daily Forty-Niner* (February 11, 1982): 3–4.

Knight, Christopher. "Photos That Shun the 'Real World.'" *Los Angeles Herald Examiner* (August 1, 1982): E4.

Muchnic, Suzanne. "On Photography: Breakthrough at Museum." *Los Angeles Times* (July 18, 1982): K90.

—. "Art Review: Photos That Are Made, Not Found." *Los Angeles Times* (September 1, 1982): G1–4.

Murray, Joan. "Beauty with Problem." *Artweek* 13 no. 29 (September 17, 1982): 13.

Nicholson, Chuck. "Studio Work: Color It Large." *Artweek* 13 no. 28 (September 4, 1982): 11–12.

Portner, Dinah Berland. "On Photography: Taking Leap Into Third Dimension." *Los Angeles Times* (February 21, 1982): K98.

—. "The Hot and The Cool." *L.A. Weekly* 4 no. 10 (February 5–11, 1982): 14–16.

Schipper, Merle. "*Barbara Kasten* at Cal State Long Beach." *Images & Issues* (September/October 1982): 72.

"Studio Work: Photographs by Ten Los Angeles Artists." *Los Angeles County Museum of Art Members' Calendar* 20 no. 7 (July 1982).

1981

Enyeart, James, ed. *Center for Creative Photography Research Series* 14: *Recent Color* (Tucson: Center for Creative Photography, University of Arizona, 1981).

Garner, Gretchen, ed. "Connections: An Invitational Portfolio of Images and Statements by Twenty-Eight Women." *Exposure* 19 no. 3 (December 1981): 19–44.

Phillips, Deborah C. "New York Reviews: Group Show (John Weber)." *ARTNews* 80 no. 7 (September 1981): 234–36.

"Women in Photography." *Exposure* 19 no. 3 (December 1981).

1980

Grundberg, Andy. "Photography." *Soho News* (July 2, 1980).

Grundberg, Andy, and Julia Scully. "Currents: American Photography Today." *Modern Photography* 44 no. 10 (October 1980): 94–97, 160, 166–70, 173.

Lifson, Ben. "Photography." *The Village Voice* (July 2–8, 1980): 62.

McDarrah, Fred. "Photo: Color Photographs." *The Village Voice* 25 no. 27 (July 2–8, 1980): 49.

Wilson, William. "Photo Shows That Don't Quite Click." *Los Angeles Times* (March 2, 1980): O85.

1979

Muchnic, Suzanne. "Photography as Art and History." *Los Angeles Times* (March 11, 1979): M93.

Rubenstein, Meridel. "New Mexico: Work by Women 'Outside the Mainstream.'" *Afterimage* 7 no. 3 (October 1979): 13–14.

1978

Welling, James. "Working Between Photography and Painting." *Artweek* 9 no. 5 (February 4, 1978).

1977

Dunham, Judith L. "Barbara Kasten." *Artweek* 8 no. 38 (November 12, 1977): 4.

Finkel, Claudia. "Light Lines." *Afterimage* 5 no. 1–2 (May–June 1977): 8–9.

Lewis, Louise. "A Point of View—Four L.A. Artists." *Artweek* 8 no. 25 (July 16, 1977): 1, 16.

Wortz, Melinda. "Majority Rule." *ARTNews* 76 no. 3 (March 1977): 92–93.

1975

App, Timothy. "Gallery as Studio." *Artweek* 6 no. 37 (October 1975): 3–4.

1974

Wortz, Melinda. "Kasten and Rice." *Artweek* 5 no. 12 (March 23, 1974): 3.

1973

Hagberg, Marilyn. "Barbara Kasten's Seated Forms." *Artweek* 4 no. 31 (September 22, 1973): 16.

—. "Fiber: Barbara Kasten." *Craft Horizons* (December 1973): 50.

1971

Albright, Thomas. "Fiber Sculpture Exhibition." *The San Francisco Chronicle* (March 25, 1971).

Anderson, Web. "Intriguing Works by Craftsmen Exhibited." *The Sunday Star-Bulletin and Advertiser* (June 27, 1971).

Frankenstein, Alfred. "Photo Image in Printmaking: Trumpets for This Show." *The San Francisco Chronicle* (November 9, 1971): 35.

Fried, Alexander. "Novel Blends of Camera and Print Arts." *The San Francisco Examiner* (November 1, 1971).

Jaszi, Jean. "The Centennnial—Graphics." *Artweek* 2 no. 4 (January 18, 1971): 1–2.

Jerome, Patti. "Fiber Artist Gets Fulbright." *The Phoenix Gazette* (August 31, 1971).

"Miss Kasten to Study in Poland." *The Paper* (September 8, 1971): 13.

Rice, Leland. "Photography: Photo/Graphics Surveyed." *Artweek* 2 no. 40 (November 20, 1971): 7.

—. "Photo-Media, New York." *Artweek* 2 no. 42 (December 4, 1971).

"Weaving Class Is Dimensional." *Waikiki Beach Press* (July 16–18, 1971): 9.

1970

Coleman, A. D. "California Report: A Break with Tradition." *The New York Times* (July 5, 1970): D12.

McCann, Cecile N. "Media '70." *Artweek* 1 no. 13 (May 16, 1970): 7.

Documentary Videos

1997

Printed Moments. Interview with Barbara Kasten. Produced by Lexmark, Inc.

1995

An Impression: Barbara Kasten. Vilnius, Lithuania. Produced by Liucija Armonaite.

1992

EL MEDOL. Tarragona, Spain: Tinglado Dos.

1991

Barbara Kasten: The Making of an Image. Chicago, Illinois: Loyola University.

Barbara Kasten: Painting With Light. Smart TV. Produced by Susan Murphy.

1988

Barbara Kasten: Architectural Sites. Atlanta, Georgia: High Museum of Art. Produced by Lucinda Bunnen.

Lenders to the Exhibition

BAM Hamm Archives, Brooklyn
Academy of Music
Diana Billes, Toronto
Bortolami, New York
Stefania Bortolami, New York
Center for Creative Photography,
University of Arizona
Marwan and Hana Dalloul
JK Brown and Eric Diefenbach
Gregory and Aline Gooding
Rodney Lubeznik and Susan Goodman
Gallery Luisotti, Santa Monica
Kadel Willborn Gallery,
Düsseldorf, Germany
Los Angeles County Museum of Art
Museum of Contemporary Art Chicago
Darlene and Jorge M. Pérez
Kathryn Fleck Persach, Aspen
Philadelphia Museum of Art
Private Collection, New Jersey
University Art Museum, California
State University Long Beach

Image Credits

All images © and courtesy of the artist, unless otherwise noted. Installation photography of *Barbara Kasten: Stages* by Constance Mensh. Wherever possible every effort has been made to provide accurate attribution and appropriate permissions for archival images and materials reproduced in this catalogue. Any errors or omissions will be corrected in any future editions.

p.19 ©Barbara Kasten, courtesy Los Angeles County Museum of Art; **p.31** (top) ©Barbara Kasten, courtesy University Art Museum, California State University Long Beach; **p.33** ©Barbara Kasten, courtesy University Art Museum, California State University Long Beach; **p.34** ©Barbara Kasten, courtesy Gallery Kadel Willborn, Düsseldorf, Germany, Photo: Achim Kukulies; **p.35** (top) ©Barbara Kasten, courtesy University Art Museum, California State University Long Beach; **p.61** ©Barbara Kasten, courtesy the Museum of Contemporary Art, Chicago; **p.70** (top) Courtesy Arata Isozaki & Associates; **p.71** (bottom) ©The Metropolitan Museum of Art © 2014 Estate of Gordon Matta-Clark/Artists Right Society (ARS), New York; **p.73** (bottom right) Ruby Washington/The New York Times/Redux; **p.75** (bottom) ©2015 Robert Irwin/Artists Rights Society (ARS), courtesy Walker Art Center, Minneapolis; **pp.90–91** Courtesy the Robert and Elaine Stein Galleries, Wright State University; **p.98** ©Barbara Kasten, courtesy Los Angeles County Museum of Art; **p.101** ©Barbara Kasten, courtesy Los Angeles County Museum of Art; **pp.102–103** ©Barbara Kasten, courtesy Los Angeles County Museum of Art; **p.106** (bottom) ©Artists Rights Society (ARS), New York / VG Bild-Kunst, Bonn, Imaging Department ©President and Fellows of Harvard College; **p.107** (top) ©Barbara Kasten, courtesy University Art Museum, California State University Long Beach; **p.108** (top left) Photo: Kurt Kilgus; **p.110** (top right) Paul Outerbridge, Jr. ©2015 G. Ray Hawkins Gallery, Beverly Hills, CA, courtesy Marek Lieberberg, Photography courtesy the J. Paul Getty Museum, Los Angeles; **p.110** (bottom left) Courtesy the Estate of Guy de Cointet / Air de Paris, Paris and Robert Wilhite, Photo: Manuel Fuentes; **p.111** (top) Photo: Bonnie Kamin; **p.118** ©Barbara Kasten, courtesy the University Art Museum, California State University Long Beach; **p.143** ©Barbara Kasten, courtesy Philadelphia Museum of Art; **p.150** (top) Photograph gift of Mr. Eric and Mrs. Sylvia Elesser, The Trude Guermonprez Archives, 1993-121-118, courtesy Cooper-Hewitt, National Design Museum, Smithsonian Institution / Art Resource, New York; **p.151** (middle) University Archives RS 665, Wight Art Gallery Exhibit files, Library Special Collections, Charles E. Young Research Library, UCLA; **p.152** (bottom) ©Magdalena Abakanowicz, courtesy Marlborough Gallery, New York; **p.154** (top) ©Magdalena Abakanowicz, courtesy Marlborough Gallery, New York, courtesy the National Museum of Women in the Arts, Washington D.C.; **p.176** (left) Photography courtesy The J. Paul Getty Museum, Los Angeles; **p.176** (right) Photo: Judy Dater; **p.177** (bottom) ©Smith Family Trust; **p.177** (top) ©2014 Artists Rights Society (ARS), New York/VG Bild-Kunst, Bonn, courtesy the Museum of Fine Arts, Houston; **p.178** Courtesy The Museum of Modern Art, New York, NY, USA, digital image ©The Museum of Modern Art/Licensed by SCALA/Art Resource, NY, Florence Henri ©Galleria Martini & Ronchetti, Genova; **p.180** ©Barbara Kasten, courtesy University Art Museum, California State University Long Beach; **p.182** Photo: Bonnie Kamin; **p.183** (left) Courtesy the Robert and Elaine Stein Galleries, Wright State University; **p.186** ©Barbara Kasten, ABSOLUT is a registered trademark of The Absolut Company

Published on the occasion of the exhibition *Barbara Kasten: Stages* February 4 – August 16, 2015

Organized by Alex Klein, Dorothy and Stephen R. Weber (CHE'60) Program Curator, Insitute of Contemporary Art University of Pennsylvania, Philadelphia

Published by Institute of Contemporary Art and JRP|Ringier

Institute of Contemporary Art University of Pennsylvania 118 South 36th Street Philadelphia, PA 19104

www.icaphila.org

Curator
Alex Klein

Publications Coordinator
Anthony Elms

Copy Editor
Nell McClister

Installation Photography
Constance Mensh

Image Permissions
Sarah Burford
Gee Wesley

Design
Mark Owens with
Nilas Andersen

Printing
The Avery Group at
Shapco Printing, Minneapolis

Front and back cover
Barbara Kasten installing her exhibition *Centric 2: Barbara Kasten, installation/ photographs*, University Art Museum, California State Univerisity Long Beach, 1982 © Barbara Kasten, courtesy University Art Museum, California State University Long Beach

Major support for *Barbara Kasten: Stages* has been provided by The Pew Center for Arts & Heritage, with additional support from the Nancy E. and Leonard M. Amoroso Exhibition Fund, Pamela Toub Berkman & David J. Berkman, Bortolami, the Carol T. & John G. Finley Fund, Gallery Luisotti, Kadel Willborn Gallery, the Marjorie E. and Michael J. Levine Fund, Toby Devan Lewis, Amanda & Andrew Megibow, Stephanie B. & David E. Simon, Babette L. & Harvey A. Snyder, and Meredith L. & Bryan S.Verona.

ICA is always Free for All.
Free admission is courtesy of Amanda and Glenn Fuhrman.

ICA acknowledges the generous sponsorship of Barbara B. & Theodore R. Aronson for exhibition catalogues. Programming at ICA has been made possible in part by the Emily and Jerry Spiegel Fund to Support Contemporary Culture and Visual Arts and the Lise Spiegel Wilks and Jeffrey Wilks Family Foundation, the Ruth Ivor Foundation and by Hilarie L. & Mitchell Morgan. Marketing is supported by Pamela Toub Berkman & David J. Berkman and by Lisa A. and Steven A. Tananbaum. Additional funding has been provided by the Horace W. Goldsmith Foundation, the Dietrich Foundation, the Overseers Board for the Institute of Contemporary Art, friends and members of ICA, and the University of Pennsylvania. General operating support provided, in part, by the Philadelphia Cultural Fund. ICA receives state arts funding support through a grant from the Pennsylvania Council on the Arts, a state agency funded by the Commonwealth of Pennsylvania and the National Endowment for the Arts, a federal agency. ICA thanks La Colombe for providing complimentary coffee at public events. ICA acknowledges Le Méridien Philadelphia as our official Unlock Art™ partner hotel.

Distributed by

JRP|Ringier
Limmatstrasse 270
CH–8005 Zurich
T +41 (0) 43 311 27 50
F +41 (0) 43 311 27 51
E info@jrp-ringier.com
www.jrp-ringier.com

ISBN 978-3-03764-410-2

JRP|Ringier publications are available internationally at selected bookstores and from the following distribution partners:

Switzerland
AVA Verlagsauslieferung AG, Centralweg 16, CH–8910 Affoltern a.A., verlagsservice@ava.ch, www.ava.ch

Germany and Austria
Vice Versa Distribution GmbH, Immanuelkirchstrasse 12, D–10405 Berlin, info@vice-versa-distribution.com, www.vice-versa-distribution.com

France
Les presses du réel, 35 rue Colson, F-21000 Dijon, info@lespressesdureel. com, www.lespressesdureel.com

UK and other European countries
Cornerhouse Publications, HOME, 2 Tony Wilson Place, UK-Manchester M15 4FN, publications@cornerhouse.org www.cornerhouse.org/books

USA, Canada, Asia, and Australia
ARTBOOK|D.A.P.,155 Sixth Avenue, 2nd Floor, USA-New York, NY 10013, orders@dapinc.com, www.artbook.com

For a list of our partner bookshops or for any general questions, please contact JRP|Ringier directly at info@jrp-ringier. com, or visit our homepage www. jrp-ringier.com for further information about our program.